TOP WILDLIFE SITES
OF THE WORLD

FOR PRIMROSE

First published in 2015 by Reed New Holland Publishers Pty Ltd
London • Sydney • Auckland

The Chandlery, Unit 704, 50 Westminster Bridge Road, London SE1 7QY, UK
1/66 Gibbes Street, Chatswood, NSW 2067, Australia
5/39 Woodside Avenue, Northcote, Auckland 0627, New Zealand

www.newhollandpublishers.com

A record of this book is held at the British Library and the National Library of Australia.

ISBN 978 1 92151 759 4

Managing Director: Fiona Schultz
Publisher and Project Editor: Simon Papps
Cover design: Andrew Quinlan
Internal design: Thomas Casey
Production Director: Olga Dementiev
Printer: Toppan Leefung Printing Ltd

10 9 8 7 6 5 4 3 2 1

Keep up with New Holland Publishers on Facebook
www.facebook.com/NewHollandPublishers

Keep up with Burrard-Lucas Photography on Facebook and Instagram
www.facebook.com/BLphotography
instagram.com/willbl

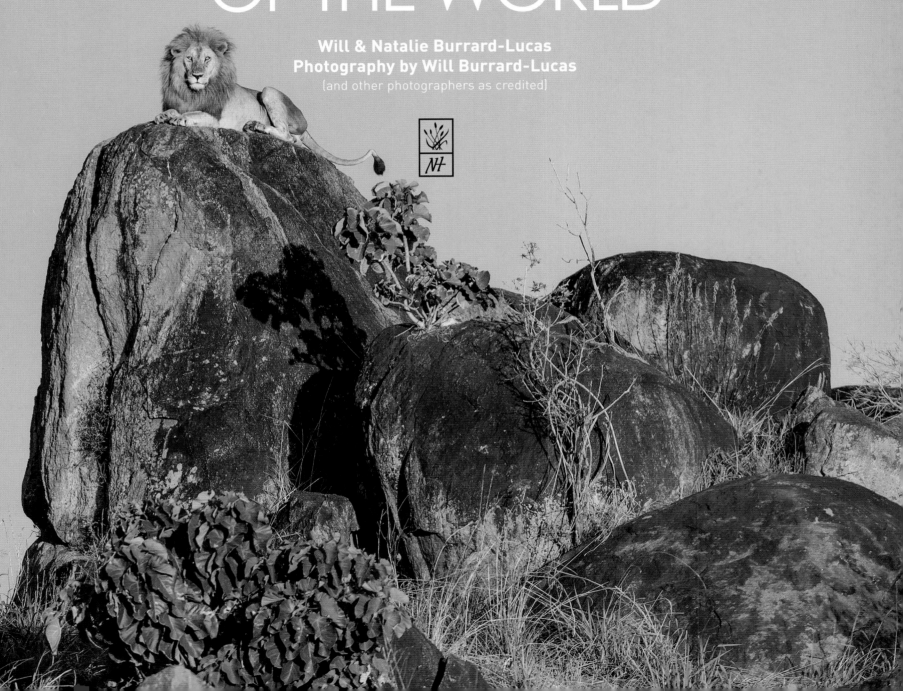

TOP WILDLIFE SITES
OF THE WORLD

Will & Natalie Burrard-Lucas
Photography by Will Burrard-Lucas
(and other photographers as credited)

CONTENTS

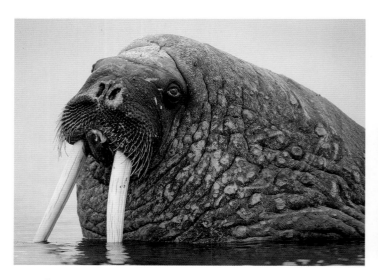

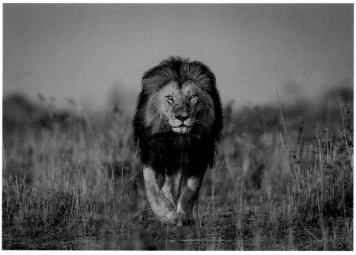

Introduction .. 6

Eurasia ... 12

Norway: Svalbard ... 14

Finland: Kainuu and Kuhmo regions 20

United Kingdom: Farne Islands 26

China: Qinling Mountains 32

Nepal: Chitwan National Park 38

India: Ranthambore National Park 44

Sri Lanka: Minneriya National Park 50

Indonesia: Tanjung Puting
 National Park, Kalimantan 56

Indonesia: Komodo National Park 62

Africa ... 68

Ethiopia: Bale Mountains National Park 70

Republic of Congo: Odzala-Kokoua National Park 76

Kenya: Maasai Mara National Reserve 82

Tanzania: Serengeti National Park 88

Rwanda: Volcanoes National Park 96

Zambia: South Luangwa National Park 102

Zambia: Kasanka National Park 110

Zimbabwe: Hwange National Park 118

Botswana: Makgadikgadi Pans National Park 126

Botswana: Okavango Delta 132

Namibia: Palmwag Concession, Kunene Region 140

Madagascar: Amber Mountain National Park 146

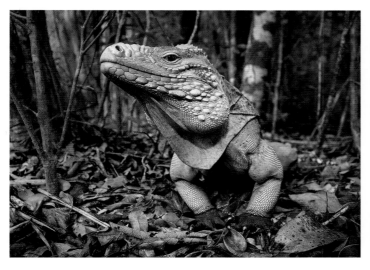

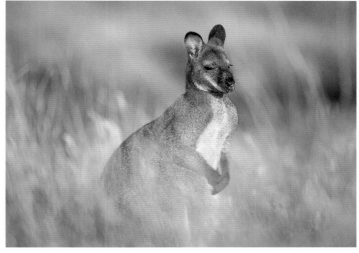

Americas ... 154

USA: Katmai National Park, Alaska 156

USA: Yellowstone and
 Grand Teton National Parks 162

Cayman Islands .. 170

Costa Rica: Corcovado National Park 176

Ecuador: Galápagos Islands 184

Peru: Manú National Park 192

Brazil: Pantanal ... 198

Australasia and the
Antarctic Zone 206

Australia: Tasmania ... 208

New Zealand: Rakiura National Park,
 Stewart Island ... 216

The Falkland Islands .. 222

Antarctica ... 230

About the images in this book 236

Index ... 239

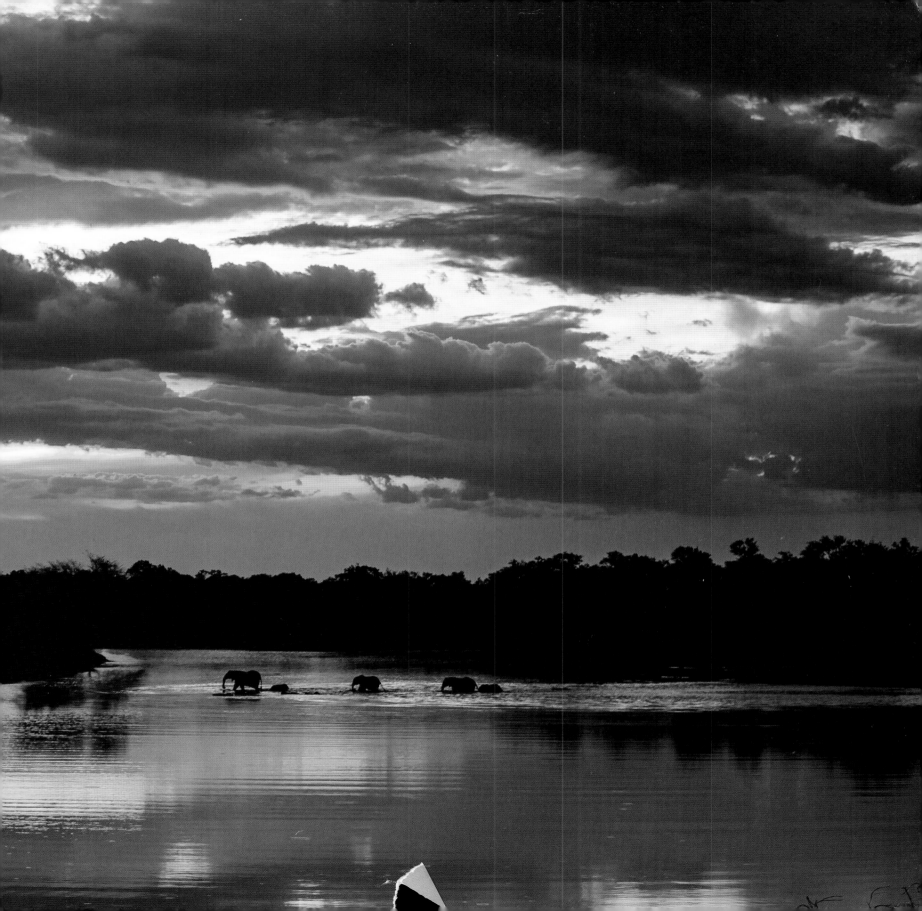

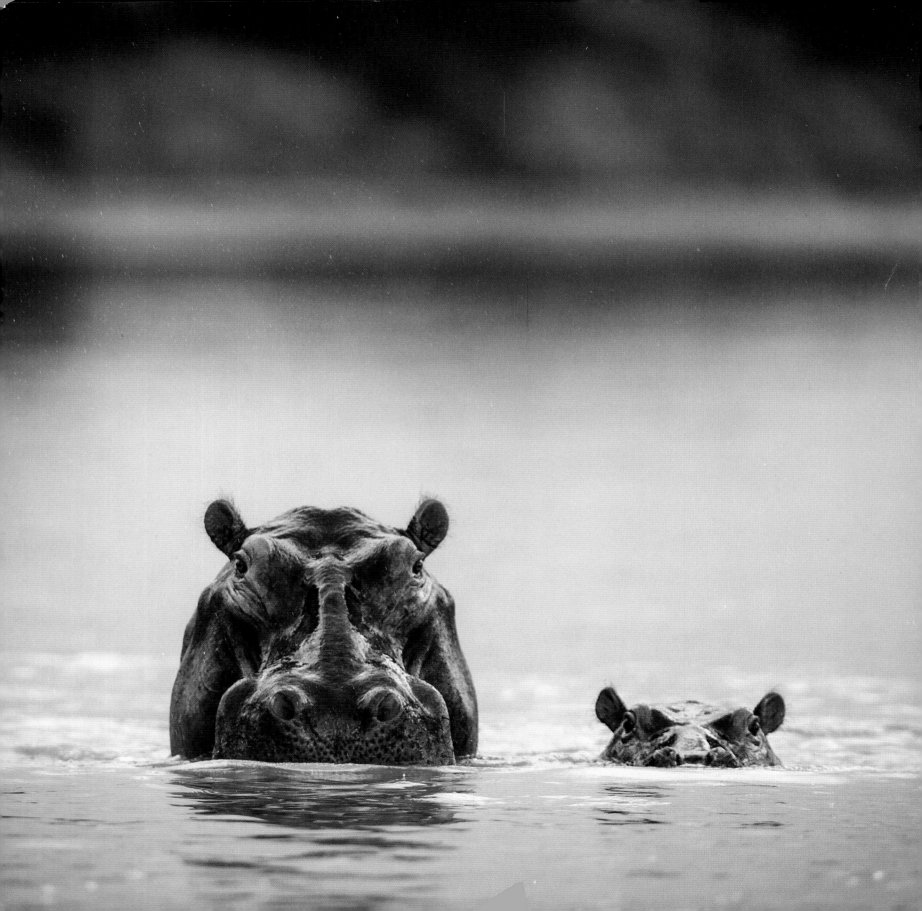

INTRODUCTION

Glass Frog, Corcovado National Park, Costa Rica.

Orca, the Falkland Islands.

THE NATURAL WORLD never fails to amaze me with its beauty, ingenuity and magnificence. Over a million wildebeest migrating across the plains of the Serengeti in pursuit of rain, male Emperor Penguins huddling together for two months without food during the Antarctic winter to incubate their eggs, or hundreds of macaws gathering to eat clay on the banks of a river in Peru to neutralise the toxins in their diet are just some of the awe-inspiring phenomena that are taking place out there in the world we live in. The biological diversity that surrounds us on Earth is undoubtedly the greatest treasure that we have.

There has never been a better time than today to be a wildlife enthusiast. This may seem counter-intuitive given the rate at which the natural world is deteriorating, with habitat loss, human encroachment and poaching pushing more and more species onto endangered lists. However, increasing ease of travel and eco-tourism infrastructure has made it possible for us to reach remote regions and see wildlife that, until recent years, existed only on the pages of books and television screens for most. There is plenty of wildlife out there still to be seen and appreciated, but this is unlikely to be true for future generations unless dramatic steps are taken to protect and conserve what we have left.

In many situations, the reason that wildlife is suffering is because people feel that they can gain more from destroying it rather than preserving it, such as through poaching, logging and mining. From my experience, one of the most effective approaches to encourage local people to preserve the wildlife on their doorstep is to turn the wildlife into their most valuable asset through eco-tourism. If tourists pay to visit these destinations through responsible organisations that ensure revenues reach the local communities, such as by employing local staff and sourcing food from local producers, then these communities benefit and the wildlife is protected.

PREVIOUS PAGES Elephants wading through a lagoon during the wet season, South Luangwa National Park, Zambia.
OPPOSITE Hippos in the Luangwa River, South Luangwa, Zambia.

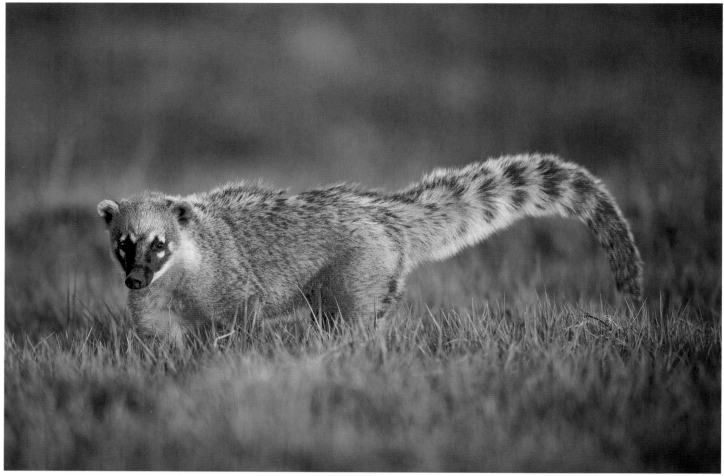
Coati, Pantanal, Brazil.

As a professional wildlife photographer, I have been fortunate enough to visit many wonderful and wild places around the world. I have drawn on my experience to select 32 of my favourite wildlife destinations to share in this book.

The places I have included are not exhaustive. I know that many great sites have been left out. Each person will have their own favourite wildlife destinations and a book of this kind will always invite debate, but I hope that you will feel inspired by these places that have inspired me and that continue to take my breath away.

Some of the places are well-known, such as the Serengeti in Tanzania and Yellowstone National Park in the USA. Others are less famous, such as Zambia's Kasanka National Park and Tanjung Puting National Park in Indonesia. I have included a wide spread of locations from around the globe and have tried to include some places that are easily accessible such as the Maasai Mara in Kenya, along with some destinations that are slightly more challenging to reach, including Odzala-Kokoua in the Congo Basin and the Bale Mountains in Ethiopia.

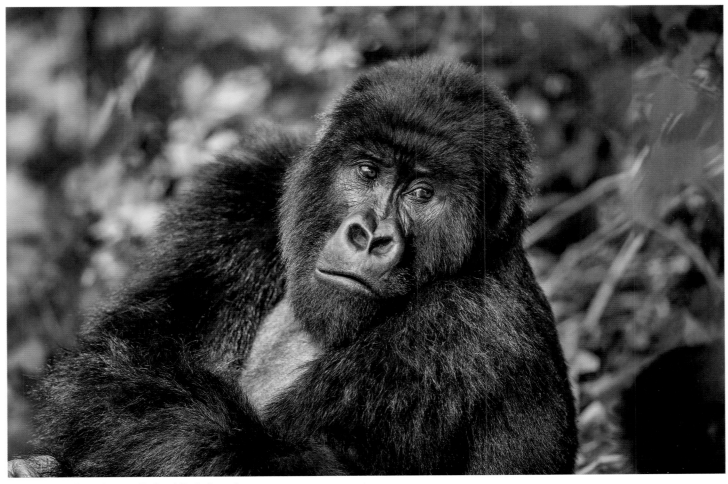

Mountain Gorilla, Volcanoes National Park, Rwanda.

Although my line of work means that I have been lucky enough to visit the majority of these destinations, there are four locations in this book that are still on my 'bucket list' of places to go, but could not be omitted from a book entitled *Top Wildlife Sites of the World*. For the places that I have not yet visited, I have researched and discussed them with my colleagues to ensure that I present an accurate description of each. The book is illustrated with my own wildlife photographs along with a small number of images taken by other photographers. Where an image is not mine, the photographer has been credited.

I hope this book will inspire you to get out there and visit some of the world's unforgettable wildlife spots — in doing so, you may very well be contributing to their survival. In addition, I hope that like me, the wildlife that awaits you in these destinations will etch a place in your memory forever.

Will Burrard-Lucas

EURASIA

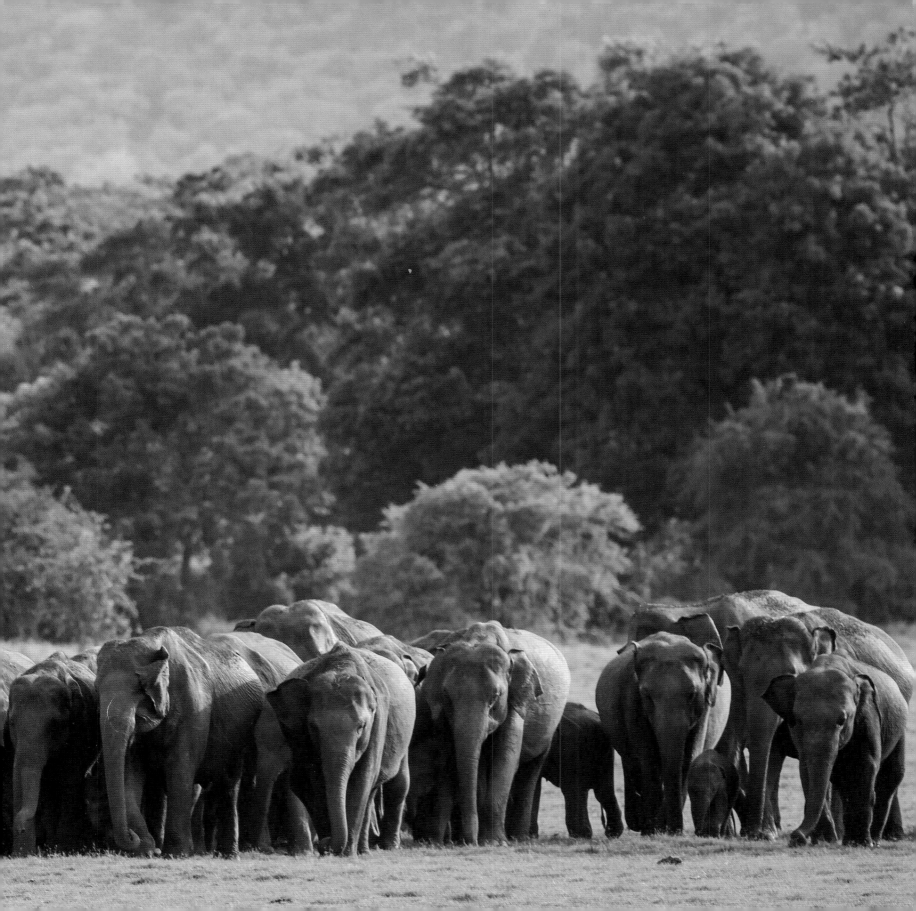

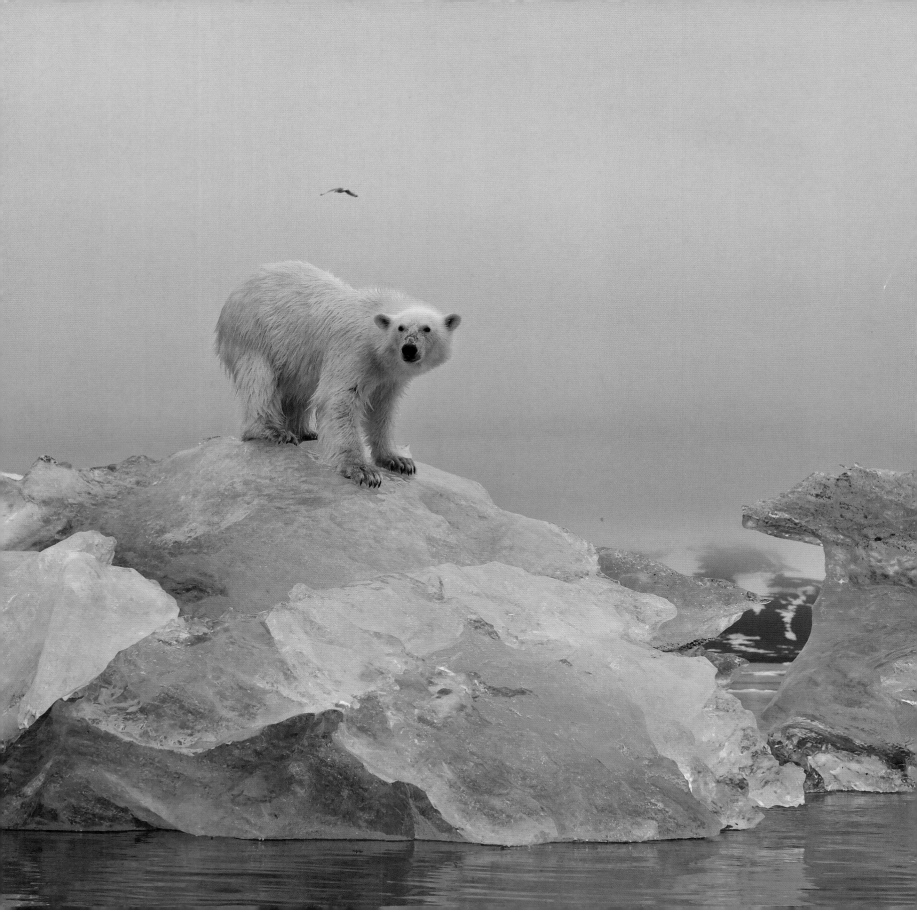

NORWAY: SVALBARD

"The boat pushed through the still water towards an imposing wall of ice.
Every now and then, large chunks of blue ice fell from the glacier front.
I wondered how any life could exist in such a harsh and frigid landscape."

SVALBARD IS A NORWEGIAN ARCHIPELAGO located deep inside the Arctic Circle, just over 1,300km (800 miles) from the North Pole. It has an Arctic climate and much of the terrain is permanently covered in ice, with approximately 60 per cent of the land area covered by glaciers. However, the West Spitsbergen Current (a branch of the Gulf Stream) helps to raise the temperatures on Svalbard, enabling human habitation, and this also means that wildlife is more abundant than would be expected for such a location. This does not mean that the temperatures are balmy however. The winter months are dark, cold and quiet; the birds that are so prolific in the summer migrate to warmer climates, leaving behind the Svalbard Rock Ptarmigan (the only landbird that remains throughout the year) and a handful of seabird species which spend the winter in the archipelago. There are only three permanent land-based mammals in Svalbard (Svalbard Reindeer, Arctic Fox and Sibling Vole), all of which have cold-weather adaptions enabling them to survive the harsh conditions by laying down fat stores to use up during the cold months when the food supply dwindles.

The archipelago's history is in whaling and mining, but today it is the lure of the abundant Arctic wildlife that puts Svalbard on the map. It can be visited in the summer months, typically between June and September, when the sun never sets. Most visitors cruise around the archipelago aboard ice-capable vessels, being taken to the best spots for Polar Bear sightings, whale-watching and guided walks across the tundra. Most visitors will leave having seen Polar Bear, Svalbard Reindeer, Arctic Fox, Walrus, seals and whales, as well as many seabirds.

OPPOSITE Polar Bear on ice.

NOTABLE SPECIES

Polar Bear
Arctic Fox
Walrus
Ringed Seal
Bearded Seal

Harbour Seal
Bowhead Whale
Beluga Whale
Narwhal
Svalbard Reindeer

WHEN TO GO

Visit during the summer months from June to September.

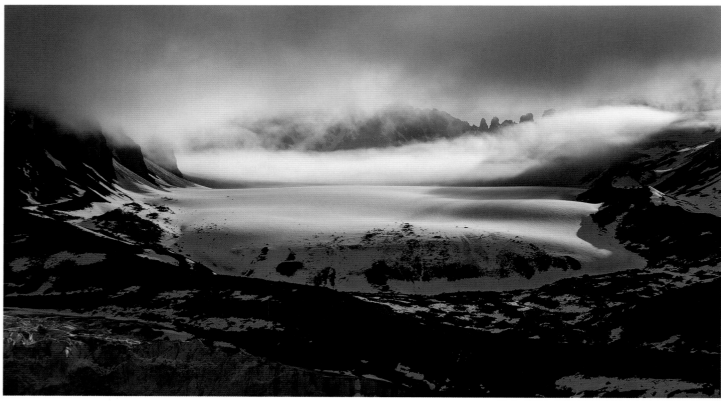

ABOVE Hanging glacier.

Polar Bears are the most iconic of Arctic species. They are large and powerful predators, similar in size to Kodiak Bears (a subspecies of the Brown Bear). Polar Bears and Kodiak Bears are the largest terrestrial carnivores, with adult males weighing up to 700kg (1,550lb) and measuring up to 3m (10ft) in length. Compared to Brown Bears, Polar Bears have shorter, stockier legs but larger feet in order to spread their load more effectively when walking on ice and snow. Large feet are also an advantage when swimming, with Polar Bears' front paws serving as paddles and turning them into very capable swimmers. Other adaptions for the cold Arctic conditions include a thick coat of fur (even on the bottom of their paws) and blubber for insulation, which together can measure up to 10cm (4in) in thickness. Being equipped for the cold is essential for a creature that roams the ice sheets and swims in the frigid waters. They mainly prey on seals, spending time on the ice near cracks, edges and breathing holes waiting for their quarry to surface.

Another quintessential Arctic animal is the Walrus, a large marine mammal with distinctive tusks, whiskers and ample blubber, all of which serve useful functions for surviving in the Arctic. The thick layer of blubber under their skin insulates them from the cold and can bring an adult male Walrus's weight up to 2,000kg (4,400lb). Their iconic tusks can measure up to 1m (3.3ft) in length and have multiple uses, including fighting, creating holes in the ice and for climbing out of the water onto the ice. Their whiskers, called vibrissae, are similar to the whiskers of a cat in function; they are extremely sensitive stiff bristles used as tactile sensory apparatus when foraging.

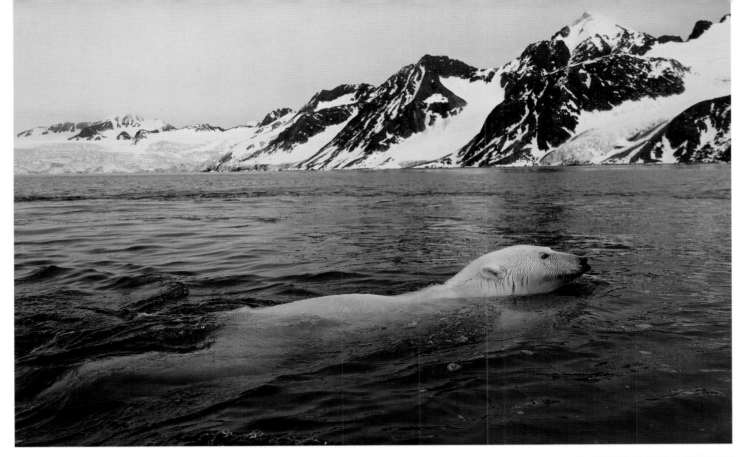

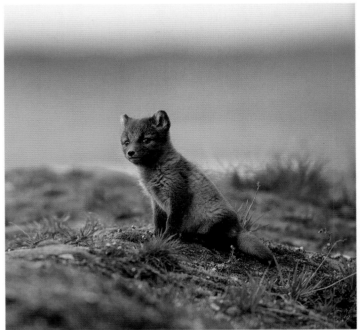

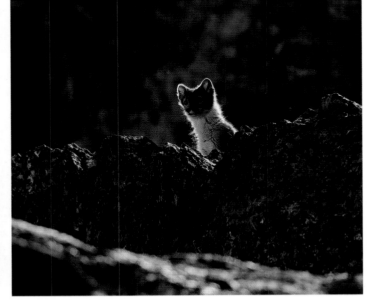

ABOVE CLOCKWISE FROM TOP Swimming Polar Bear; Arctic Fox; Arctic Fox cub.

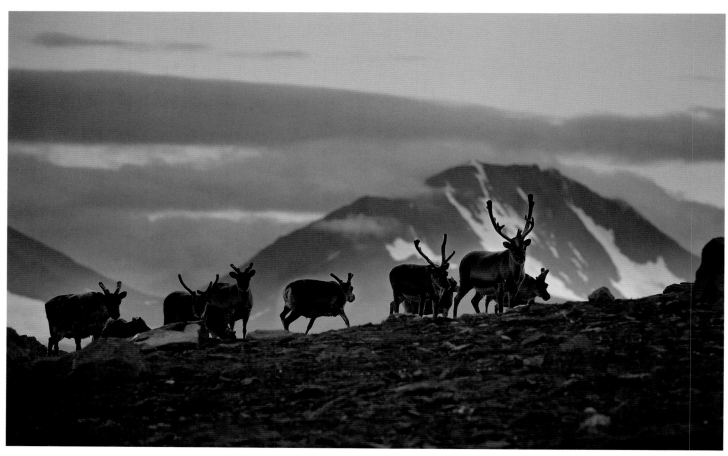

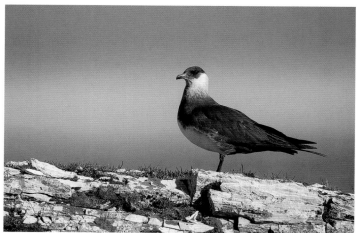

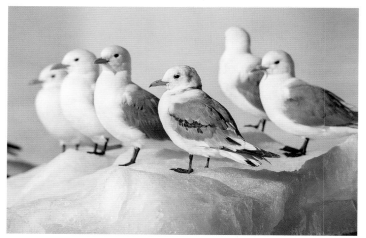

ABOVE CLOCKWISE FROM TOP Reindeer herd; Black-legged Kittiwakes on iceberg; Arctic Skua.

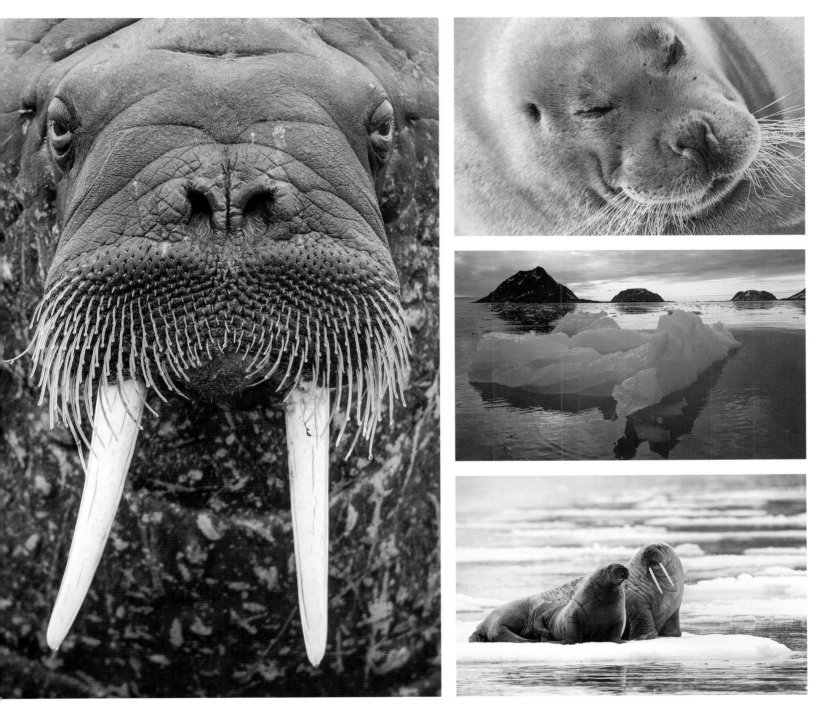

ABOVE CLOCKWISE FROM LEFT Walrus; Bearded Seal; a chunk of glacial ice floating in Smeerenburgfjorden; Walrus on ice.

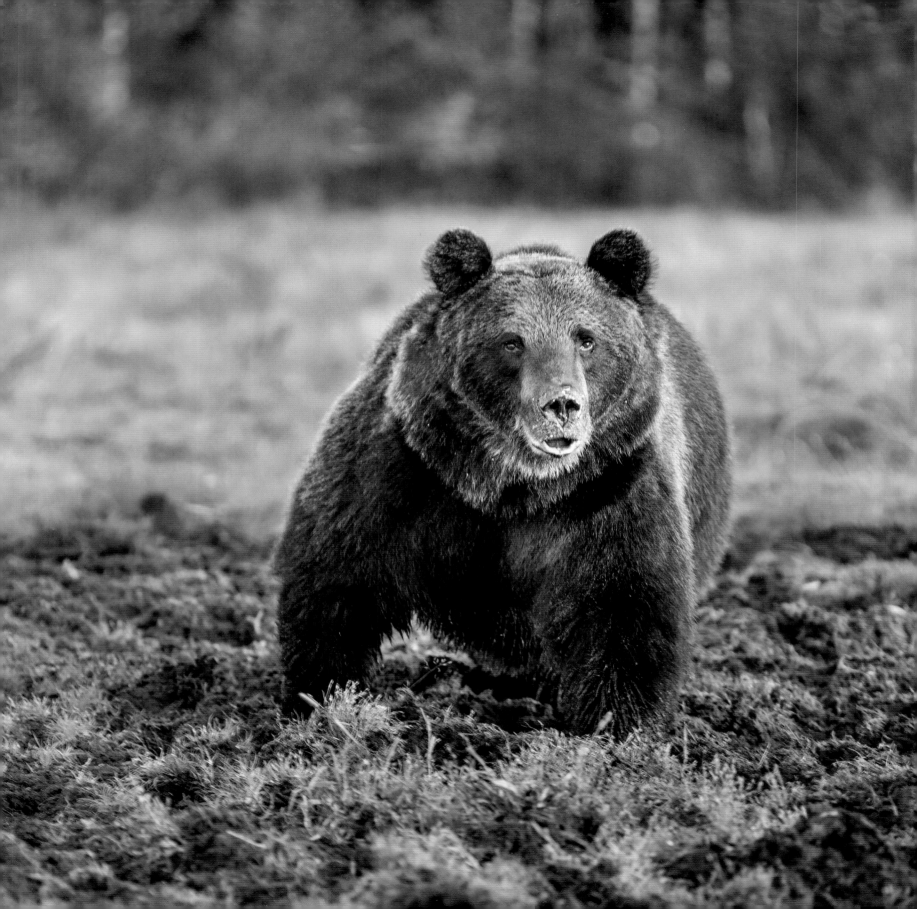

FINLAND: KAINUU AND KUHMO REGIONS

"Despite the late hour, a permanent twilight glow filtered through the trees. It wasn't just the light keeping me awake at 3am in the forest hide, the presence of a huge male Brown Bear padding around on the mossy forest floor less than 20m (65ft) away had me captivated."

FINLAND IS EUROPE'S MOST FORESTED country with about 70 per cent of the land area covered in trees. The dense forests of eastern Finland on the border with Russia, in the Kainuu and Kuhmo regions, provide the ideal environment for a wide range of north European wildlife species including all four of the continent's large predatory mammals: Brown Bear, Grey Wolf, Wolverine and Eurasian Lynx. Other attractions include Moose and Great Grey Owl. Over 95 per cent of the land area in the region is forested and it is regarded as one of the best places in Europe to see Brown Bears. Most of the forests are coniferous, continuous with the vast taiga forests of Russia and Siberia to the east. Damp, peaty bogs are also commonplace. The flora and fauna has to withstand the pronounced seasonal variations, with many of the animals and plants lying dormant for the long, dark winter.

Brown Bears are found in North America, Europe and Asia, and are the most widely distributed bear species in the world. They hibernate during the winter months, digging dens in which to see out the cold weather. They awaken in the spring, typically in April in Finland, although it can be earlier or later depending on the temperatures that year. Hungry from their long hibernation, having used up the fat stores that they laid down the previous year, the bears then begin to forage voraciously. They are omnivores, eating anything from nuts, berries, fruit, leaves and roots through to rodents and even Moose. Their ability to reach speeds of almost 50km per hour (30 miles per hour), along with their large size, makes them formidable predators. Throughout May, the hungry bears continue to forage and build their strength in preparation for the mating season in June. The adult male bear seeks out a mate, following her around with

OPPOSITE European Brown Bear.

NOTABLE SPECIES

Brown Bear
Moose
Wolverine
Grey Wolf
Great Grey Owl

WHEN TO GO

The forest hides take visitors between April and August.

TIPS

Prepare to go nocturnal!

Lake at sunrise.

great persistence. During this time there can be aggressive clashes between males. Big males can weigh up to 300kg (660lb), so clashes can be quite an event. Once the mating season is over, the bears begin foraging for food once more, fattening up in preparation for winter. During these late summer to early autumn months, an adult bear will eat so much food that it will weigh twice as much pre-hibernation as it will in the spring. Female bears give birth during the winter hibernation and therefore require sufficient fat stores for themselves and their nursing cubs, who will survive on their mother's milk until spring.

Bears usually try to avoid people. Therefore, it is uncommon to encounter bears just by walking off into the woods. Several operators have set up bear safaris in the region to offer visitors the opportunity to see these magnificent animals. Between April and August, visitors can spend the night in specially constructed forest hides, with an excellent chance of seeing wild Brown Bears as well as the other wildlife of the region including Wolverines and Grey Wolves.

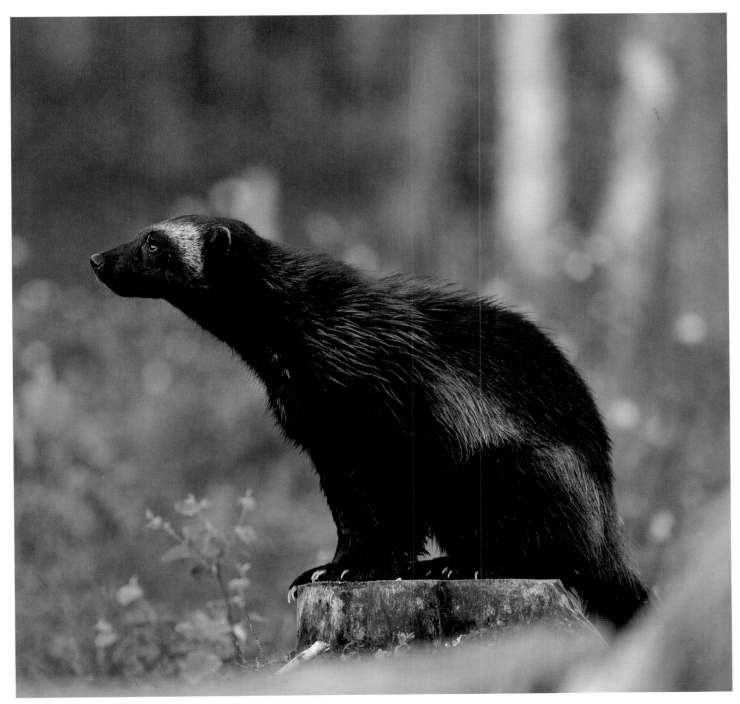

Wolverine.

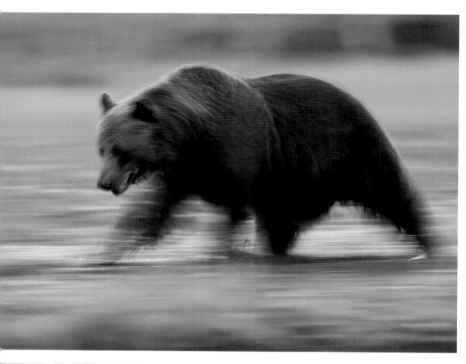

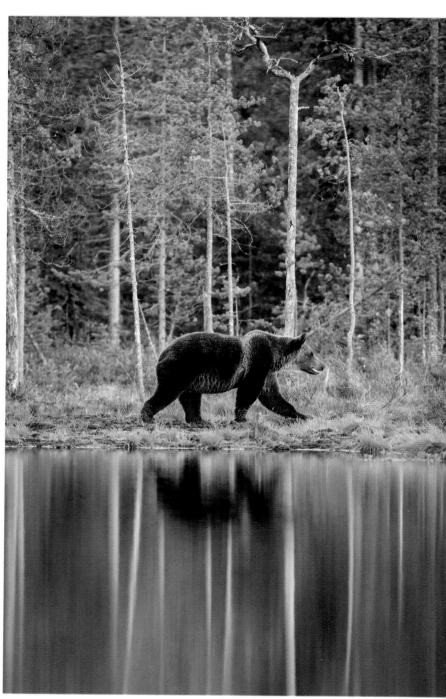

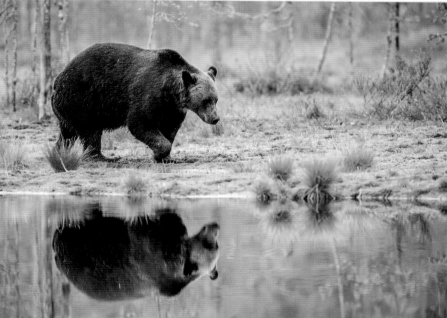

ABOVE European Brown Bear.

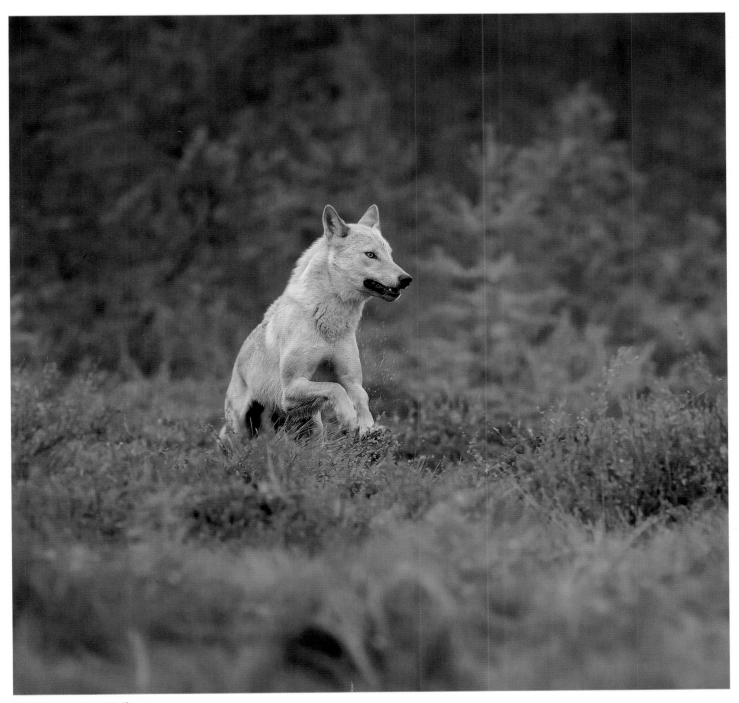

Wild European Grey Wolf.

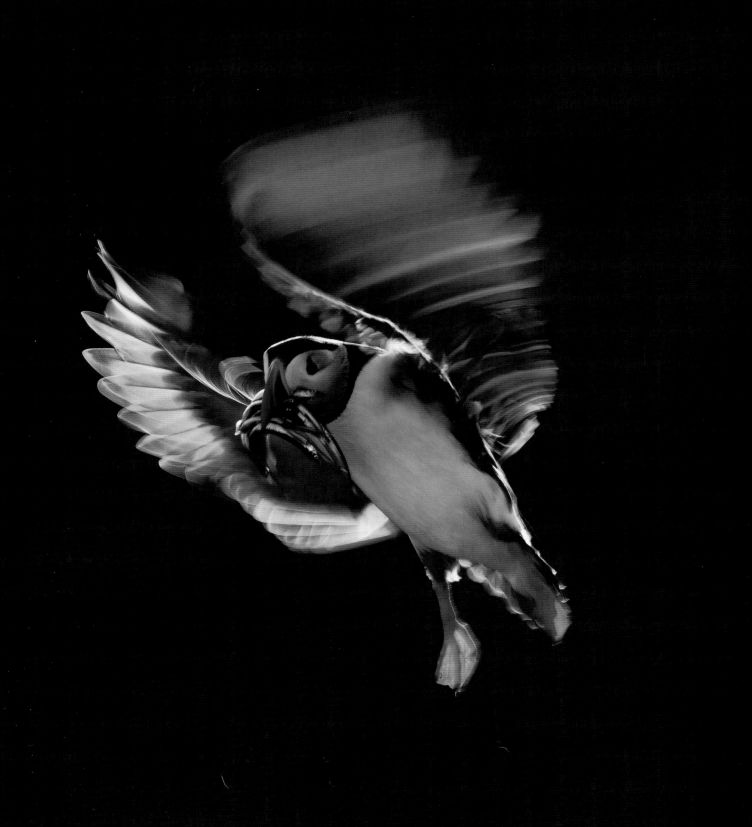

UNITED KINGDOM: FARNE ISLANDS

"I donned my hat to protect my head from the raucous, dive-bombing terns above me. On the ground were hundreds of puffins, shuffling around and dipping in and out of their burrows. The sheer number of birds around me was overwhelming!"

THE FARNE ISLANDS are a group of 20 islands located approximately 3km (2 miles) off the coast of Northumberland. The islands have been used by Celtic monks since the 7th century and are also a haven for seabirds. Monastic records show that Saint Cuthbert passed laws to protect the seabirds on the islands in 676, which is the earliest evidence of any bird protection laws existing anywhere in the world. The islands were once attached to the mainland of England, but erosion of weak limestone rock that lay between strong igneous rock, along with a rise in the sea level, led to the creation of today's Farne Islands with stacks, sea cliffs and columns aplenty.

In the time that records have been kept on the islands, over 290 different species of bird have been recorded. It is considered to be the most exciting seabird colony in England with 24 nesting species of seabirds, including over 35,000 breeding pairs of Atlantic Puffin. Although famed for the puffins and Arctic Terns, the Farnes are also home to Common Eiders, European Shags, Great Cormorants, Black-legged Kittiwakes, Common Guillemots and Razorbills to name a few. Most of the birds are migratory, flying in from far-flung locations such as Antarctica and Africa to spend the summer months breeding and rearing their young. Another wildlife attraction of the Farnes is the large Grey Seal colony, with around 1,000 pups born each year between September and November.

Atlantic Puffins are comical-looking seabirds with a brightly coloured bill, black back, white underparts and bright orange legs. They breed in large colonies, such as the one on the Farne Islands, nesting in burrows in the soil. The puffins on the Farne Islands tend to use pre-existing rabbit burrows to nest, evicting the rabbits with intimidation tactics. They are graceful swimmers, using their short wings to 'fly' through the water. In the air, they look slightly less graceful, beating their wings up to 400 times per minute and often landing in the water with a plop.

OPPOSITE Atlantic Puffin.

NOTABLE SPECIES
Grey Seal
Common Eider
European Shag
Great Cormorant
Black-legged Kittiwake
Arctic Tern
Atlantic Puffin
Common Guillemot
Razorbill

WHEN TO GO
Go from April through to late July for nesting seabirds.

TIPS
Wear a hat to protect yourself from dive-bombing terns.

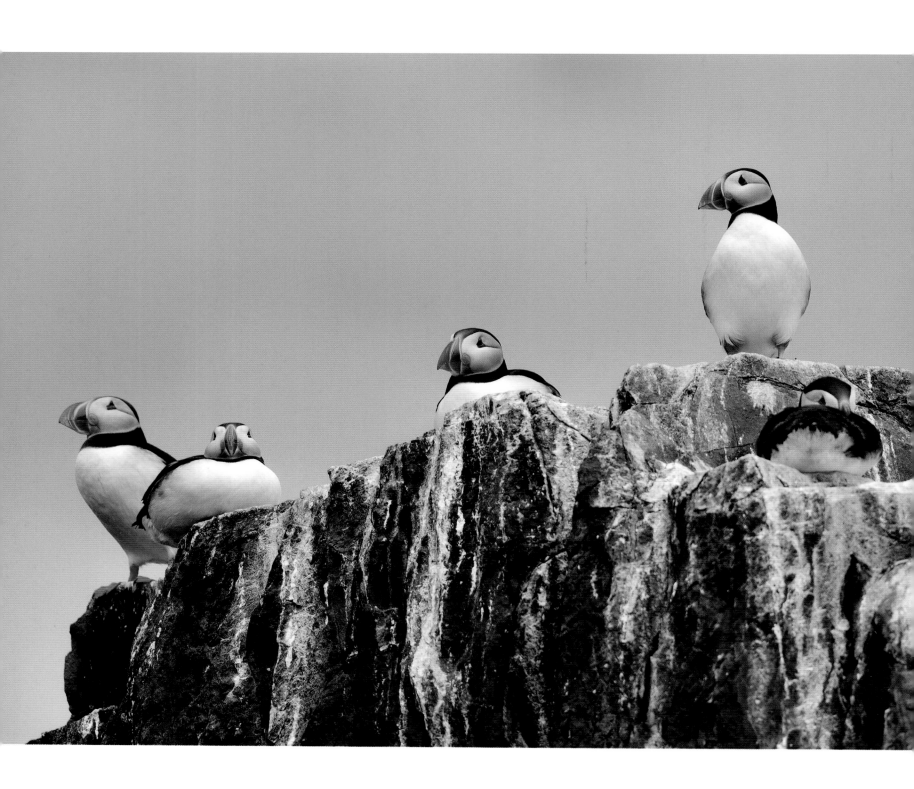

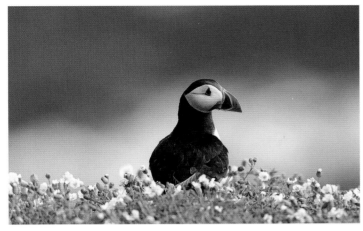

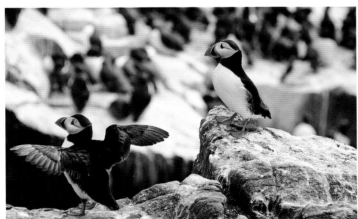

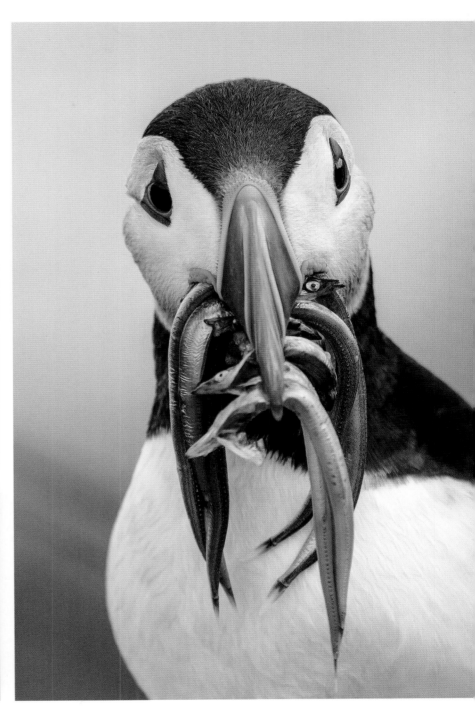

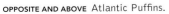 **OPPOSITE AND ABOVE** Atlantic Puffins.

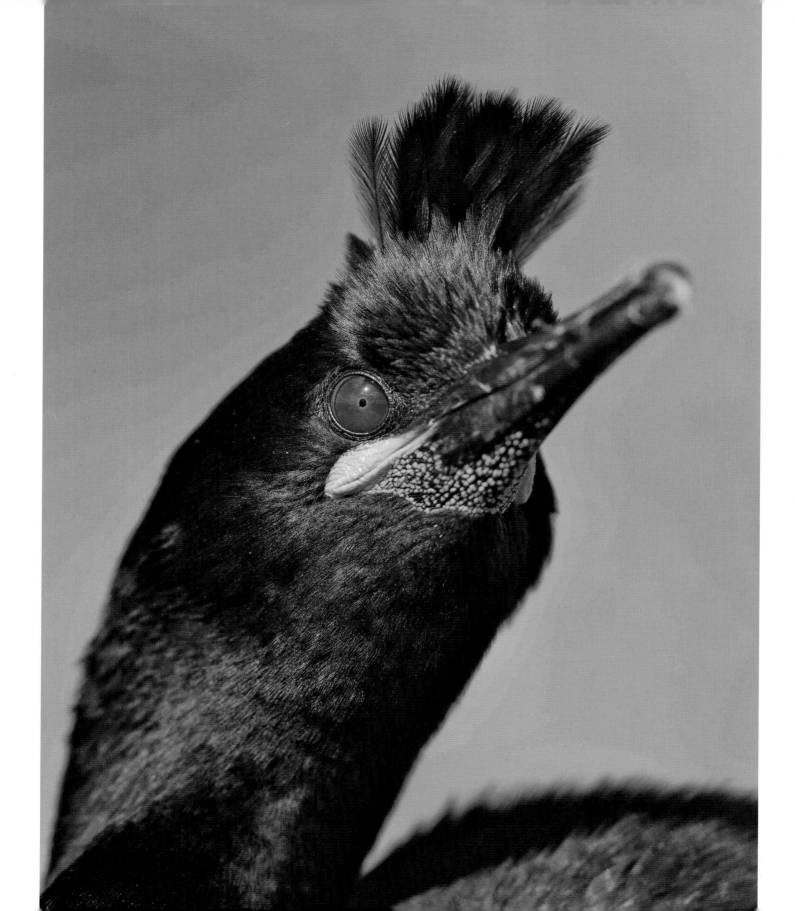

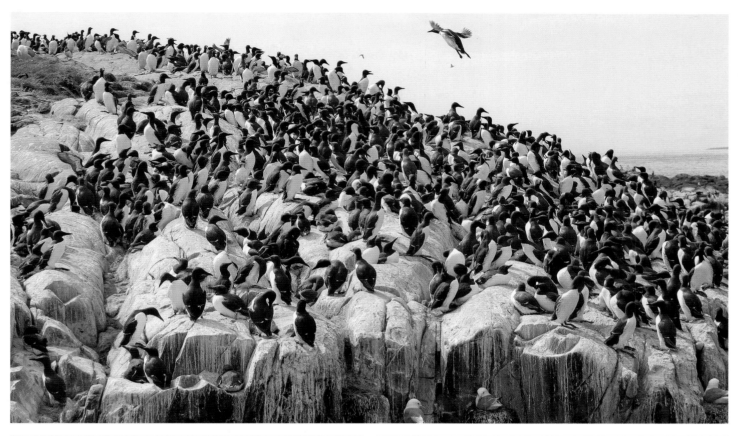

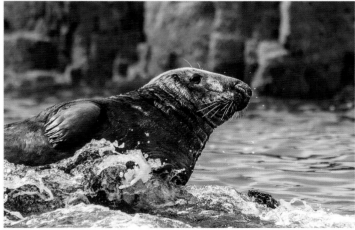

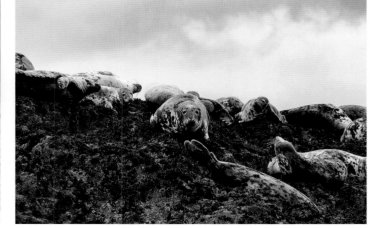

OPPOSITE European Shag.
TOP Common Guillemots and Black-legged Kittiwakes.
ABOVE Grey Seals.

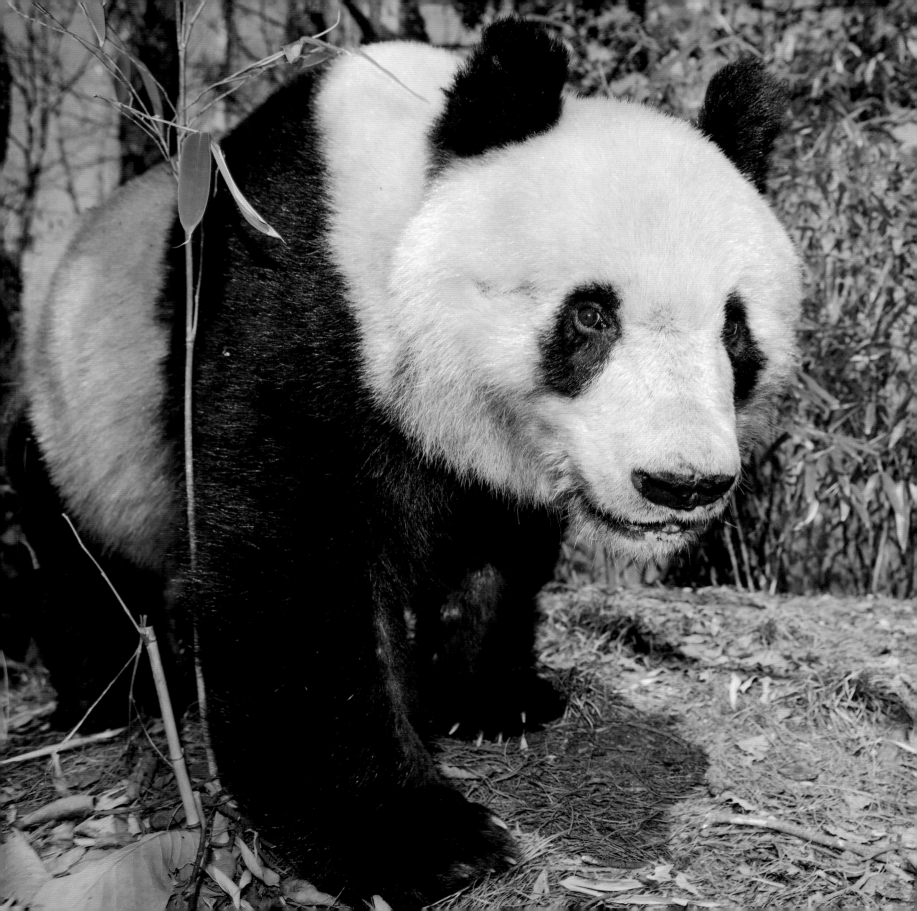

CHINA: QINLING MOUNTAINS

"I had just reached the top of another remote ridge, after a long and gruelling hike. Just then I heard the bamboo rustling somewhere down below me and a large stem seemed to disappear. I peered into the thicket and in the dappled light I saw a flash of white; my first wild Giant Panda!"

THE QINLING MOUNTAINS in China's eastern province of Shaanxi are one of the few remaining places where Giant Pandas live in the wild. The mountains have spectacular scenery and are also home to other rare and distinctive mammals including the Sichuan Snub-nosed Monkey, Golden Takin, Crested Ibis, Red Panda and Clouded Leopard.

The mountains provide a natural demarcation between the north and south of China, as well as being the watershed for the country's two great rivers (the Yellow River and the Yangtze). There is a noticeable shift in the flora on the different sides of the mountain range, with subtropical forests to the south and temperate deciduous forests to the north. Some of the Qinling peaks rise above 3,000m (9,850ft) and serve as a barrier to the cold air from the north. Therefore, the southern slopes see warm rains and abundant plant and animal life, including a number of endemic plant species.

Numerous, diverse bamboo species grow in the mountains, making this ideal habitat for the Giant Panda. There are around 300 pandas in the Qinling mountains. Giant Pandas are prolific bamboo-eaters, with an adult consuming around 12kg (26lb) of bamboo daily, munching for around 12 hours a day to achieve this feat. Despite over 99 per cent of a panda's diet being bamboo, it has the digestive system of a carnivore and derives little protein or energy from this food, which is why they have to eat such vast quantities each day. They also limit physical exertion to conserve their scarce energy supplies. As well as having five digits, pandas have a modified, elongated bone from the wrist that functions and looks like a thumb, helping them to holding bamboo while eating. It gives pandas the appearance of having six digits on each hand.

Pandas have distinctive, thick, black and white coats to

OPPOSITE Giant Panda.

NOTABLE SPECIES
Giant Panda
Qinling Golden Snub-nosed
 Monkey
Golden Takin
Red Panda
Clouded Leopard
Crested Ibis
Golden Eagle

TIPS
Check whether Giant Panda trekking is currently permitted before booking your trip.

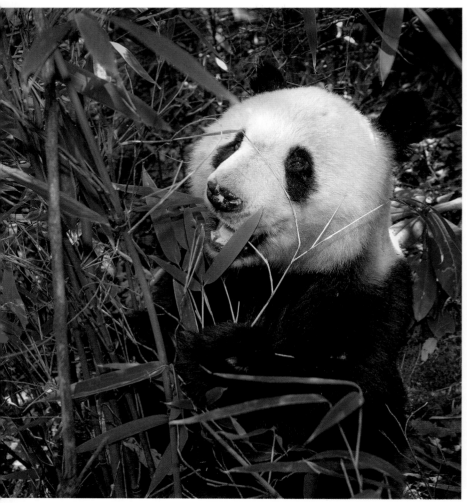

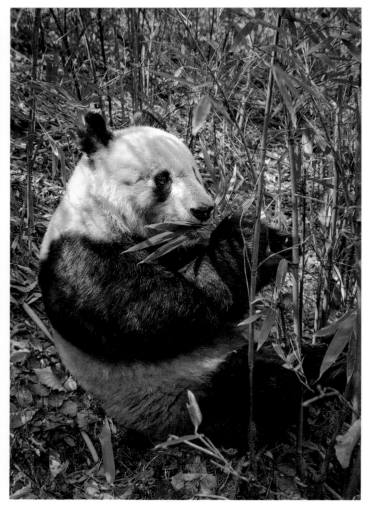

ABOVE LEFT AND RIGHT Giant Panda.
OPPOSITE Golden Takin.

keep them warm in the cool, damp bamboo forests. As solitary animals, they tend to roam the forests alone within their territory, marking trees with their scent as they go. Their keen sense of smell helps male pandas to avoid other males and to seek out females as mates. They do not create permanent dens and do not hibernate, choosing to move to a lower altitude with warmer temperatures when necessary.

Sadly, despite being the national symbol of China and the symbol for conservation itself (the WWF logo has been a Giant Panda since the organisation formed in 1961), Giant Pandas face grave challenges. There are only 1,600 remaining in the wild and many live in fragmented, unsustainable populations, in small areas of suitable forest surrounded by human settlements. Roads and railroads are increasingly fragmenting their habitat, isolating panda populations and preventing mating. Thankfully, poaching has seen a huge decline. Habitat loss and degradation remain the biggest threat to the species.

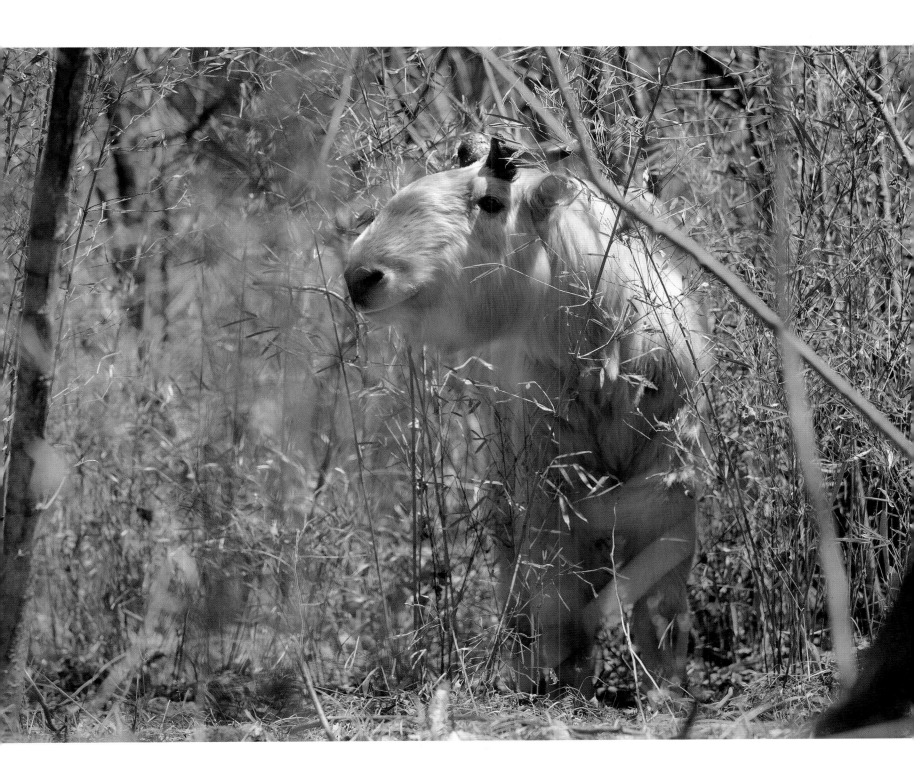

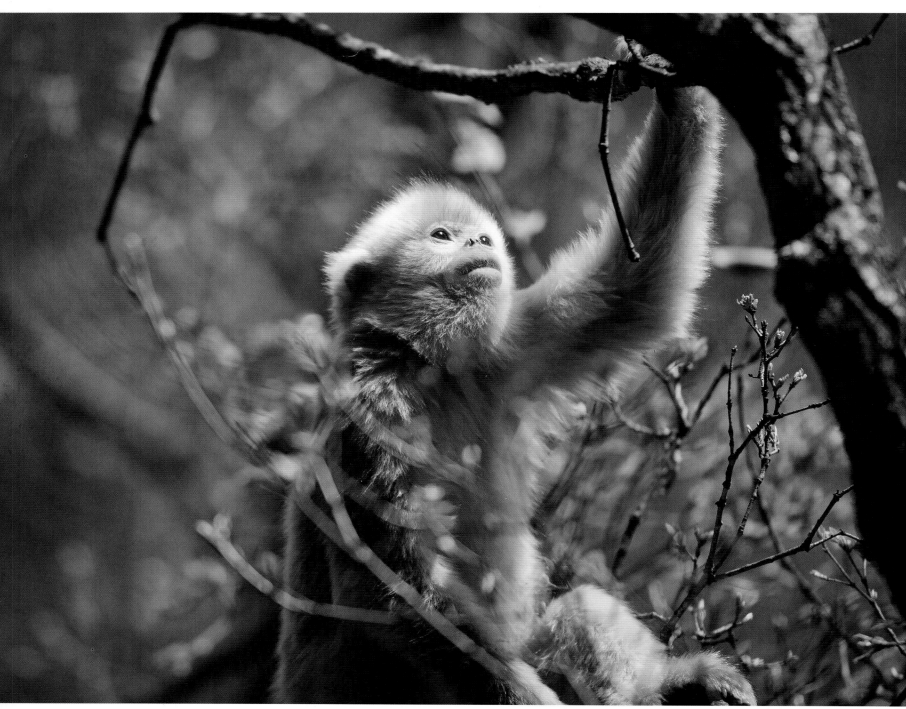

ABOVE Qinling Golden Snub-nosed Monkey.
OPPOSITE TOP TO BOTTOM Red-and-white Giant Flying Squirrel; Golden Pheasant.

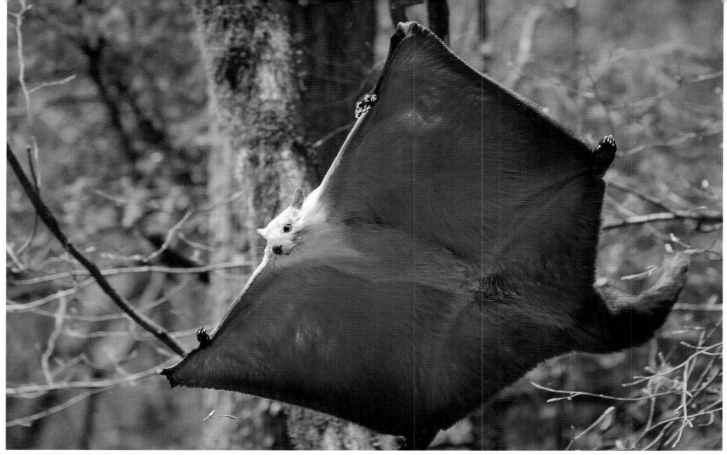

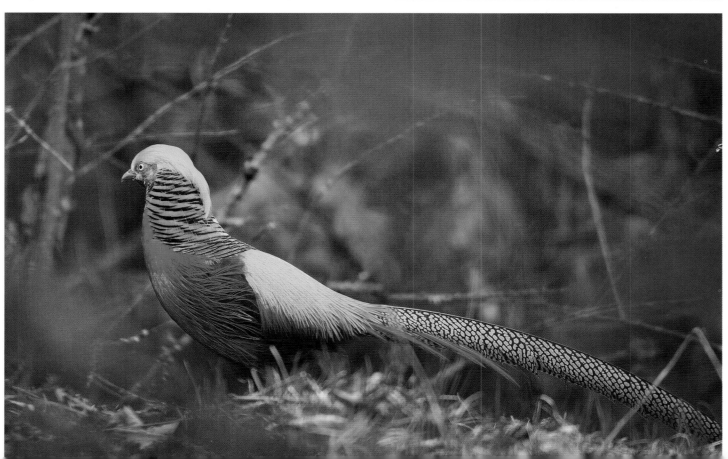

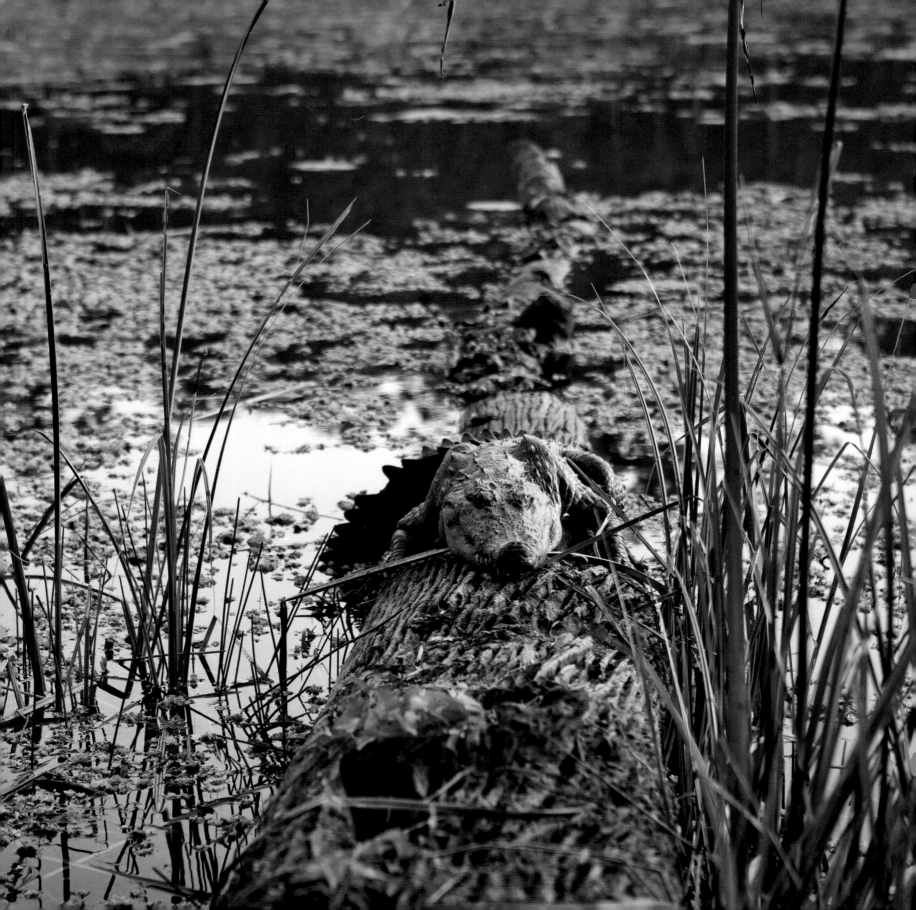

NEPAL: CHITWAN NATIONAL PARK

"There was a chill in the morning air. From my vantage point on the back of an elephant, I watched birds flitting over the marshland. As we plodded around a thicket, we came across a rhinoceros knee-deep in water, with a mist hovering around him. After some noisy snorting as he detected our presence, he continued munching on aquatic plants nonchalantly."

CHITWAN NATIONAL PARK is located in south-central Nepal, covering over 900 sq km (350 sq miles). It is situated in the Terai, which is a belt of marshy grasslands and forests beneath the Himalayas. Initially a royal hunting reserve between 1846 and 1951, it was established as a national park in 1973, with the intention of protecting the Greater One-horned Rhinoceros and other wildlife. It became a World Heritage Site in 1984.

It is widely regarded as one of the best national parks in Asia for spotting wildlife. Most visitors will see deer, monkeys and rhinos, and there is also a chance of encountering Leopards, wild elephants, Sloth Bears and even tigers. Wildlife activities include elephant-back safaris and walking safaris.

The Greater One-horned Rhinoceros (also known as the Indian Rhinoceros) have a single black horn, which can be 20–60cm (8–24in) long and thick skin folds that give them a distinctive armour-plated appearance. They are around 2m (6.5ft) tall, weighing over 2,000kg (4,400lb). They are grazers; eating grasses, leaves, fruit and aquatic plants. They favour semi-aquatic habitats and spend a lot of time wallowing in marshes, lakes and rivers. Despite their size and shape, they are excellent swimmers, even diving and feeding underwater on occasion. They are solitary creatures, but may be seen together when wallowing in water or when grazing. As with other rhinoceros species, they have poor eyesight but a keen sense of smell.

In the 1950s, the park was home to around 800 rhinos, but increased population pressure and a rise in poaching led to the dwindling of rhino numbers down to only 95 in 1970. The national park was established in 1973 in an attempt to protect the rhinos and their habitat. Thankfully, the rhino numbers have been recovering, with a population of 500 in 2011.

OPPOSITE Mugger Crocodile.

NOTABLE SPECIES

Greater One-horned Rhinoceros
Sambar
Hanuman Langur
Rhesus Macaque
Wild Boar
Bengal Tiger
Leopard
Sloth Bear

WHEN TO GO

In the dry season, between September and April.

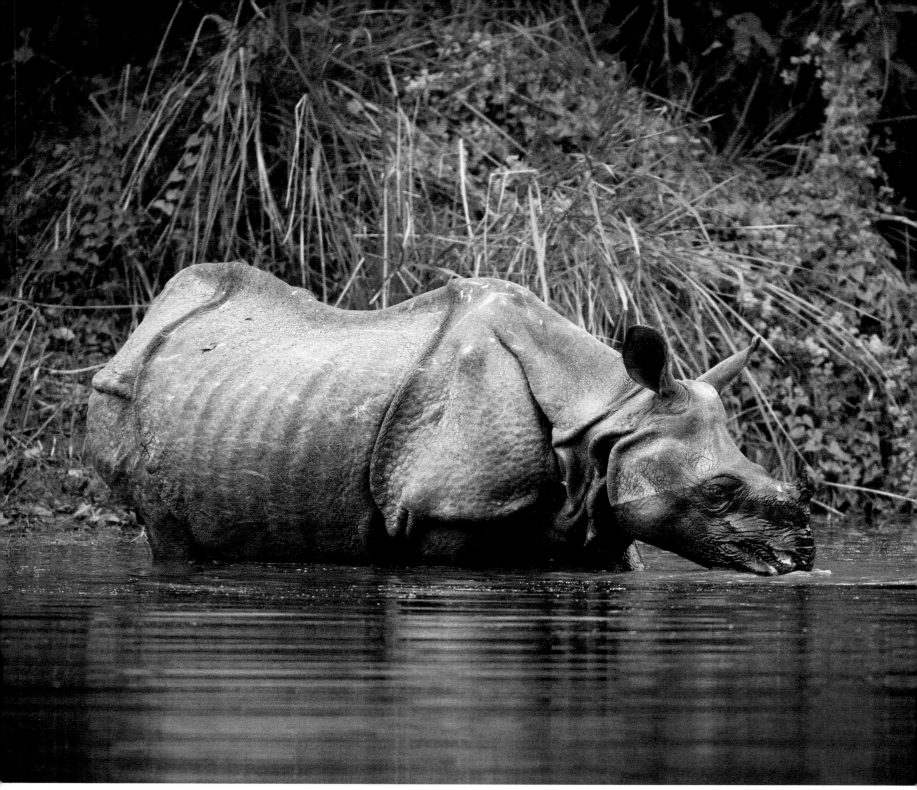

Greater One-horned Rhinoceros.

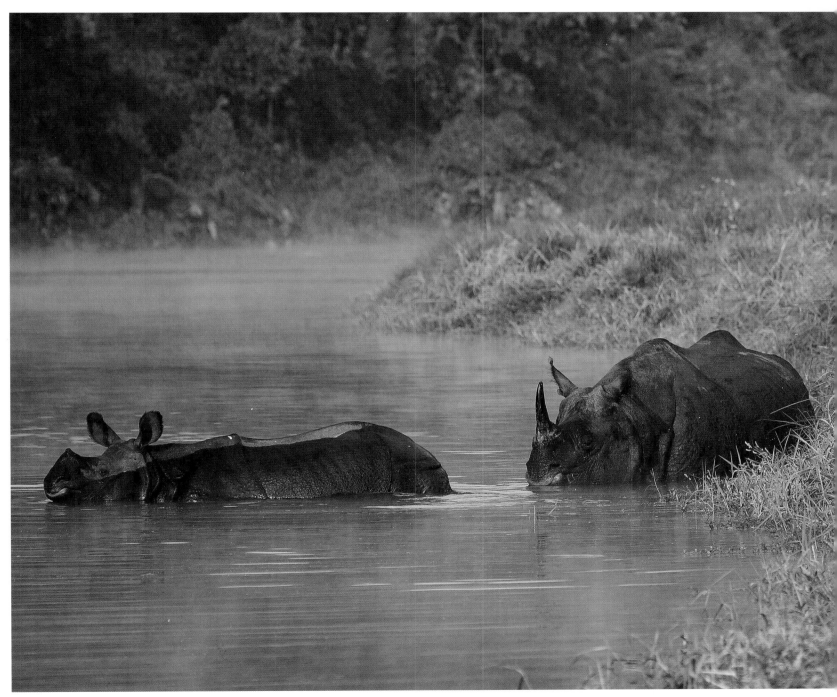

Greater One-horned Rhinoceros.

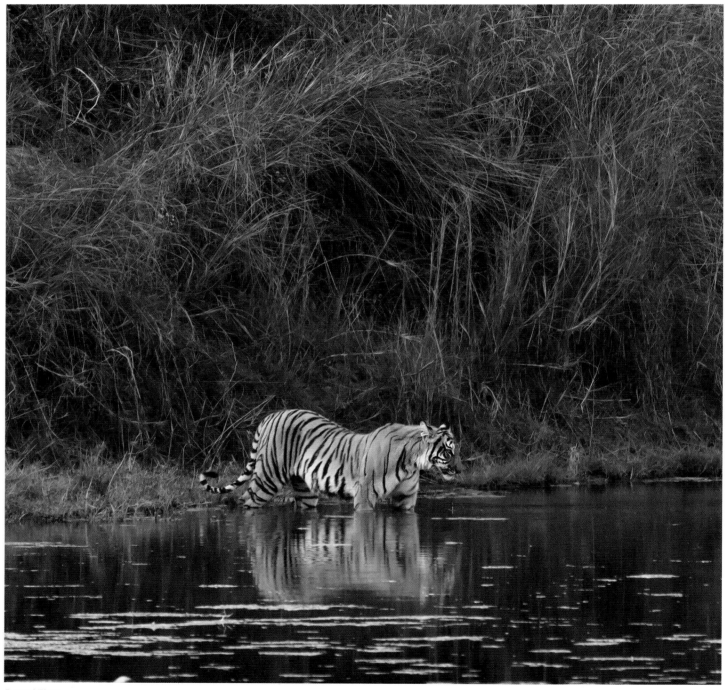

Bengal Tiger.

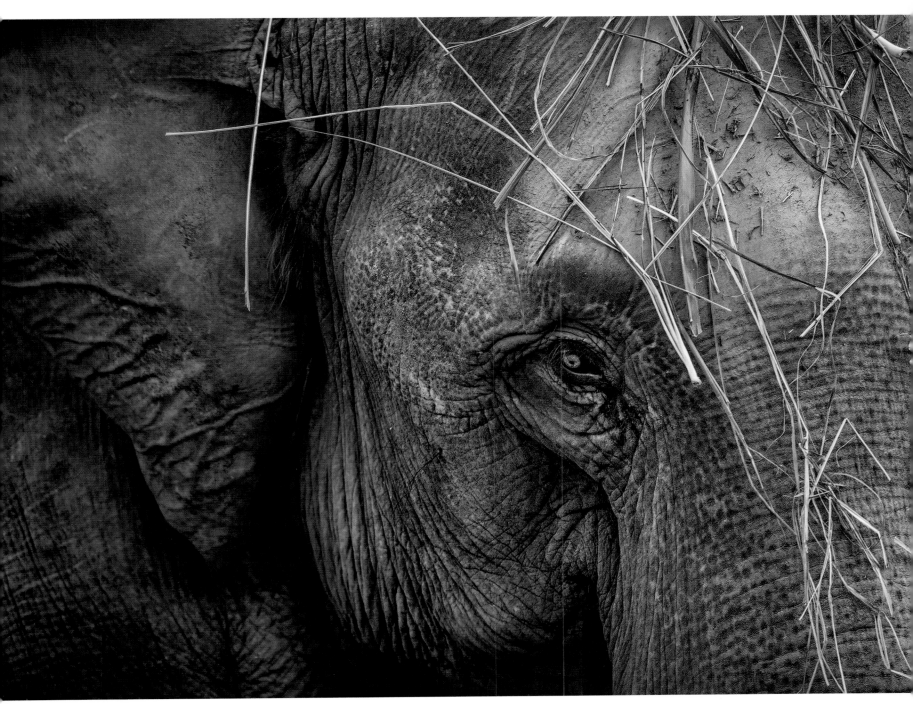

Asian Elephant.

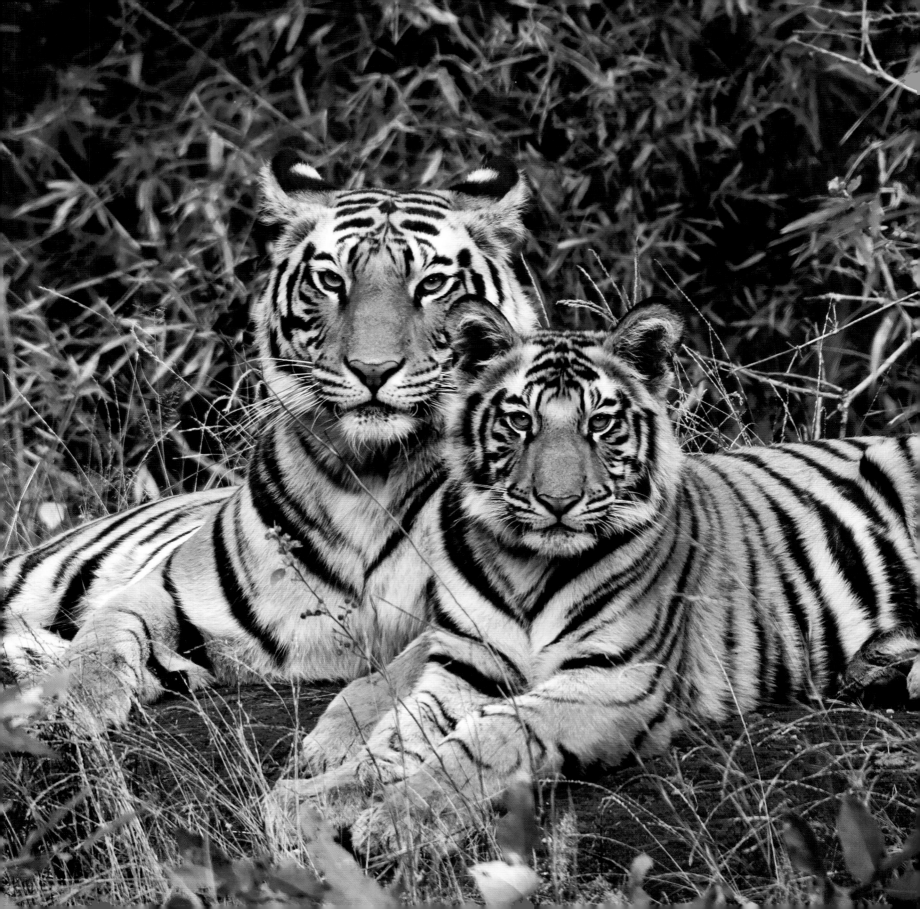

INDIA: RANTHAMBORE NATIONAL PARK

"The eyes of the tiger are the brightest of any animal on Earth. They blaze back the ambient light with awe-inspiring intensity. It would be a tragedy, and a terrible dereliction of duty, if we allowed that magical fire to burn out."

– Billy Arjan Singh, Indian conservationist.

RANTHAMBORE NATIONAL PARK in northern India is renowned for being one of the best places to spot the endangered Bengal Tiger in the wild. The park covers around 400 sq km (150 sq miles) of Rajasthan's wild jungle, grassy clearings and crocodile-filled lakes. It was declared as a wildlife sanctuary in 1957, but nonetheless remained a hunting ground for the maharajas of Jaipur until 1970. Project Tiger was launched in 1973 with a base in Ranthambore to try and protect the threatened tigers. In 1981, Ranthambore became a national park as awareness grew about the plight of the Bengal Tiger. At the centre of the park lies the 10th-century Ranthambore Fort jutting out from the jungle atop a craggy outcrop, creating a spectacular and atmospheric backdrop for wildlife sightings.

Although the Bengal Tiger is the big wildlife attraction in the park, it is also possible to see Leopard, Wild Boar, Sambar, Striped Hyena, Sloth Bear and Mugger Crocodile. In addition, some 300 different species of birds can be found in the park.

Tigers are the largest member of the cat family and are also one of the most endangered. They were once found over large areas of Asia, but now occur in only seven per cent of their original range. In the last century, tiger numbers have fallen by over 95 per cent due to poaching (for Chinese medicine and for trophy hunting) as well as forest destruction. *National Geographic* estimates that the hundreds of thousands of individuals that existed a century ago have dwindled down to less than 2,500 animals today. Three subspecies of tiger became extinct during the 20th century, leaving five subspecies today, all of which are endangered.

OPPOSITE Bengal Tigers.

NOTABLE SPECIES

Bengal Tiger
Sambar
Spotted Deer
Barking Deer
Leopard
Sloth Bear

WHEN TO GO

In the dry season, between November to March.

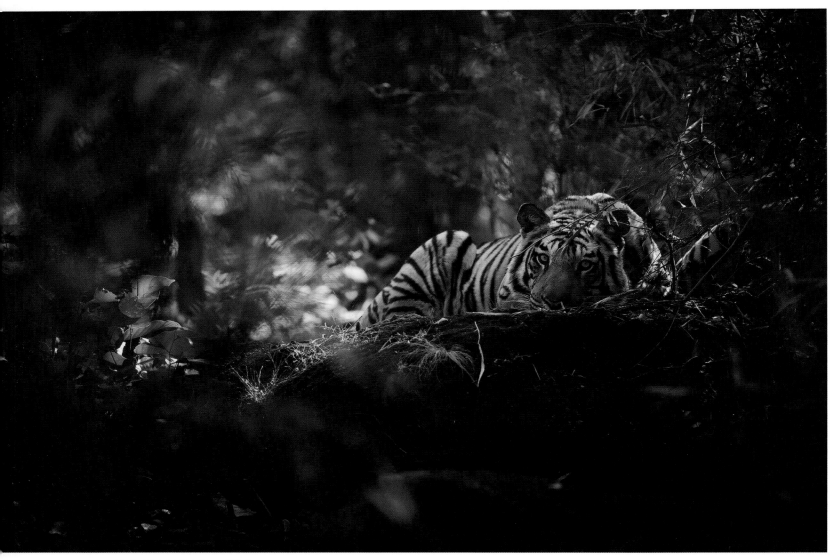

ABOVE AND OPPOSITE Bengal Tiger.

The Bengal Tiger found in Ranthambore National Park is the most common subspecies of tiger. It is the national animal of India and is an important part of Indian folklore. Bengal Tigers have a yellow-orange coat with dark brown stripes, giving a distinctive appearance but also serving as camouflage for stalking prey in the forest. Males can be over 3m (10ft) in length and weigh up to 250kg (550lb). They are carnivores, hunting ungulates such as Sambar, Water Buffalo, Wild Boar and occasionally even other predators such as Leopards, jackals and crocodiles. Tigers often live and hunt alone, scenting their territories to keep other tigers away. They stalk and ambush their prey, lying in wait until it is close enough to pounce upon.

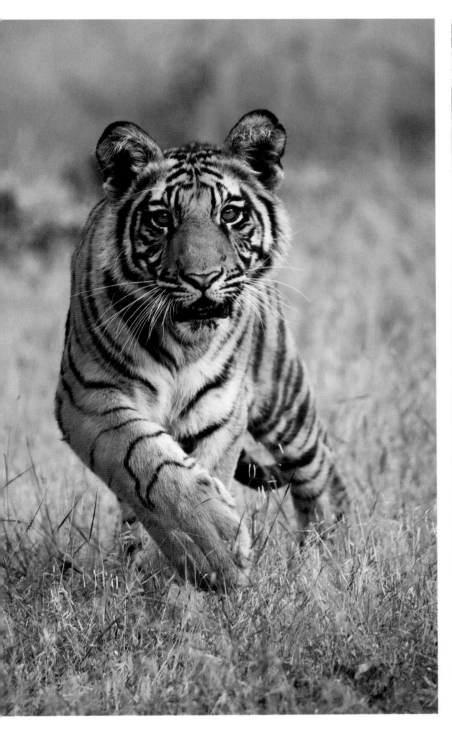
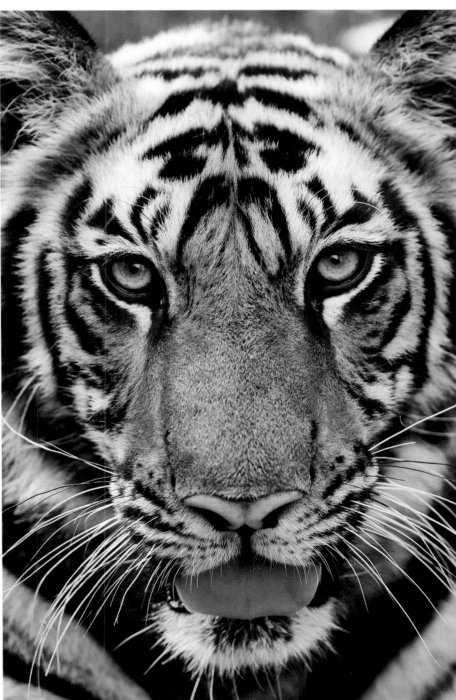

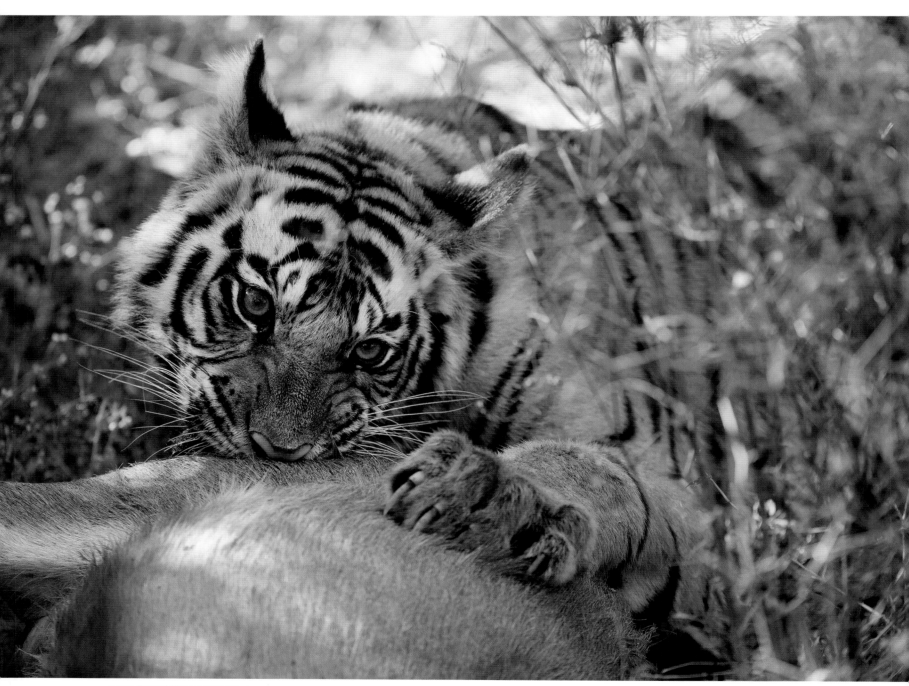

ABOVE Bengal Tiger eating Sambar.
OPPOSITE TOP TO BOTTOM Grey Langurs; Sambar deer.

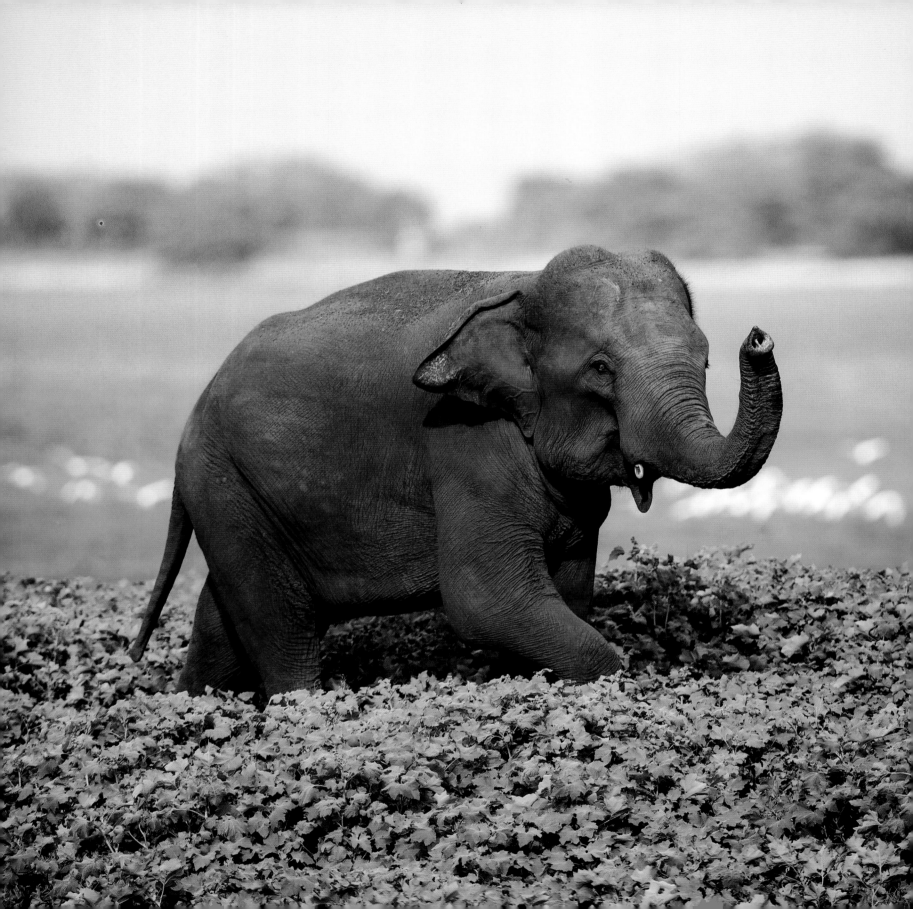

SRI LANKA: MINNERIYA NATIONAL PARK

"I could see why it is known as 'The Gathering'. In front of me, over a hundred elephants splashed around, fed and mingled. The atmosphere was positively festive!"

MINNERIYA NATIONAL PARK is located in the North Central Province of Sri Lanka and is one of the best places in the country to see Sri Lankan Elephants in the wild. It became a national park in 1997, but has existed as a wildlife sanctuary since 1938 to protect the wildlife surrounding the Minneriya Tank – an ancient lake created by King Mahasen (276–303AD) of the Anuradhapura Kingdom. Despite a relatively small size of 89 sq km (34 sq miles), the park has a wide variety of habitat types including scrub, tropical forests, evergreen forests, wetlands and grasslands providing environments for a range of fauna including Toque Macaque, Sambar, Water Buffalo, Mugger Crocodile and Asian Elephant.

During the dry season, from May to September, water in the park becomes increasingly scarce for the animals. Elephants and other animals flock to the tank to drink and bathe. During August and September, which are the driest months, water in the tank becomes so depleted that grasses and shoots grow from the exposed lake-bed. The tasty, fresh vegetation entices animals from far and wide. Up to 300 elephants can be present around the tank's shores during that time in an event referred to as 'The Gathering'. Similarly flocks of birds including cormorants, herons and pelicans gather to feast on the fish that become marooned in the remaining bodies of water.

OPPOSITE Asian Elephant.

NOTABLE SPECIES

Sri Lankan Elephant
Sambar
Spotted Deer
Grey Langur
Toque Macaque

Sri Lankan Sloth Bear
Water Buffalo
Sri Lankan Leopard
Mugger Crocodile

WHEN TO GO

Visit during the dry season between May and September to see 'The Gathering' of elephants and other wildlife around Minneriya Tank.

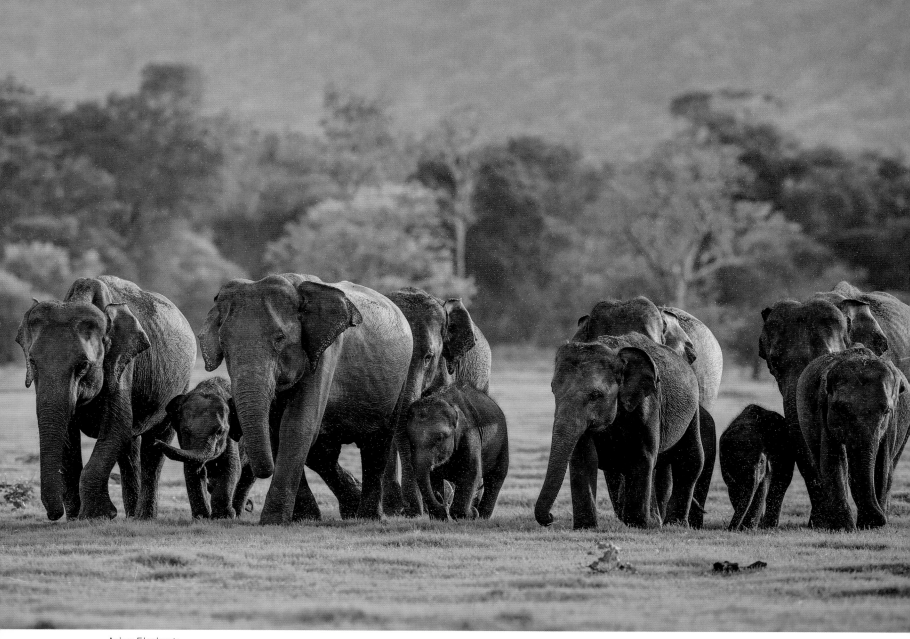

Asian Elephants.

Sri Lankan Elephants are one of three subspecies of Asian Elephant, with the others being the Indian Elephant and Sumatran Elephant. Asian Elephants are smaller than African Elephants and have smaller ears and more pronounced foreheads. The Sri Lankan Elephant is the largest of the subspecies and can reach a shoulder height of up to 3.5m (11.5ft) and weigh over 5,000kg (11,000lb). They have a darker skin colour than other Asian Elephants with more prominent depigmented patches. Asian Elephants have been domesticated and exploited for thousands of years, used in logging, transportation and even in wars. Domesticated Asian Elephants are still commonly found around the region, however populations of these animals in the wild are declining. With ever-increasing human populations, habitat loss and fragmentation are two of the biggest threats facing these magnificent animals.

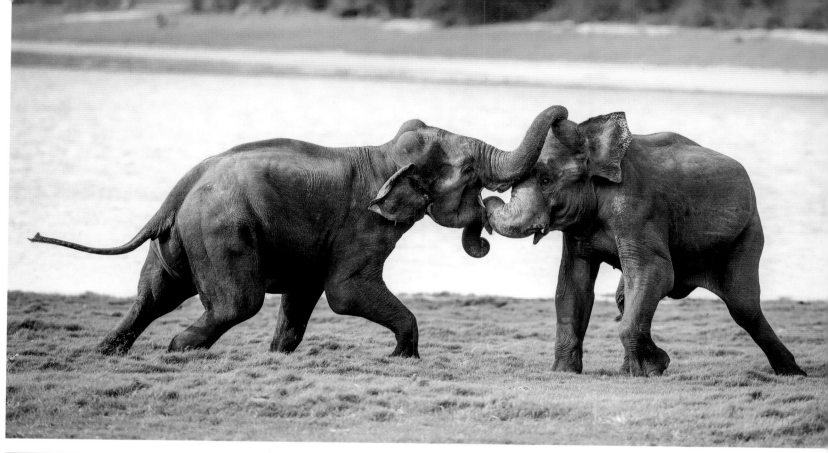

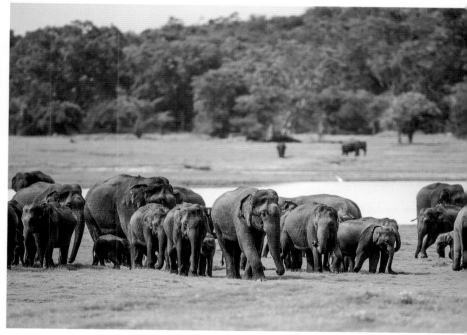

ABOVE CLOCKWISE FROM TOP Bull elephants fighting; elephant gathering; elephant close-up.

ABOVE AND OPPOSITE Grey Langur.

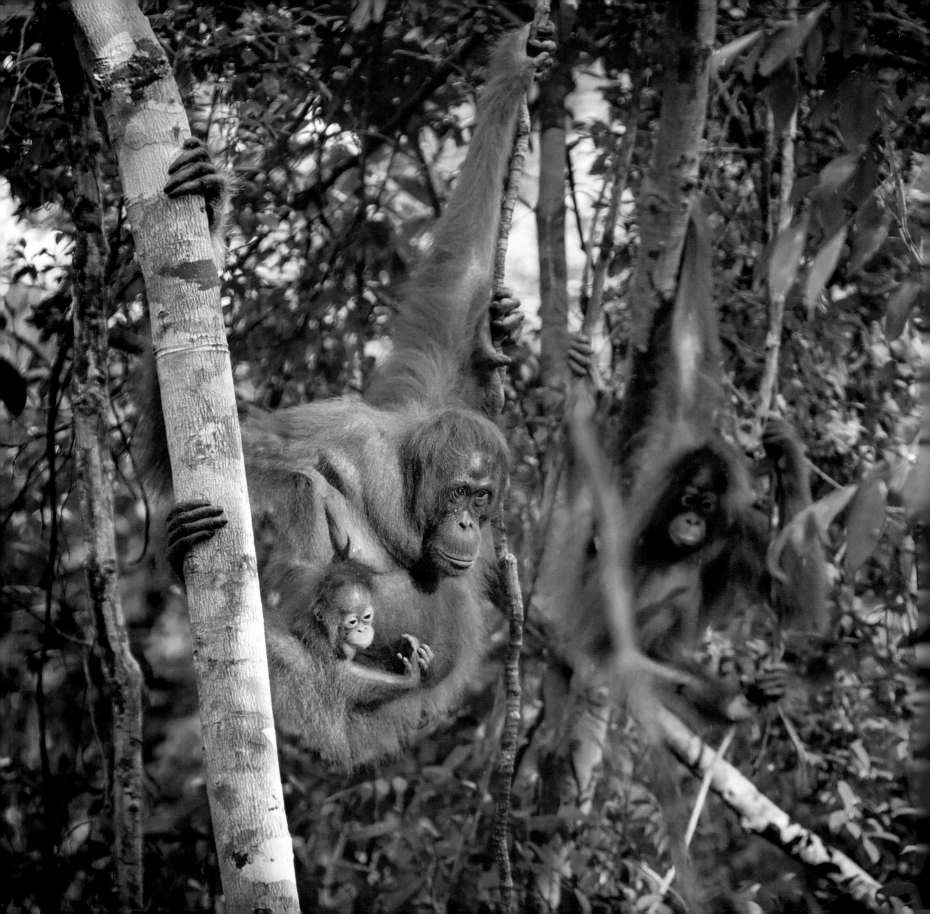

INDONESIA: TANJUNG PUTING NATIONAL PARK, KALIMANTAN

"The jungle air was thick and humid under the mosquito net, the morning light was still just a faint glow in the sky and I lay listening to the gentle lapping of water against the side of the klotok boat. Just then, somewhere in the distance, I heard some deep and mournful cries. It was exciting to know that nearby a male Orangutan had also just awoken to start his day."

TANJUNG PUTING NATIONAL PARK is in the Indonesian province of Central Kalimantan on the island of Borneo. It has been a game reserve since 1935 and a national park since 1982, covering just over 3,000 sq km (1,160 sq miles) of mangrove, tropical rainforest, tropical heath forest and peat swamp forest with a network of blackwater rivers flowing through it en route to the Java Sea. Heath forest and peat swamp forest used to cover much of southern Borneo, but have been significantly degraded as a result of logging, mining and agriculture. Habitat loss has posed a great threat to the wildlife of the region, and national parks such as Tanjung Puting are therefore extremely valuable in the conservation efforts for local wildlife. The most famous inhabitant of the park is the Orangutan. According to the Orangutan Foundation International, Tanjung Puting boasts the largest wild Orangutan population in the world. Many of the conservation projects in the area focus on reforestation and reducing further habitat loss in order to protect this great ape and the other primates of the region. As well as Orangutan, the park is home to eight other primate species including the Proboscis Monkey and gibbons, as well as Clouded Leopard, Sun Bear, Wild Boar, Sambar, porcupines, crocodiles, snakes and abundant birdlife.

Orangutan means 'man of the forest' in Malay and is a fitting name for these highly intelligent, orange-haired great apes. They are the largest arboreal mammal, spending over 90 per cent of their time in trees. Well adapted to their lifestyle, they have incredibly long, strong arms for swinging through the trees. A male Orangutan's arm-span can be over 2m (6.5ft) in length, which is considerably longer than his height of around 1.5m (5ft). Male Orangutans may

OPPOSITE Mother Orangutan with baby.

NOTABLE SPECIES

Orangutan
Proboscis Monkey
Gibbons
Wild Boar
Sun Bear

WHEN TO GO

This is a year-round destination with a warm and humid climate. The wet season is from November to April, but you can experience torrential downpours followed by intense sunshine at any time of the year.

TIPS

Combine with a trip to Komodo Island to see the Komodo Dragons (see next chapter), or combine with other wildlife destinations within Indonesia such as Sumatra or over in Malaysian Borneo.

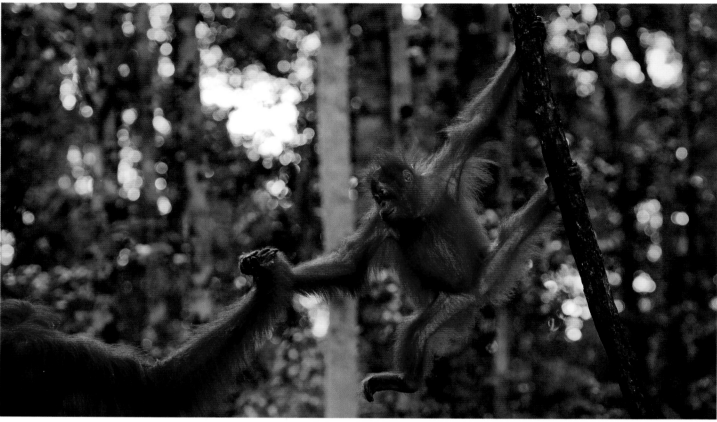
Young Orangutan.

develop distinctive cheek pads called flanges and a throat sac to make a long call that can be heard over 2km (1.25 miles) away. Orangutans are more solitary than the other great apes and the long call helps to ensure that they keep their distance from each other. These animals spend their days foraging in the trees for fruits such as lychees and gathering leaves to make tree-nests to sleep in at night.

Dr Birute Galdikas, who is considered to be one of the world's leading experts on Orangutan behaviour, started conducting her research from Tanjung Puting in the 1970s. She was based at Camp Leakey, which was the first of four research centres set up in the area. These research centres still exist and can be visited. They are an excellent place for learning about the rehabilitation and conservation efforts over the years, as well as seeing orphaned and rescued Orangutans. Rehabilitated Orangutans, released from these centres, often still appear for food top-ups. It is a joy to be there at feeding time to see both wild and rehabilitated Orangutans emerging from the forest to fill up on bananas or jack fruit.

The nearest town to the national park is Pangkalan Bun, and this is the staging post for most trips into the park. From here you can organise a multi-day boating trip into the park, sleeping overnight on basic wooden klotok boats or at a simple lodge at the edge of the park. Wildlife viewing occurs from the boat itself, with the chance to see Proboscis Monkeys in the trees alongside the narrow backwaters and even spot wild Orangutans.

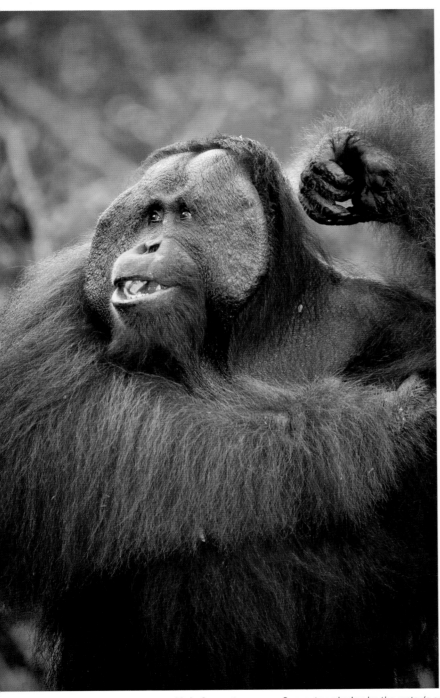
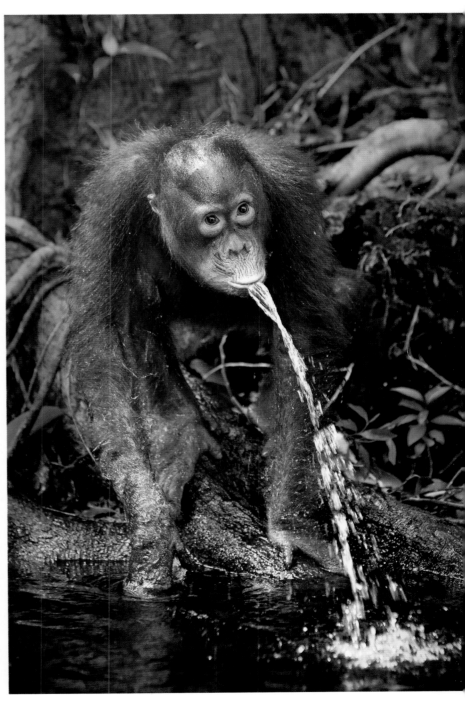

ABOVE LEFT TO RIGHT Male Orangutan; young Orangutan playing by the water's edge.

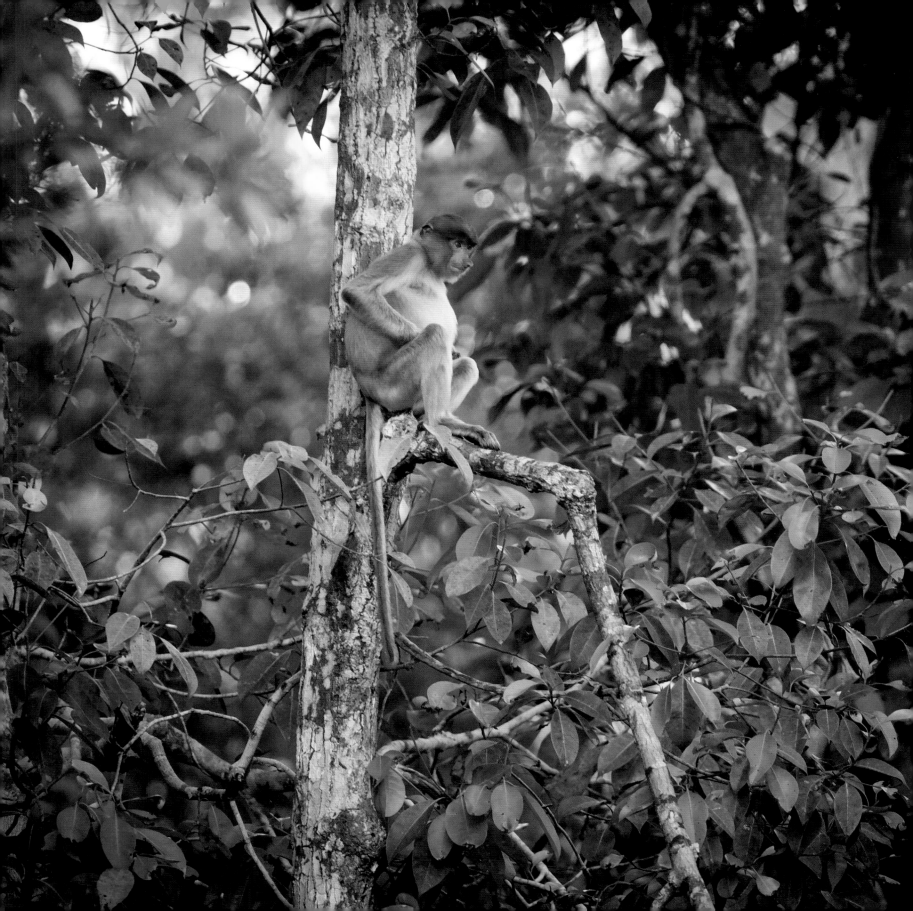

ABOVE Wild gibbon.
OPPOSITE Proboscis Monkey.

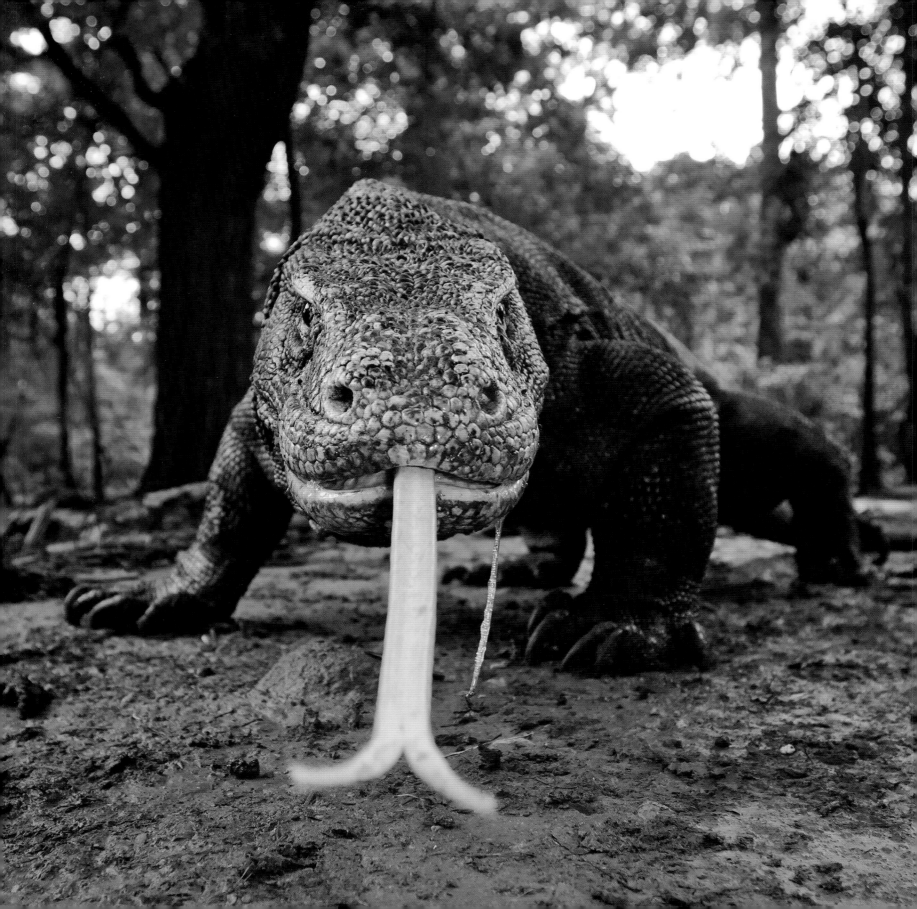

INDONESIA: KOMODO NATIONAL PARK

"It is hard to describe the excitement and sense of trepidation I felt as the foreboding volcanic peaks loomed up out of the water and my boat chugged slowly towards them. The island was shrouded in dark clouds and even the sea seemed to have turned black. It looked like a prehistoric land; a land fit for dragons."

KOMODO NATIONAL PARK is made up of the volcanic islands of Komodo, Rinca, part of Flores and some of the smaller Lesser Sunda Islands of Indonesia, as well as the surrounding tempestuous waters of the Sape Strait. The islands are home to the legendary Komodo Dragon, which is the world's largest lizard and was the main reason for my visit. The park is the only place on Earth where the dragons live in the wild, and for this reason they were designated as a national park in 1980 and became a UNESCO World Heritage Site in 1991 with the purpose of protecting Komodo Dragons and their habitat.

My first sighting of a Komodo Dragon came shortly after I stepped off the boat when I encountered one lying in the shade of a tree. I knew that Komodo Dragons were the world's largest lizard, but I was taken aback by the sheer size of this individual. Komodo Dragons have been known to grow up to 3m (10ft) in length and can weigh over 100kg (220lb). They are a member of the monitor lizard family Varanidae and, like all reptiles, they are cold-blooded. This means they are caught in a constant thermal juggling act; in the mornings they must find sunlight in order to warm up, but later in the day they must retreat to the shade before their bodies overheat. Komodo National Park has one of the driest climates in Indonesia, and in the dry season from May to October temperatures can reach over 40°C (104°F).

The Komodo Dragon looks like other large monitor lizards, with a tapered head, long neck, very strong jaws, powerful legs with five-clawed toes, thick tail and a covering of scales. Despite their large size, the dragons are surprisingly well camouflaged. They often rely on this camouflage to ambush prey such as wild pigs, deer and Water Buffalo. However, dragons will eat almost anything

OPPOSITE Komodo Dragon.

NOTABLE SPECIES
Komodo Dragon
Crab-eating Macaque
Timor Deer
Horses
Wild Boar
Water buffalo
Asian Palm Civet
Fruit bats (flying-foxes)

WHEN TO GO
A year-round destination, but the driest months of the year are between May and October.

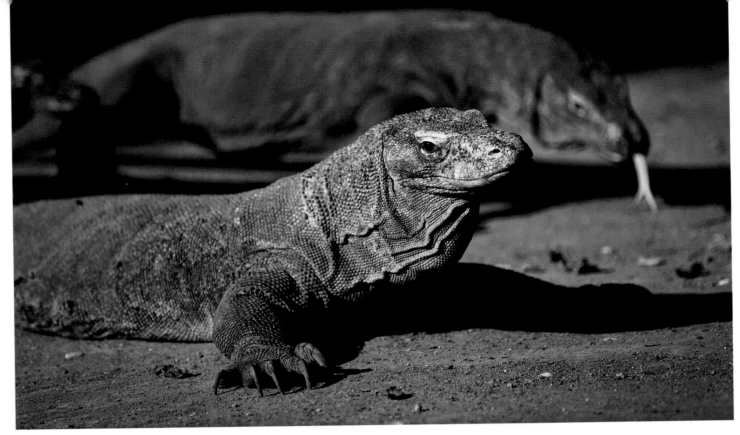

Komodo Dragon.

including invertebrates, eggs, birds and smaller dragons, and have even been known to eat humans (and human corpses from graveyards). Hunting dragons will lay still and suddenly charge when suitable prey approaches. They can be surprisingly fast, reaching speeds of up to 20km per hour (12.5 miles per hour) in short bursts, lunging at the throat or underside of the animal. The dragons have sharp claws and serrated teeth and their strikes can be immediately fatal. They can also use their strong tails to deliver blows to smaller animals. With larger animals such as buffalo, the initial attack may not kill straight away. Instead, the saliva of the dragon, which contains large quantities of virulent bacteria, infects the animal causing blood poisoning and death eventually ensues in the coming days. The dragon's keen sense of smell means that it can detect a dead or dying animal up to 9km (5.5 miles) away. The dragon will wait for its prey to die, following patiently for however long it takes.

Komodo Dragons have no predators and are at the top of the food chain on these islands, but they are a vulnerable species which is on the IUCN red list owing to illegal poaching, habitat loss from human encroachment and natural disasters. Another problem is that it takes eight to nine years for Komodo Dragons to mature, with young dragons vulnerable to predation from cannibalistic adults. There are currently around 4,000 dragons living in Komodo National Park.

Wildlife activities involve walking on trails whilst accompanied by a ranger to see the Komodo Dragons. You will almost certainly see the dragons on a visit to the park. There is also plenty of other wildlife to see, with a wide variety of snakes, lizards and birds, as well as mammals including Crab-eating Macaques, Timor Deer, Wild Boar, Water Buffalo, Asian Palm Civet and the endemic Rinca Rat. The surrounding waters host abundant marine life with Whale Sharks, rays, pygmy seahorses and nudibranchs as well as Sperm Whales, dolphins and dugongs, but you need to be careful as the waters have a reputation for riptides, undercurrents and whirlpools.

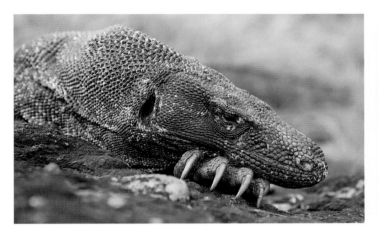
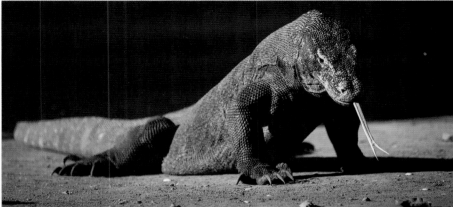
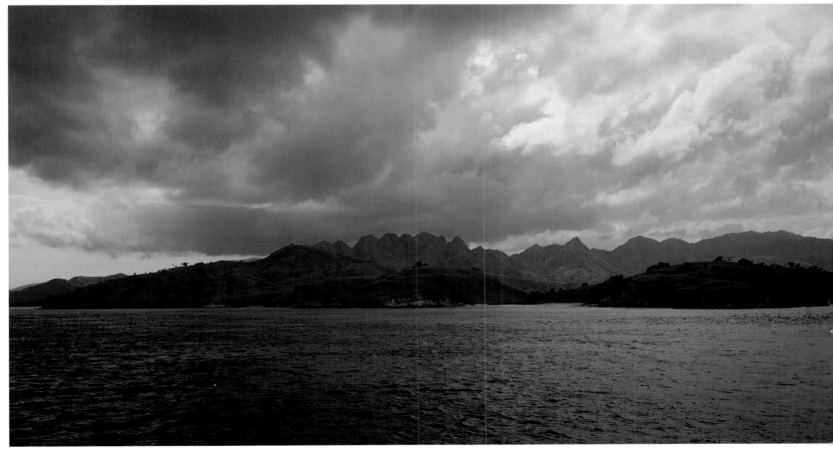

TOP Komodo Dragons.
ABOVE Approaching Komodo Island.

ABOVE Fruit bats at dusk.
OPPOSITE Komodo Island.

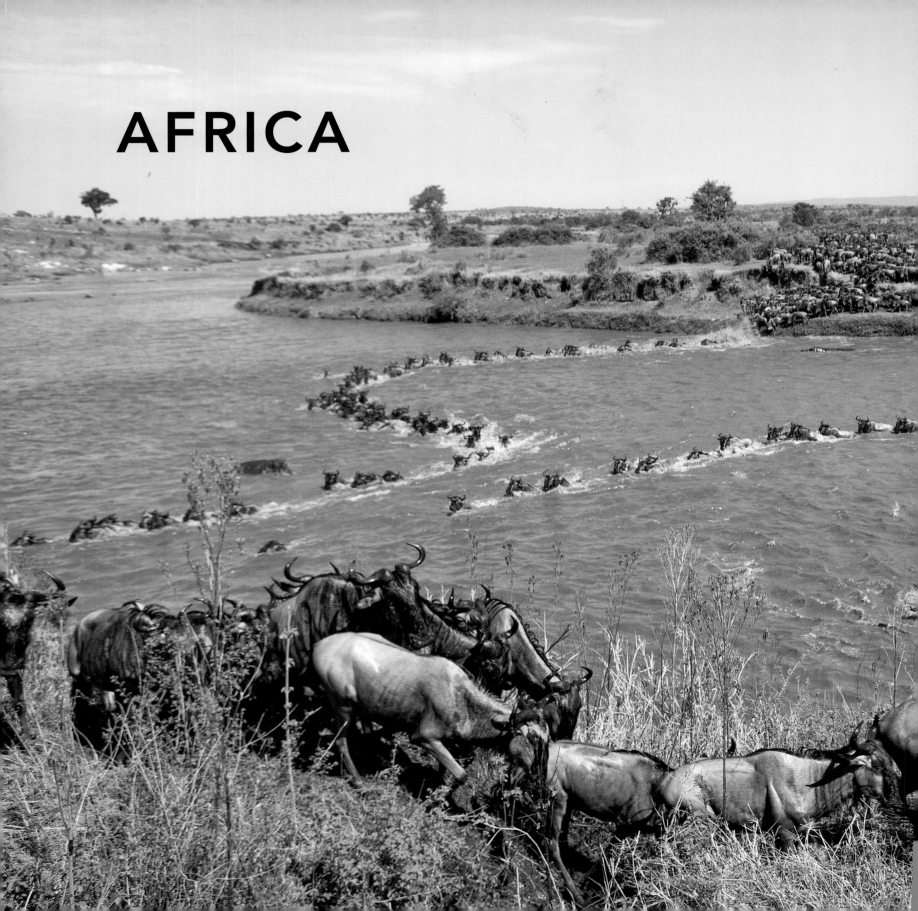

AFRICA

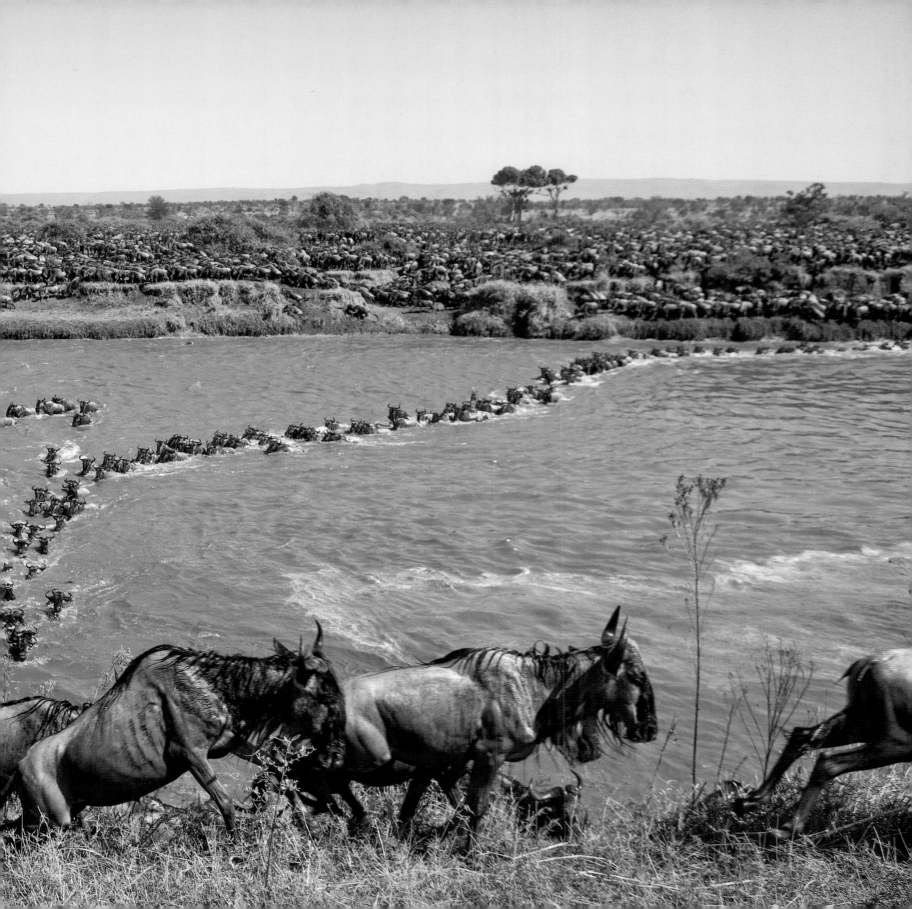

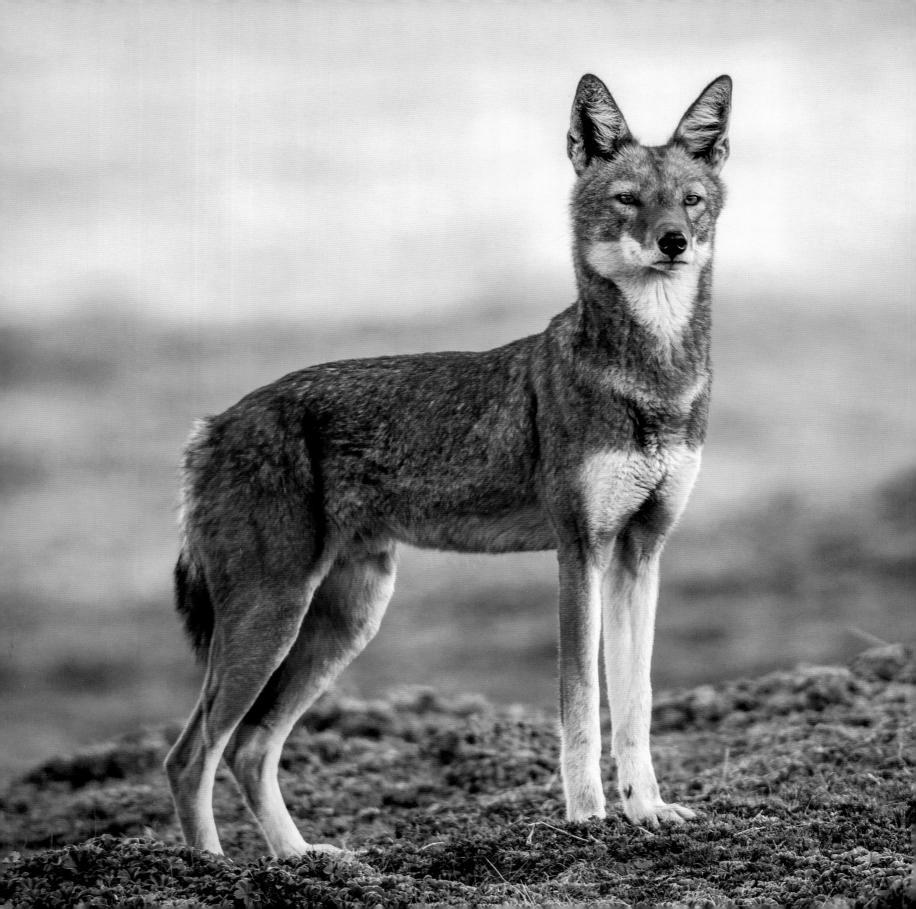

ETHIOPIA: BALE MOUNTAINS NATIONAL PARK

"Frost carpeted the ground and I jiggled to keep warm as I waited outside the den for the fifth day in a row, hoping that today would be the day that the Ethiopian Wolf pups emerged for the first time. The adult wolves sleeping around the den started to stretch and yawn, and soon after, three dark, fluffy faces poked out from the den. The adults gathered round as the pups took their first tentative steps into the outside world."

IN THE REMOTE HIGHLANDS of south-eastern Ethiopia lies Bale Mountains National Park. The park covers an area of over 2,000 sq km (770 sq miles) and sits over 3,000m (9,850ft) above sea level. The Bale Mountains were formed by lava outpourings over 30 million years ago, before the Great Rift Valley of Africa had formed. Since then, millions of years of repeated glaciation, wind and water have eroded away at the volcanic cones and lava flows to leave behind the current highland plateau. Within the park there are five different types of habitat: northern grasslands, juniper woodlands, the afro-alpine meadows of the Sanetti Plateau, erica moorlands and the Harenna forest. These habitats provide home to some of the rarest animals on Earth. The park has the most endemic animals within its boundaries of any national park, with unique and vulnerable species such as Ethiopian Wolf, Mountain Nyala, Bale Monkey and Giant Mole-rat. To see these creatures in their beautiful but fragile home is a real privilege.

The Ethiopian Wolf, also known as the Abyssinian Wolf, is Africa's only wolf. It is the rarest canid on Earth and the most endangered carnivore in Africa, with fewer than 450 of these elegant animals remaining. The entire global population is found on just seven mountains in the Ethiopian Highlands, with more than half of them living in the Bale Mountains.

The wolves have rusty red coats with paler fur underneath and black-tipped tails. They may look similar to foxes, but molecular evidence suggests they are more closely related to the Grey Wolf of Europe and Asia. It is thought that the species actually evolved from a wolf ancestor that moved

OPPOSITE Ethiopian Wolf.

NOTABLE SPECIES
Ethiopian Wolf
Mountain Nyala
Giant Mole-rat
Bale Monkey
Bohor's Reedbuck

WHEN TO GO
Between November and March when the days are warm, clear and dry. Night-time can be cold.

TIPS
The best place to see the wolves is along the road that cuts across the Sanetti Plateau.

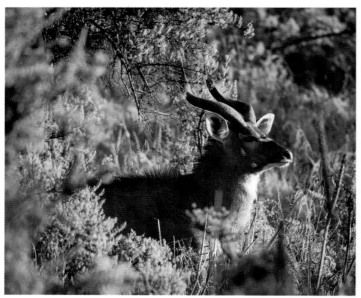

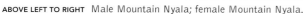
ABOVE LEFT TO RIGHT Male Mountain Nyala; female Mountain Nyala.

down from Europe to Africa some 100,000 years ago. It came across an Afro-alpine habitat that was teeming with rodents and gradually stopped hunting in packs and became a rodent-hunting specialist. The species evolved to become completely dependent on its rodent prey, developing a narrow, long muzzle and widely-spaced small teeth for the task. At the end of the last ice age, the Afro-alpine areas receded and the wolves became marooned in just a few isolated mountain highland areas surrounding the Great Rift Valley. The wolves are under siege from an ever-increasing human population, which degrades their habitat and brings other threats such as disease, including rabies and canine distemper from domestic dogs. The species has sadly been brought to the edge of extinction. The Ethiopian Wolf Conservation Programme works tirelessly in the Bale Mountains to protect the wolves and involve local communities in conservation efforts.

Ethiopian Wolves live in packs of up to 13 adults. Male wolves rarely leave the pack that they are born into, making it an extended family group. The adults hunt alone but the pack comes together to patrol and socialise several times throughout the day and to sleep at night. All members of the pack will help to feed and protect the pups. The dominant female is the only female to breed. She will only birth one litter per year. The breeding season is from August to November, with up to six pups being born around two months later with fluffy dark brown coats.

Another species endemic to the Ethiopian Highlands, that can be found in the mountain woodlands of the park, is the Mountain Nyala. This was the last large mammal to be discovered in Africa. The Mountain Nyala is a grey-brown antelope, that was named after nyala due to their similar appearance, but is actually more closely related to kudu. The male has impressive twisted horns and stands up to 135cm (53in) at the shoulder. They are only found at altitudes above 2,000m (6,550ft), eating the herbs and shrubs amidst woodlands and heathlands. There are thought to be around 2,500 Mountain Nyala left in the world.

The extremely high density of rodents makes the Bale Mountains ideal habitat for many birds of prey. You will often see Augur Buzzards and other raptors perched atop the distinctive giant lobelias that pepper the landscape.

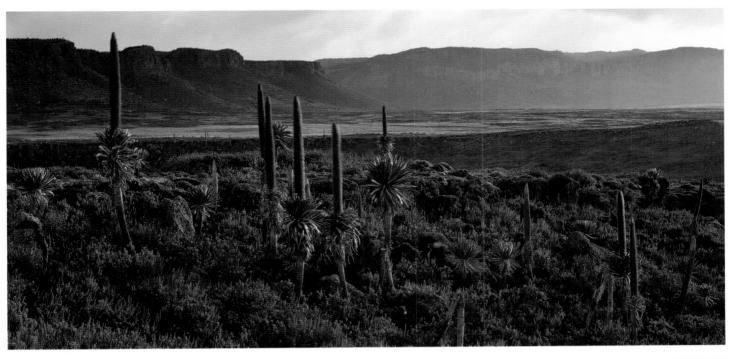

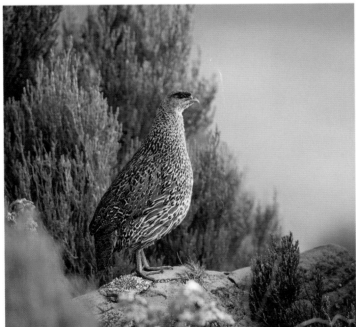

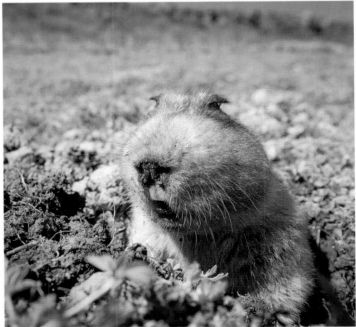

ABOVE CLOCKWISE FROM TOP Giant Lobelia, Web Valley; Giant Mole-rat; Chestnut-naped Francolin.

Ethiopian Wolf, Web Valley.

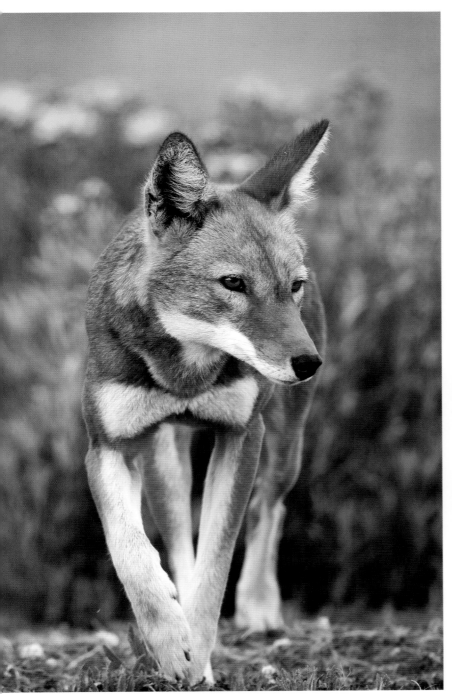

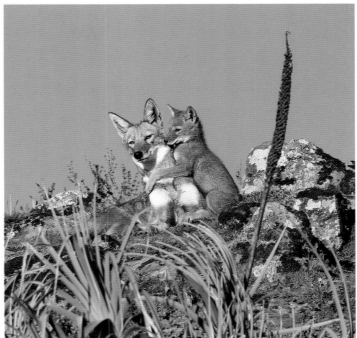

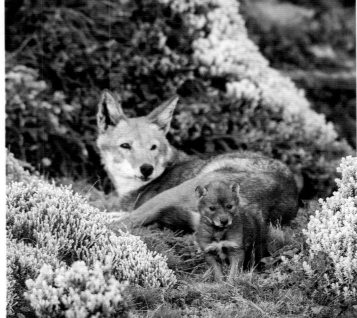

ABOVE Ethiopian Wolf adults and pups on the Sanetti Plateau.

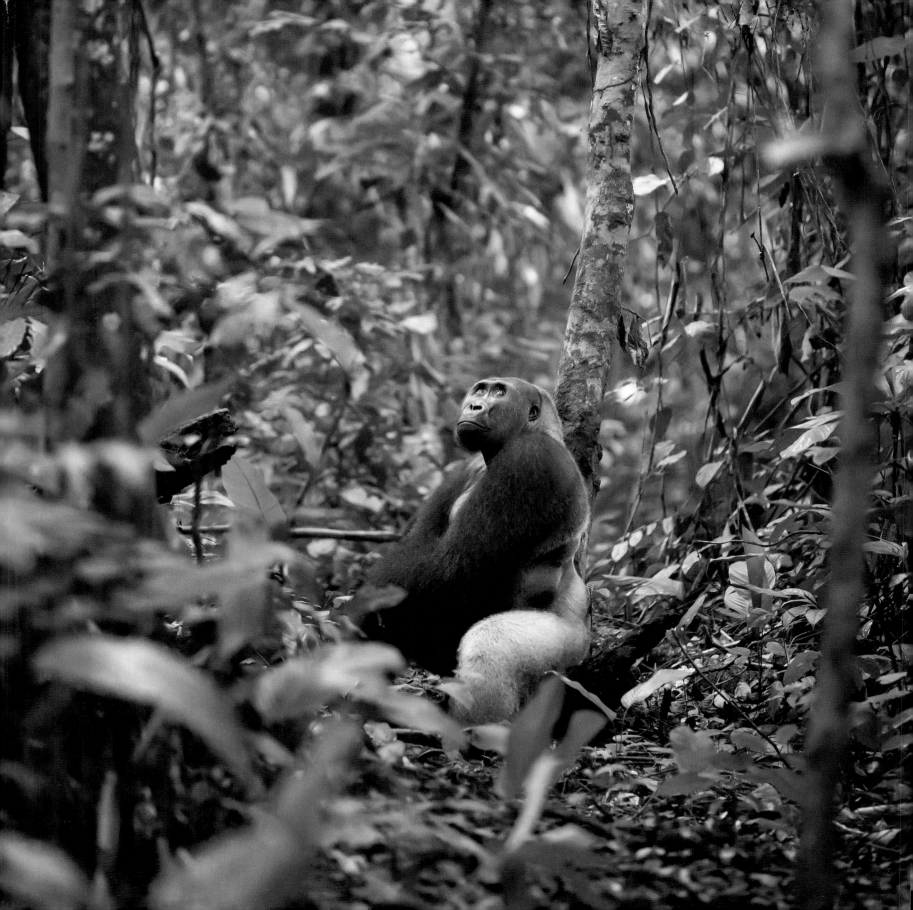

REPUBLIC OF CONGO: ODZALA-KOKOUA NATIONAL PARK

"As the sun crept up from behind the bai, the first light of day revealed a family of Forest Elephants at the edge of the water. The sloshing sound of a Forest Buffalo pushing through the swampy waters disturbed a flock of Grey Parrots. That morning scene, as the parrots lifted through the pink mist over the busy Bai, captured the essence of Odzala for me."

ODZALA-KOKOUA NATIONAL PARK is situated in the remote north-west of the Republic of Congo. It lies within the Congo Basin, in a region that contains the world's second-largest tropical rainforest after the Amazon. The park covers 13,600 sq km (5,250 sq miles) of wilderness with numerous different habitats, including primary forest, savannah, rivers and forest bais, supporting huge diversity of flora and fauna. It is home to significant populations of Western Lowland Gorilla and Forest Elephant, which were two of the biggest draws of the park for me.

Western Lowland Gorillas are slightly smaller in size than Mountain Gorillas, and have thinner, brown-grey coats, longer arms and more pronounced brow ridges. Although they are the most numerous and widespread of all gorilla subspecies, they are harder to see as they inhabit dense and remote rainforests across the Congo Basin, often in countries with little tourism or conservation infrastructure. According to WWF, because of poaching and disease (in particular, Ebola), the gorilla's numbers have declined by more than 60 per cent over the last 20–25 years. The gorillas live in troops that can have as many as 30 individuals and are led by a dominant adult male called the silverback. The silverback will move his troop around to feed on roots, fruit and tree bark in a home range of up to 40 sq km (15 sq miles), displaying shows of strength by rising to his full height, making charges, shouting, roaring and chest-pounding should another male challenge his territory.

OPPOSITE Silverback Western Lowland Gorilla.

NOTABLE SPECIES
Western Lowland Gorilla
Chimpanzee
Forest Elephant
Forest Buffalo
Bongo
Giant Forest Hog
Leopard
Grey Parrot

WHEN TO GO
This is a year-round destination. The north is driest between January and February, with more rainfall between April and October.

TIPS
Pack waders or old lace-up trainers (for wading through the bais) and plenty of insect repellent.

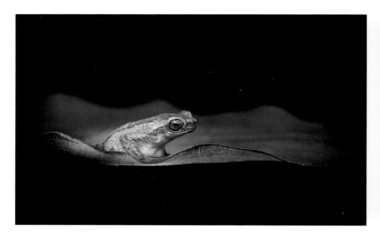

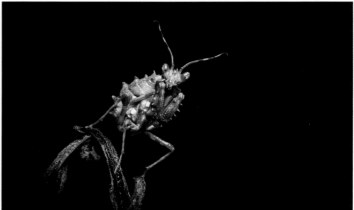

ABOVE Nocturnal images of frogs and a flower mantis in the Congo rainforest.
OPPOSITE TOP TO BOTTOM Forest Buffalo; Forest Elephant.

Forest Elephants are a forest-dwelling subspecies of African Elephant that inhabits the dense rainforests of west and central Africa. They are very distinct from the African Savannah Elephant, being smaller and darker in colour, with more oval-shaped ears and narrower, straighter tusks. They are herbivores, eating tree bark, leaves and fruit. They often frequent the salt licks at the edge of bais where they find much-needed minerals that would otherwise be lacking from their diet. Seeing these graceful giants silently moving through the forest is quite wonderful.

Wildlife activities include vehicle, boat or walking safaris, as well as gorilla tracking. There are also opportunities for night drives and walks. The length and conditions of the gorilla tracking will depend upon where the gorillas have spent the night, and can range from a one- to seven-hour trek. The expert trackers will follow the most subtle of signs in the forest to lead you through dense marantaceae thickets, across rivers and amidst breathtaking primary rainforest to bring you before these magnificent primates.

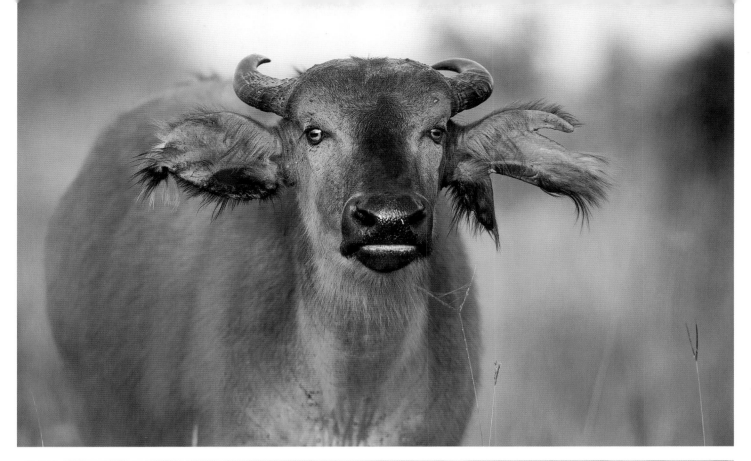
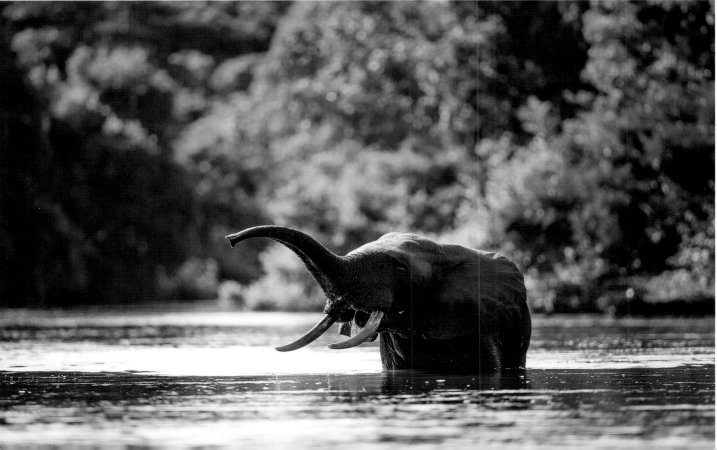

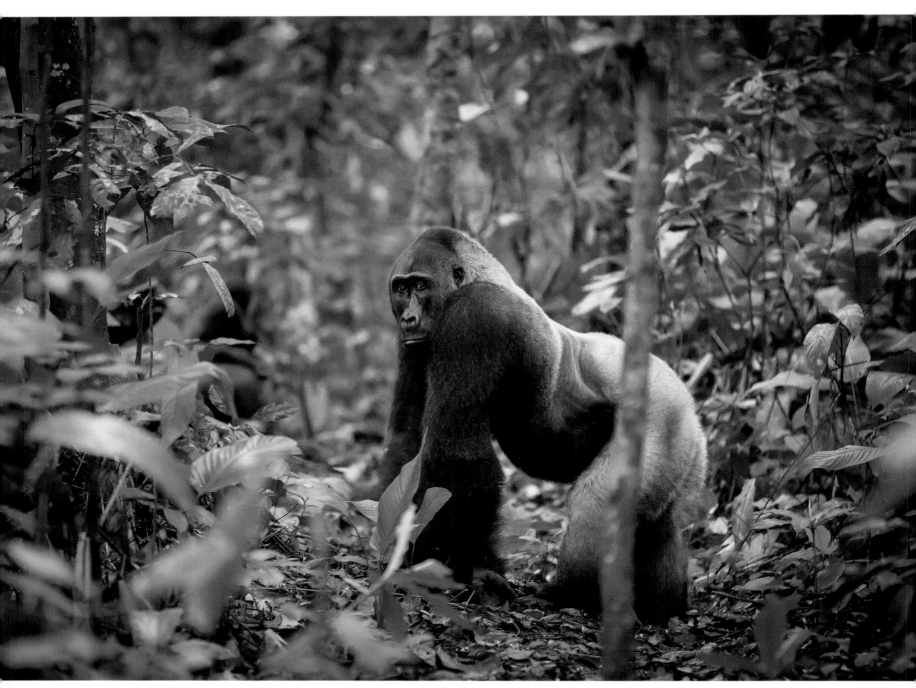

ABOVE Silverback Western Lowland Gorilla.
OPPOSITE Western Lowland Gorilla.

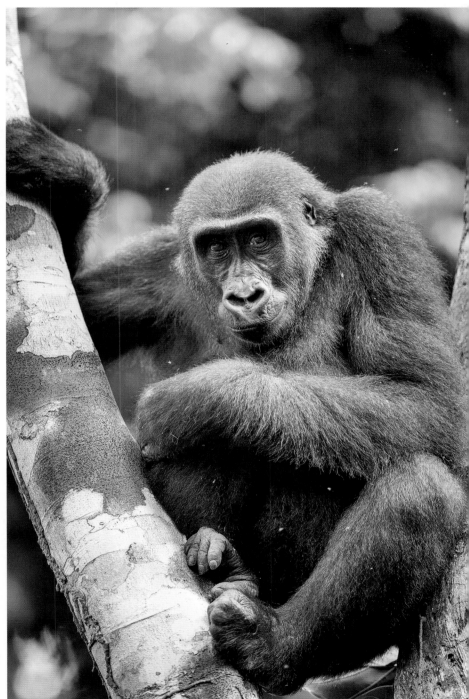

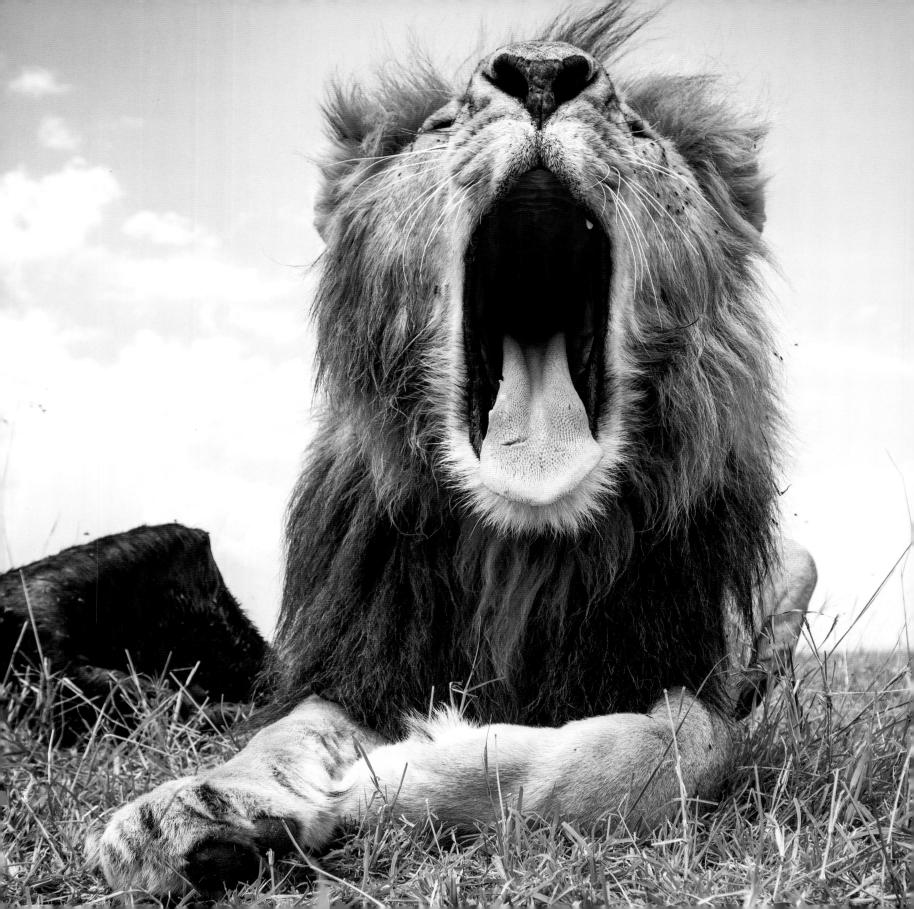

KENYA: MAASAI MARA NATIONAL RESERVE

"On my very first game drive in the Maasai Mara, I spotted three large male Lions with full and handsome manes sauntering lazily through the vast expanse of dry grassland directly towards my vehicle, occasionally nuzzling each other with brotherly affection."

THE MAASAI MARA NATIONAL RESERVE is a world-famous safari destination located in south-western Kenya. It covers 1,510 sq km (580 sq miles) of the much larger Mara-Serengeti ecosystem and is adjacent to the Serengeti National Park in Tanzania. The open grassland terrain and acacia trees dotted across the landscape, along with the high game density, creates the quintessential safari experience. Big cat sightings are common, with every chance of seeing Lion, Leopard and Cheetah on a single drive. It is also one of the best places to witness the world's fastest land mammal hunting. A Cheetah can reach speeds of over 100km per hour (62 miles per hour), and due to hard paws and semi-retractable claws can make quick turns at top speed. They are daytime hunters and their spotted coat enables stealth amidst the high grasses before they begin their fast but brief chase of their chosen prey. The abundance of antelope prey and the vast open plains make it a prime destination for seeing these spectacular animals in action.

The reserve takes its name from the Maasai people, who are the original inhabitants of the area. The word 'Mara' means 'spotted' in the Maasai language and refers to the acacia trees and circles of trees that dot the landscape. There are still Maasai people continuing their semi-nomadic way of life in the area today.

The main activities on safari in the Maasai Mara are morning and evening game drives on a safari vehicle. Bush breakfasts under the shade of an acacia tree, mid-morning tea stops on the banks of the Mara river, or sundowners looking out over the open grassland amidst grazing antelope and Maasai Giraffe are just some of the additional touches you can look forward to. At the right time of year, you can also witness the 'great migration' as millions of wildebeest make their way north from the Serengeti in search of the rains.

OPPOSITE Yawning male Lion with a wildebeest kill, photographed with BeetleCam.

NOTABLE SPECIES

Lion
Leopard
Cheetah
Maasai Giraffe
Blue Wildebeest
Thomson's Gazelle
Topi
African Elephant
Black Rhinoceros
Eland

WHEN TO GO

The Maasai Mara can be visited year-round. The game density swells between July and September owing to the great migration.

TIPS

The Maasai Mara is accessible by road from Nairobi, which can help to keep costs down.

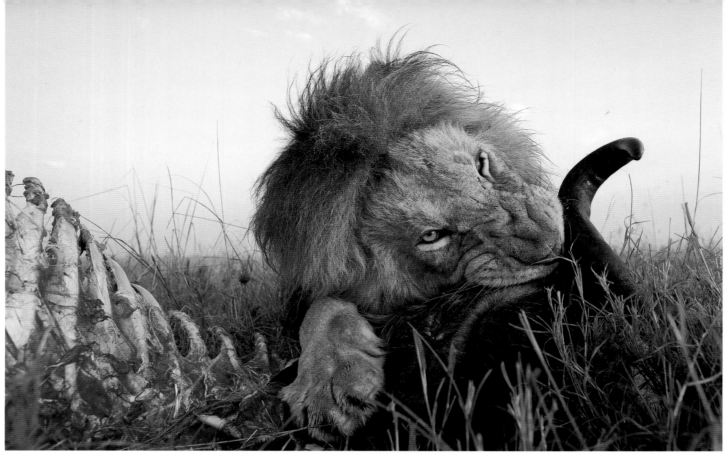
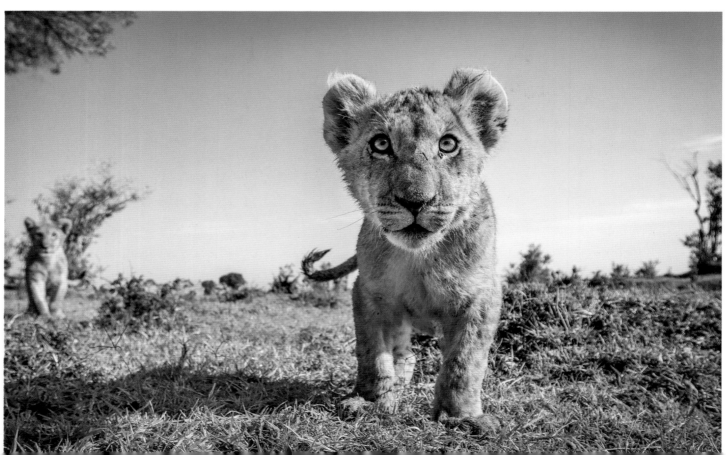

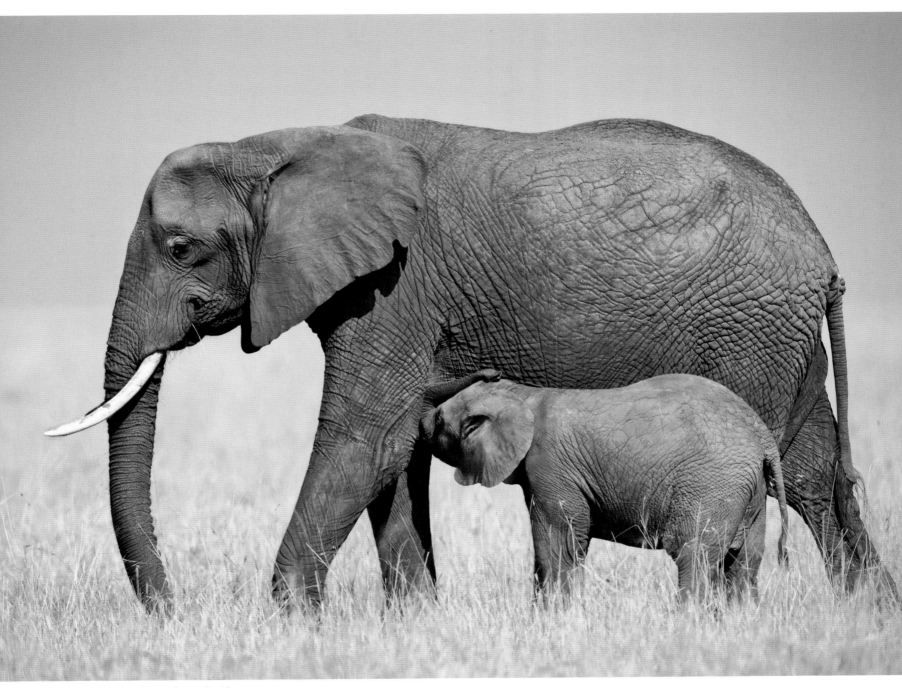

ABOVE Elephant mother and calf.
OPPOSITE TOP TO BOTTOM Male Lion with a wildebeest kill; Lion cub, photographed with BeetleCam.

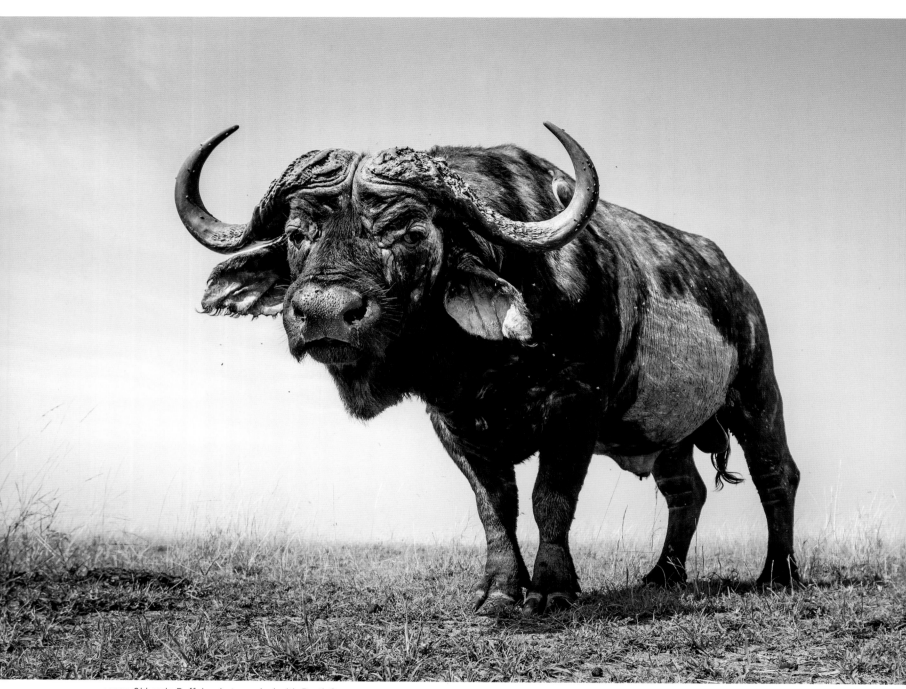

ABOVE Old male Buffalo, photographed with BeetleCam.
OPPOSITE TOP TO BOTTOM Male Cheetah; Cheetahs preparing to cross a river during the rainy season.

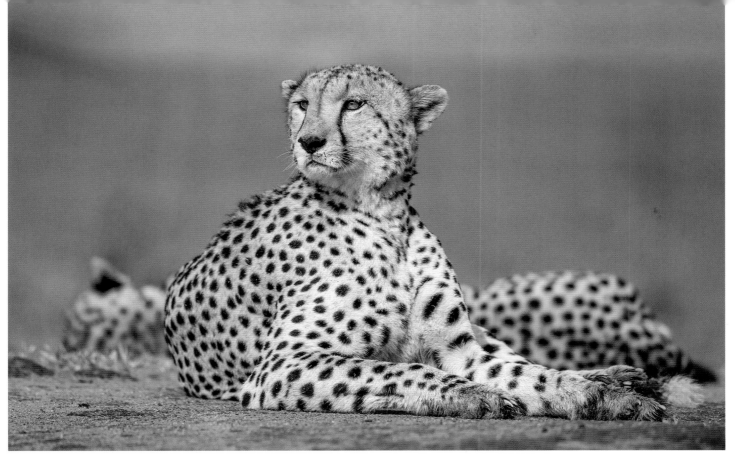

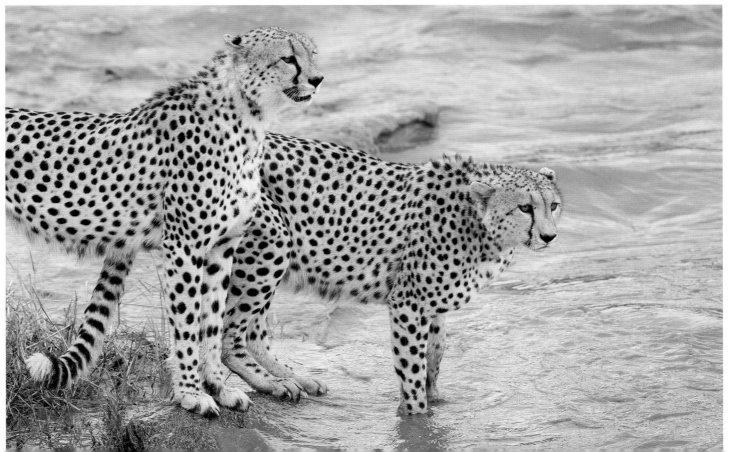

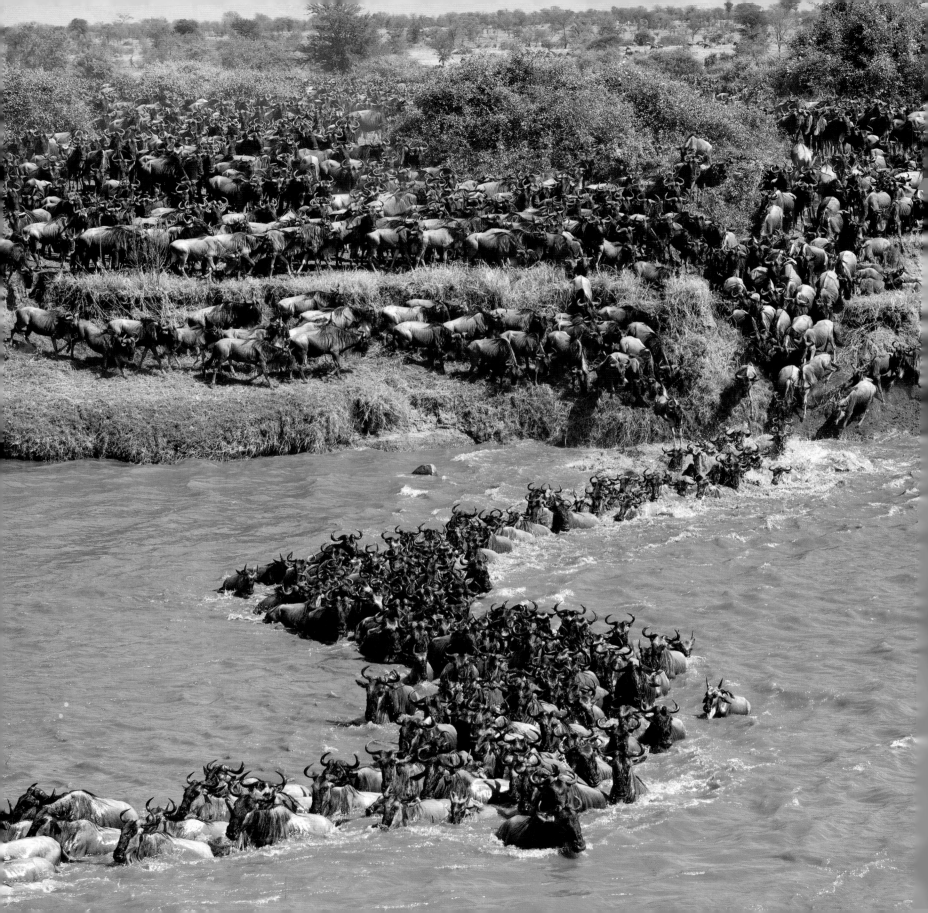

TANZANIA: SERENGETI NATIONAL PARK

"When the wildebeest reach the banks, they gather in vast herds as they summon the courage to make the crossing. The anticipation builds as you wait for one brave individual to venture into the water, prompting the rest of the herd to follow. It is hard to describe the mayhem, noise and drama that ensues as 10,000 wildebeest stream across the river, braving crocodiles and trampling each other to death all for the fresh grass that awaits them on the other side."

THE SERENGETI NATIONAL PARK in northern Tanzania lies within the larger Mara-Serengeti ecosystem that encompasses the Ngorongoro Conservation Area and crosses into south-western Kenya to include the Maasai Mara National Reserve. The name Serengeti comes from the Maasai word 'serengitu' which means endless plain. True to its name, there are many open plains of grassland, but there are also woodlands, swamps and the iconic kopjes (rocky outcrops) within the park adding to the wildlife diversity. Whilst it is an excellent area to see a wide range of animals and supports an impressively large Lion population, the Serengeti is most famed for hosting the great wildebeest migration.

The annual wildebeest migration sees over 1.5 million Blue Wildebeest migrate between the Serengeti in Tanzania and the Maasai Mara in Kenya along with significant numbers of other antelopes and zebras, making this the largest mass-movement of land mammals anywhere on Earth. It is known to be one of Africa's most impressive spectacles. The migration is driven by rains and grazing availability. Between January and March the Blue Wildebeest calving season is underway in the Serengeti in the south-eastern part of the ecosystem, a time when there is plenty of fresh grass available. When this area starts becoming drier and the grazing is less favourable, the animals begin a north-westerly journey towards the Maasai Mara in

OPPOSITE Wildebeest crossing the Mara River during the great migration.

NOTABLE SPECIES

Blue Wildebeest	Cape Buffalo
Zebra	Giraffe
Lion	Serval
Cheetah	
Leopard	
Thomson's Gazelle	
African Elephant	
Nile Crocodile	
Hippopotamus	

WHEN TO GO

All year round offers something to see.

The peak time of year for witnessing river crossings and the full scale of the great migration is June when the wildebeest encounter the Grumeti River and September when they have to cross Mara River on their way back from the Maasai Mara in Kenya.

Calving season in the Ndutu region is from January to March and this is another popular time of the year to visit.

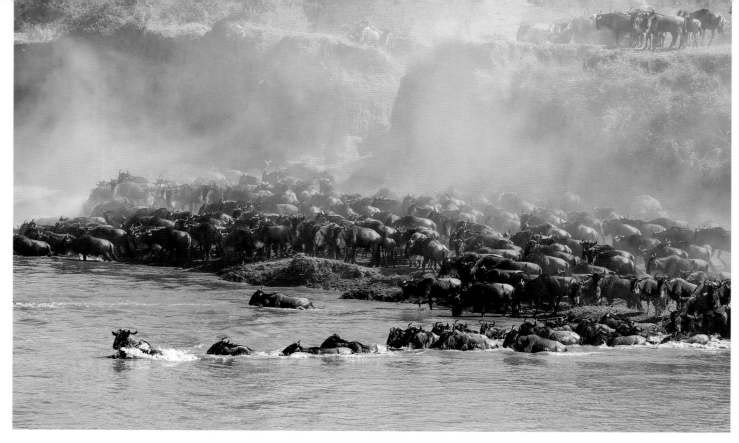

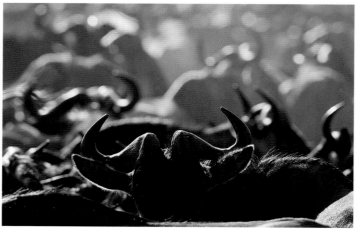

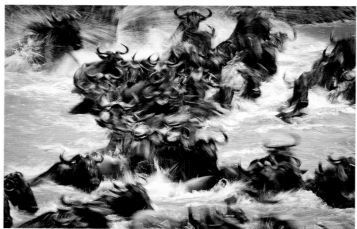

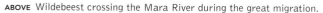

ABOVE Wildebeest crossing the Mara River during the great migration.

Kenya, crossing the crocodile-filled Grumeti and Mara rivers for the promise of more nutritious grazing ground. They arrive in Kenya around July and August and remain there throughout the dry season until the short rains in November prompt them to make the return journey south, in time for calving.

Each year, over 250,000 wildebeest will die during this journey for greener pastures. The sheer numbers of wildebeest, zebra and antelope provides ample food for predators and scavengers in the area, and it is possible to see cheetahs, lions, hyenas and vultures feasting on the fallen.

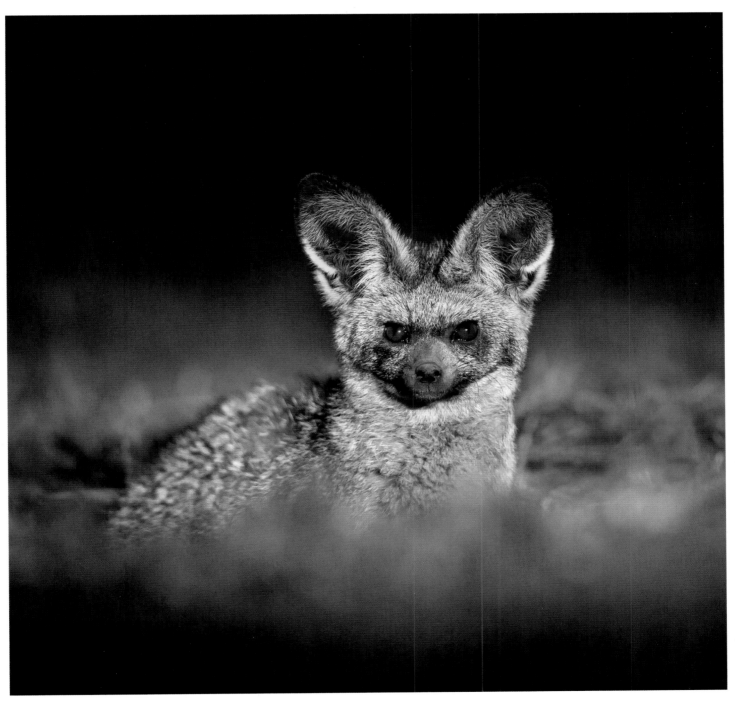

Bat-eared Fox at night.

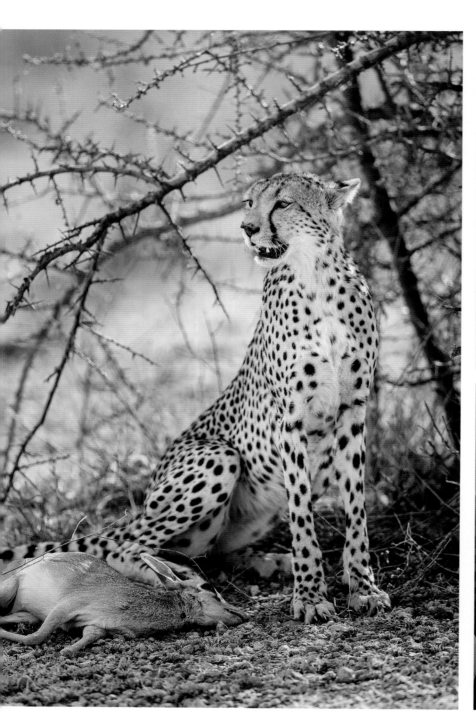
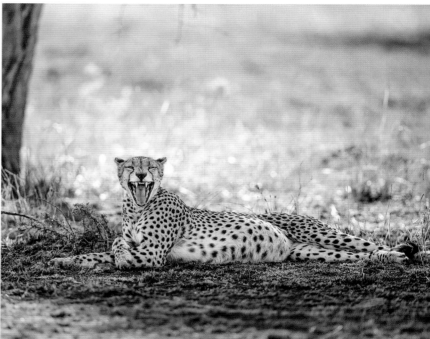
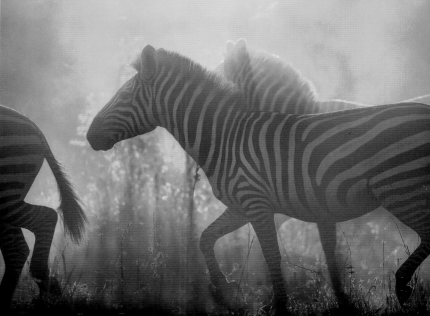

ABOVE CLOCKWISE FROM LEFT Cheetah with her kill; Cheetah resting in the shade of an acacia tree; Zebras.

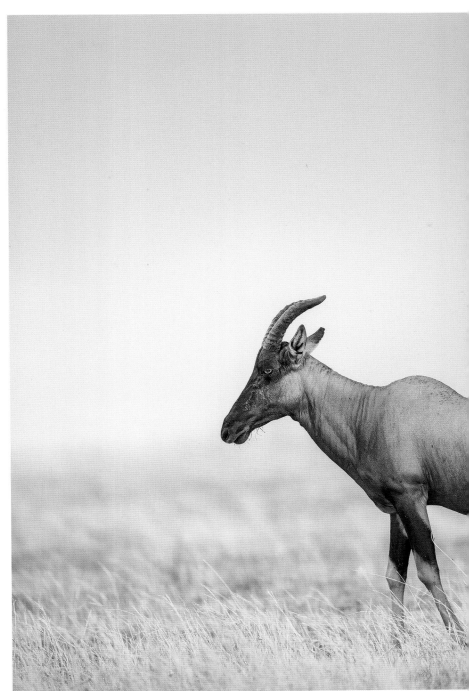

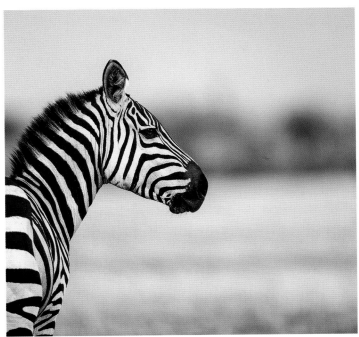

ABOVE CLOCKWISE FROM TOP LEFT Topi in a whistling acacia forest; Topi; Zebra.

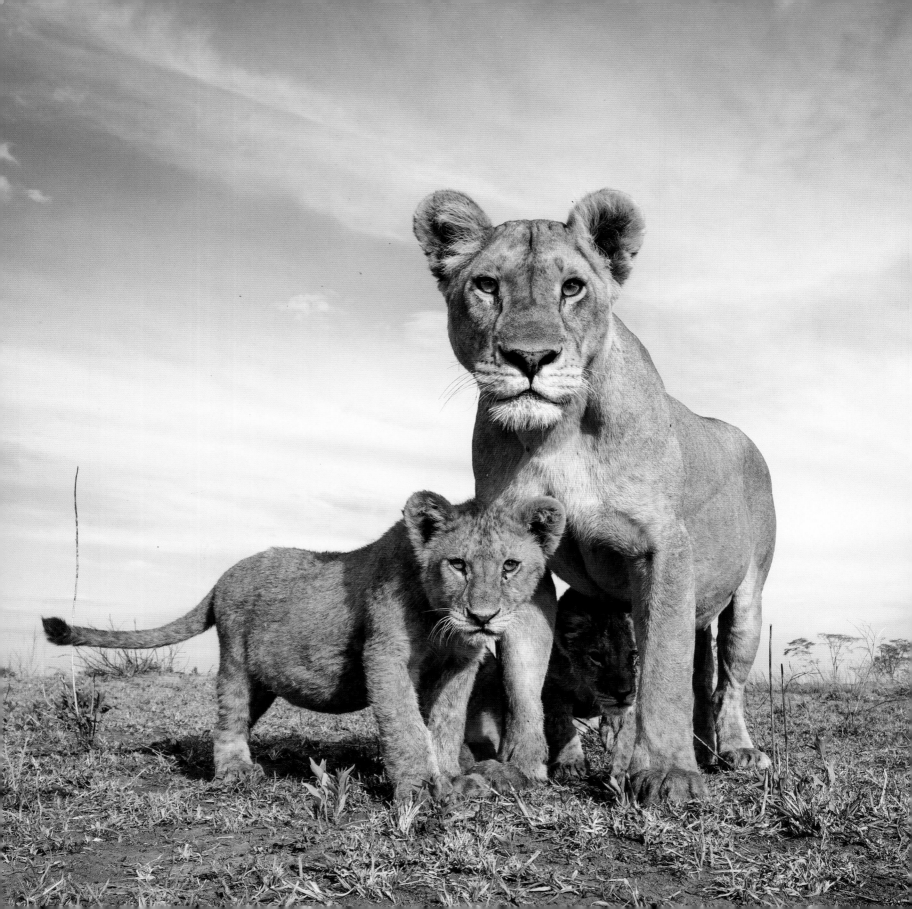

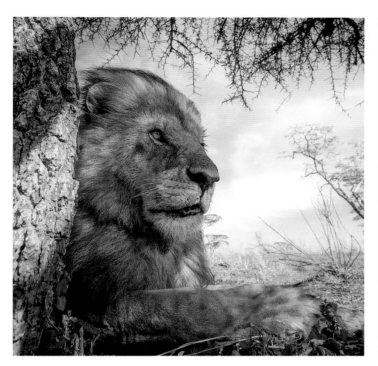
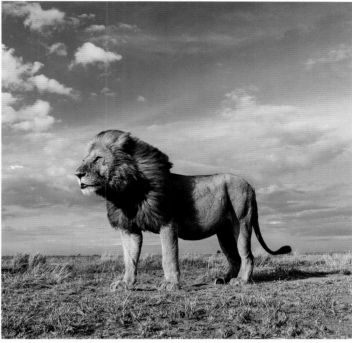
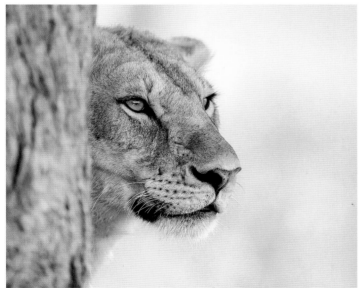
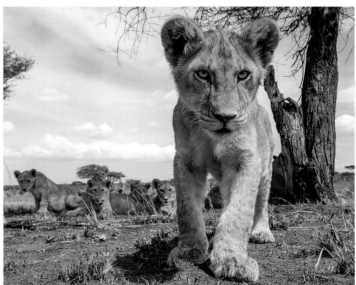

TOP Two images of Male Lions.
ABOVE LEFT Female Lion.
ABOVE RIGHT Lion cubs.
OPPOSITE Female Lion and cubs.

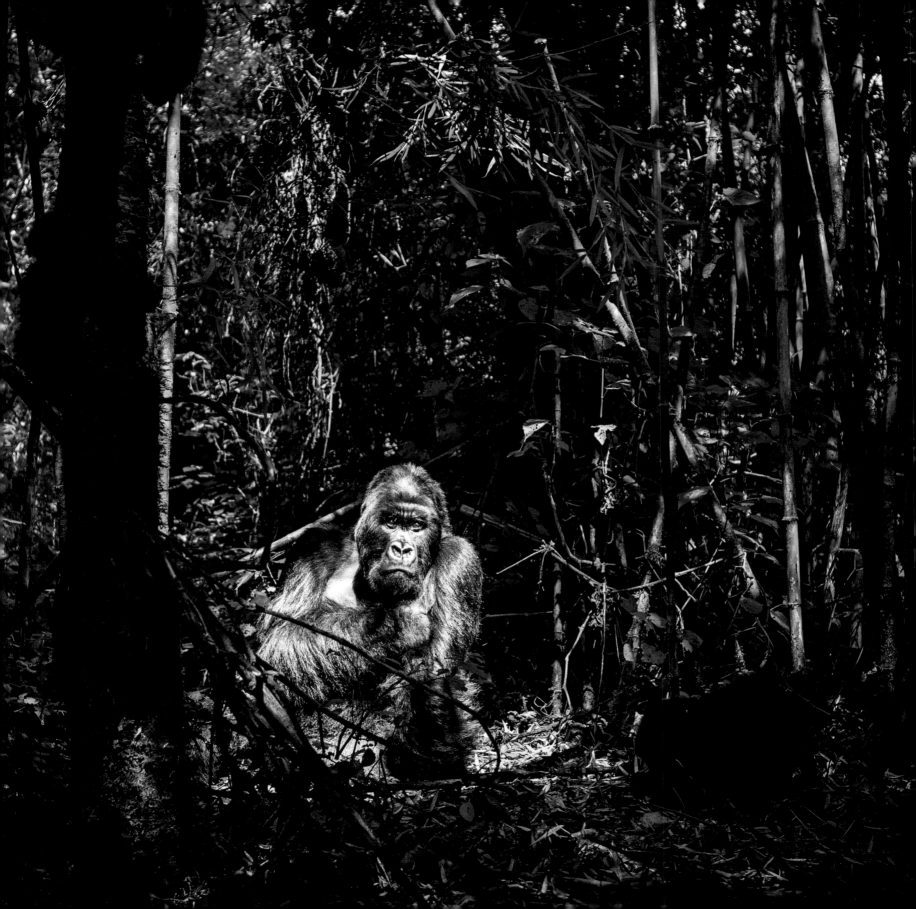

RWANDA: VOLCANOES NATIONAL PARK

"I shall never forget my first encounter with gorillas. Sound preceded sight. Odour preceded sound in the form of an overwhelming, musky-barnyard, humanlike scent. The air was suddenly rent by a high-pitched series of screams followed by the rhythmic rondo of sharp pok-pok chestbeats from a great silverbacked male obscured behind what seemed an impenetrable wall of vegetation."

—Dian Fossey

VOLCANOES NATIONAL PARK in north-western Rwanda was established in 1925, making it the oldest national park in Africa. The national park is contiguous with Virunga National Park in the Democratic Republic of Congo and Mgahinga Gorilla National Park in Uganda. The original park spread across all three of the current parks, covering over 8,000 sq km (3,090 sq miles) of the volcanic massif called the Virunga Mountains. It was divided up in the 1960s when the countries gained independence. During the following two decades, the park was repeatedly reduced in size owing to population pressures and the need for land to farm on. Today, Volcanoes National Park in Rwanda covers 160 sq km (62 sq miles). It is home to the critically endangered Mountain Gorilla and is where the late Dian Fossey conducted her research and conservation efforts.

The park is also home to other primates including the Golden Monkey, as well as Forest Elephants, Giant Forest Hogs and Bush Pigs.

The Mountain Gorillas are the reason the tri-national area was gazetted as a national park. Mountain Gorillas were discovered in 1902 and classified as a subspecies of the Eastern Gorilla. Their name aptly describes their preferred habitat, as they live at elevations of 2,000–4,000m (6,560–13,120ft). To cope with the cold temperatures that can drop below freezing, they have thicker, longer fur than their lowland cousins. Adult males can weigh over 200kg (440lb) and reach heights of almost 2m (6.5ft). Each gorilla has a unique nose print and even after short encounters with a gorilla family, it becomes possible to differentiate and identify individuals.

OPPOSITE Silverback Mountain Gorilla.

NOTABLE SPECIES

Mountain Gorilla
Golden Monkey
Forest Elephant
Giant Forest Hog

WHEN TO GO

Gorilla tracking can be done year round, but the long dry season between mid-May and mid-October are when conditions are ideal.

TIPS

The number of visitors is strictly regulated and therefore it is important to plan ahead.

Rwanda hills.

Mountain Gorillas are mostly found on the ground in groups of around 10 individuals, although they can climb trees if they need to. Similar to other gorilla species, the groups have complex social structures with a dominant silverback male whose job it is to move the group around within their home range of around 40 sq km (15 sq miles) in order to find food such as roots, fruit and tree bark as well as suitable nesting areas. Any challengers will be met by an intimidating show of charges, chest-pounding and roars from the silverback. Mountain Gorillas are herbivores and a fully-grown adult male can require up to 34kg (75lb) of leaves, shoots, bark and other vegetation daily.

Despite living within national parks, since their discovery in 1902, Mountain Gorillas have fallen victim to wars, poaching, habitat loss and disease. There are only approximately 800 remaining in the world, with over half of these living in the Virunga Mountains. The region has seen much human violence since the 1960s, including the Rwandan genocide in the 1990s and years of civil unrest in the Democratic Republic of Congo. The gorillas have suffered greatly during these conflicts, as refugees came in waves to the area around the Virunga Mountains, bringing with them diseases such as the common cold and clearing much-needed natural vegetation for farmland. The violence made it unsafe and more difficult for conservation and anti-poaching work to continue.

Dian Fossey, the zoologist who devoted her life to protecting and researching Mountain Gorillas and is

The Virunga Mountains as seen from Uganda.

credited with bringing the species back from the brink of extinction by alerting the international community to the desperate situation, was murdered in 1985 in the park. Her murder is often attributed to the poachers she spent her life trying to stop. The film *Gorillas in the Mist* tells the story of her life. Her grave is located by the research centre within the park and can be visited.

Fortunately, Rwanda is now a peaceful and safe country. There are numerous, successful conservation initiatives in place and the gorilla population is finally increasing. In 2003, there were an estimated 380 gorillas in the Virunga Mountains, which had risen to 480 in the 2010 gorilla census for the region.

Tourism is an important source of revenue for the area, helping to fund ongoing conservation efforts and raising the profile of the gorillas internationally. Visitors have the opportunity to see these magnificent creatures on gorilla-tracking safaris in small groups. The number of visitors is highly regulated by the park authorities, so visitors must plan ahead for this experience. The trekking conditions can be tough, up and down the steep slopes behind an experienced tracker in search of one of the ten habituated groups of gorillas in the park, but rest assured that the wildlife encounter that awaits within the thick vegetation will be truly unforgettable.

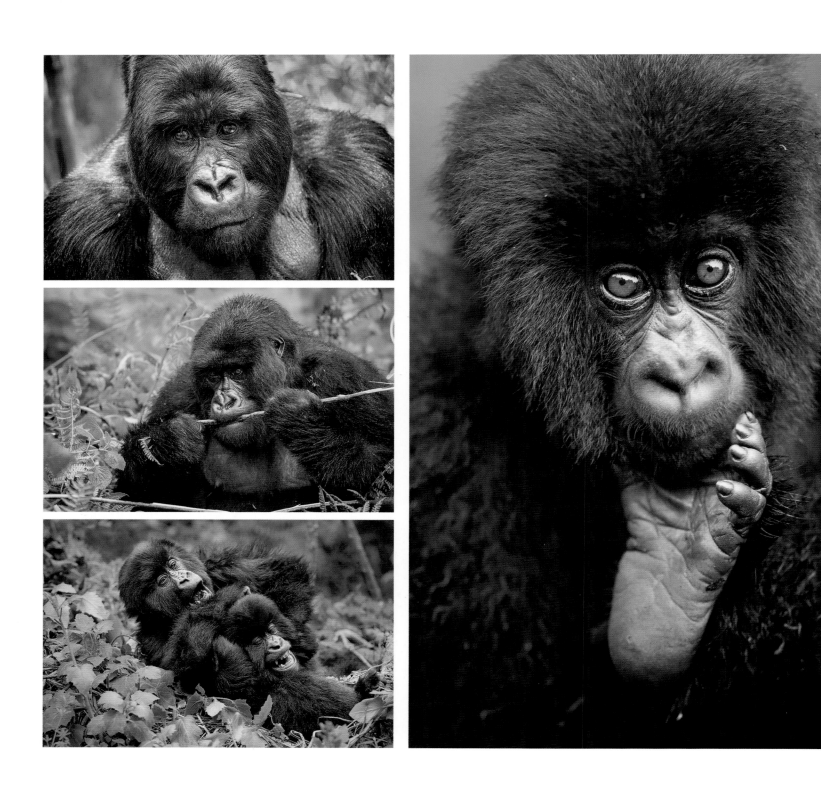

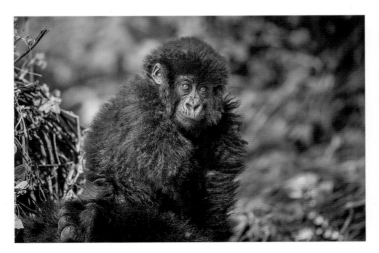

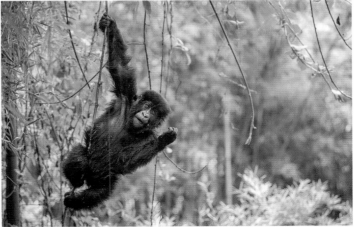

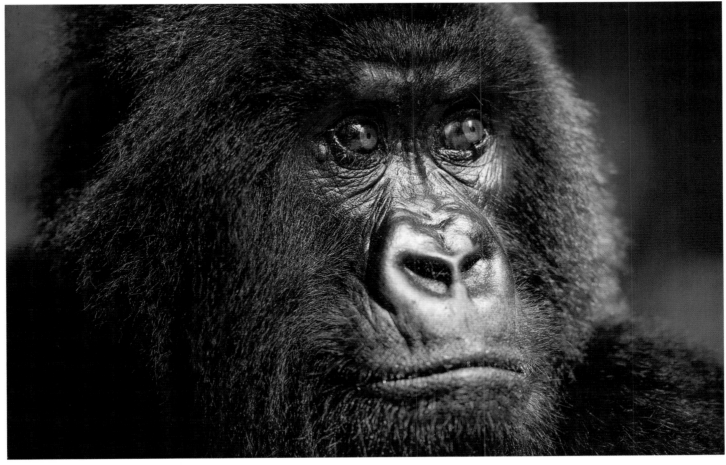

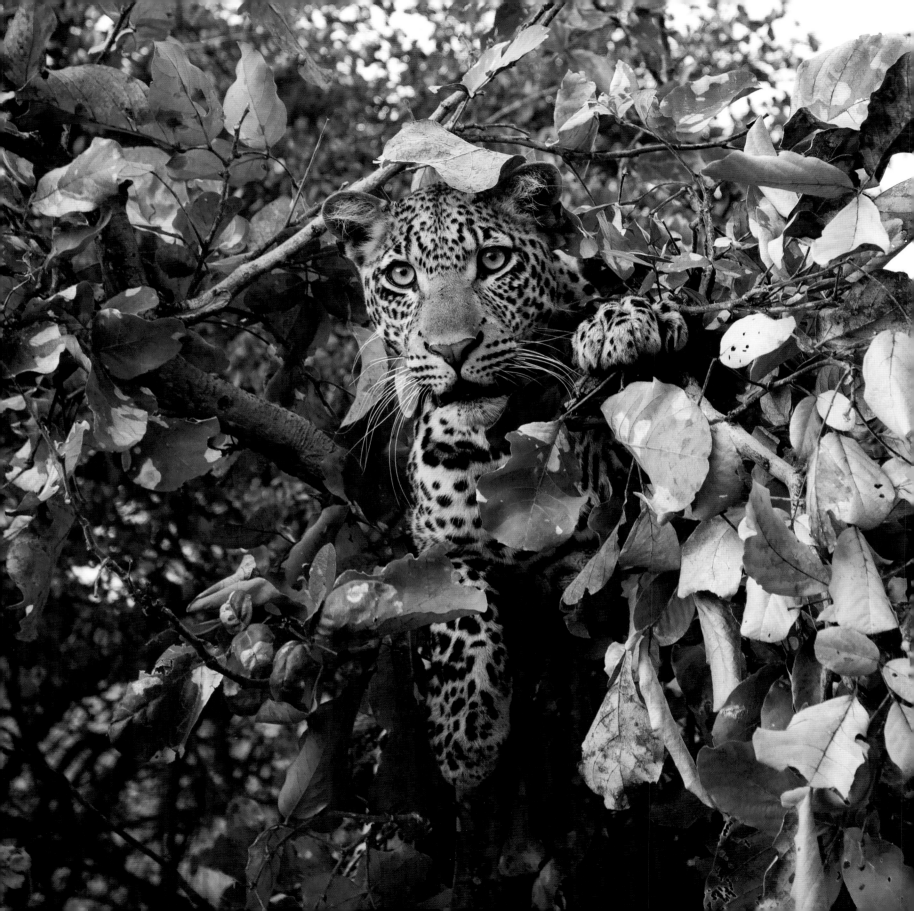

ZAMBIA: SOUTH LUANGWA NATIONAL PARK

"The land was parched and the hot air was heavy with dust. I couldn't count how many different species of bird and mammal were gathered around the baked sides of the small oxbow lake. The Puku and Impala were aware that a pride of Lions was resting under the nearby sausage tree, but the cats were full from a buffalo kill the night before and the antelope, fearing dehydration more than the lions, kept on drinking..."

SOUTH LUANGWA NATIONAL PARK in eastern Zambia is one of four parks located in the Luangwa Valley. It is the southernmost park of the valley and the largest, covering 9,050 sq km (3,495 sq miles). The lifeline of the park and an unavoidable feature of any visit to the valley is the Luangwa River, which is one of the last major unaltered rivers in southern Africa. It has no dams, no major towns on its banks, no commercial agriculture, minimal pollution and only two bridges along its entire course. As a result, the river is at the mercy of Zambia's two seasons, wet and dry. During the wet season from November to May, the rains cause the river to rise and swell, breaking its banks and flooding the parched valley floor. The bursting river and its newly filled side-channels block access to large sections of the valley for most of the wet season. When the rains end, the river shrinks back, leaving the lush green valley to steadily dry out, becoming more and more parched as months go by. The streams disappear and wildlife finds itself clinging to the river edge and permanent water holes. Prey is forced to drink alongside predator, risking all until the first rain comes once more.

The Luangwa Valley is widely considered to be one of Africa's finest wildlife areas. This reputation is owed to a combination of the beautiful wilderness of the valley, the high game density, the wide diversity of habitat and the very high quality of accommodation and guiding. The habitats provide an ideal environment for Leopards and the river supports vast numbers of hippos. The valley is also blessed with large elephant and buffalo herds, other predators such as Lion and African Wild Dog, endemic subspecies such as the Thornicroft's Giraffe and Cookson's Wildebeest, as well as abundant birdlife.

OPPOSITE Leopard in a tree.

NOTABLE SPECIES
Leopard
Lion
Cape Buffalo
African Elephant
Puku
Hippopotamus
Nile Crocodile
Thornicroft's Giraffe
Cookson's Wildebeest
Crawshay's Zebra
African Wild Dog

WHEN TO GO
The peak season for game-viewing is during the dry season from May to November, with the most popular time being from August to October, when the game density is highest and animals concentrate by the river and the shrinking lagoons.

The emerald 'wet' season from December to April sees the park transform into a lush, green paradise. Some areas of the park are inaccessible due to the rainfall and the game is more dispersed at this time of year, but the birdlife is abundant and any wildlife that you see you are likely to have all to yourself with a vibrant green backdrop for stunning photographs.

TIPS
If you visit South Luangwa in October or November then combine your trip with a visit to Kasanka National Park.

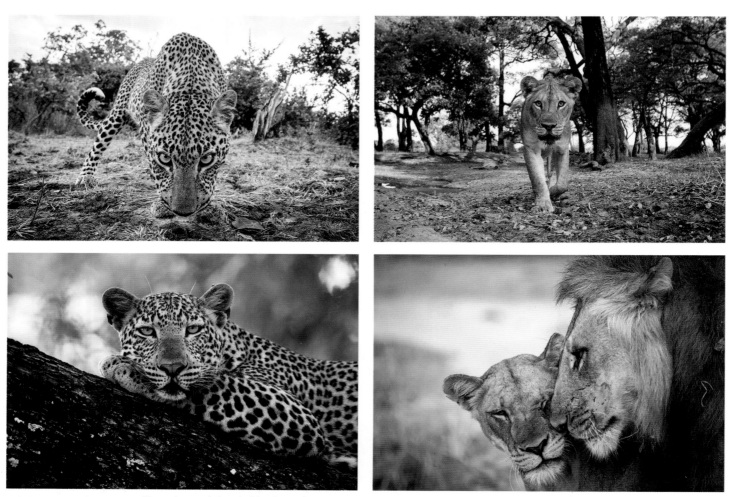

ABOVE CLOCKWISE FROM TOP LEFT Young Leopard; female Lion in an ebony grove; Lions nuzzling affectionately; Leopard resting in an ebony tree.
OPPOSITE FROM TOP TO BOTTOM African Wild Dogs; Cape Buffalo at sunset.

Although Leopards are the most geographically widespread of the big cats, they are often the hardest to spot on safari, as they are elusive, solitary and secretive animals that are most active at night. South Luangwa, however, is a renowned destination for Leopard sightings. This is owing to the park having ideal vegetation, gullies and dense thickets to support a healthy Leopard population, as well as the fact that night-drives are permitted in the park, enabling Leopards to be spotted as they hunt at night. Most visitors to the park will be rewarded with unrivalled Leopard sightings during their stay, both at night and in the daytime. Leopard are strong, powerful carnivores. Their prey includes fish, reptiles and mammals such as rodents, warthogs, antelopes and baboons. They have a pale coat that is covered in characteristic dark spots called rosettes, which provides excellent camouflage in undergrowth and vegetation. Leopards are good climbers and spend a lot of time up in trees resting, stalking and eating prey. Taking food up into a tree can help to prevent a Lion or hyena from stealing its hard-earned kill.

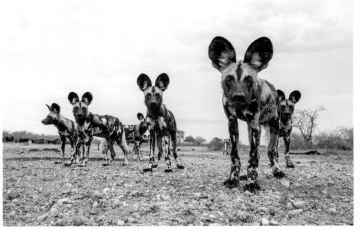

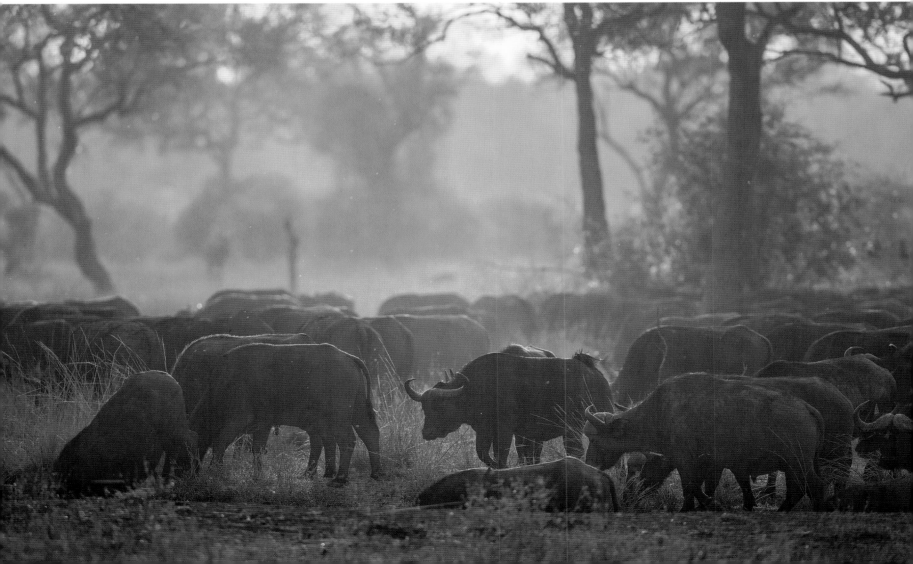

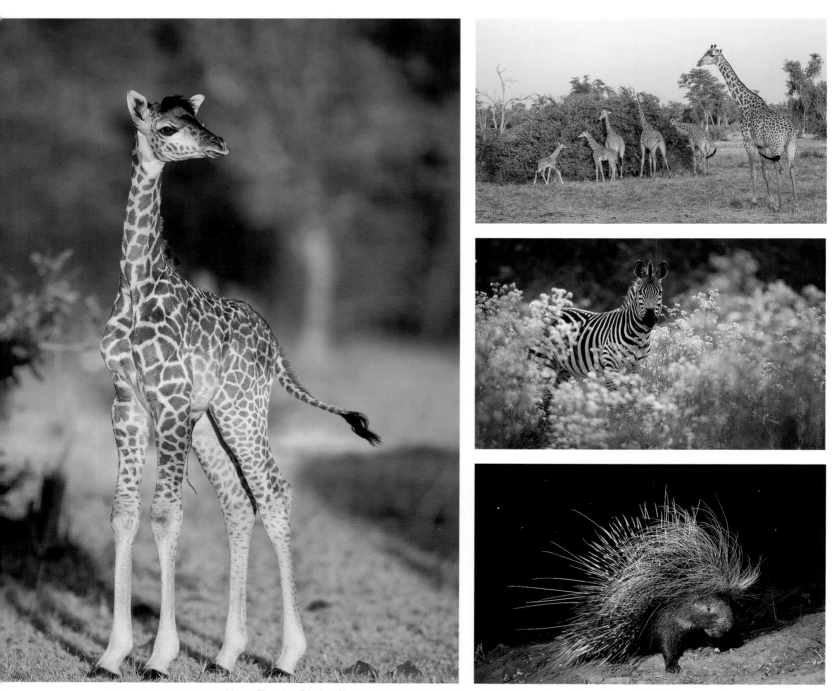

ABOVE CLOCKWISE FROM LEFT Young Thornicroft's Giraffe; Thornicroft's Giraffes; Crawshay's Zebra; Porcupine, photographed with a camera trap.
OPPOSITE FROM TOP TO BOTTOM Elephants; baby Hippopotamus.

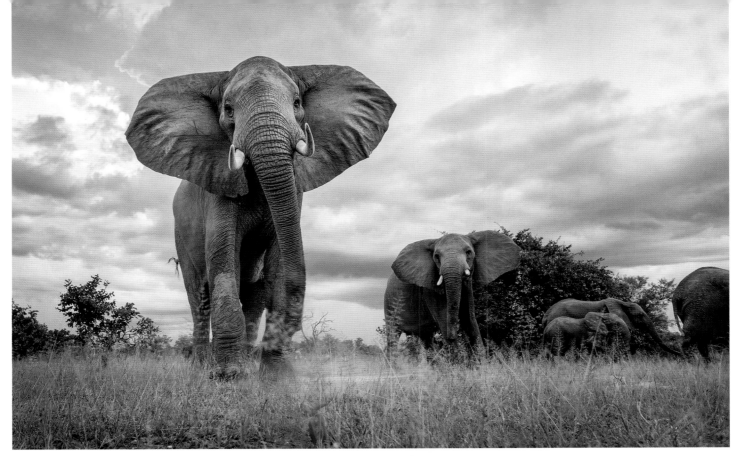

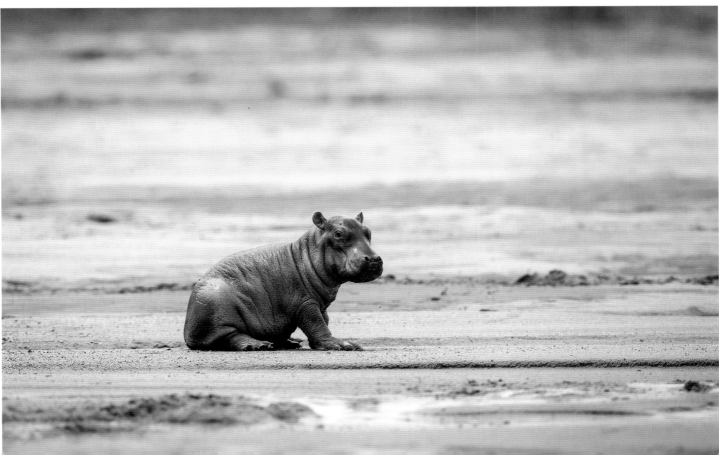

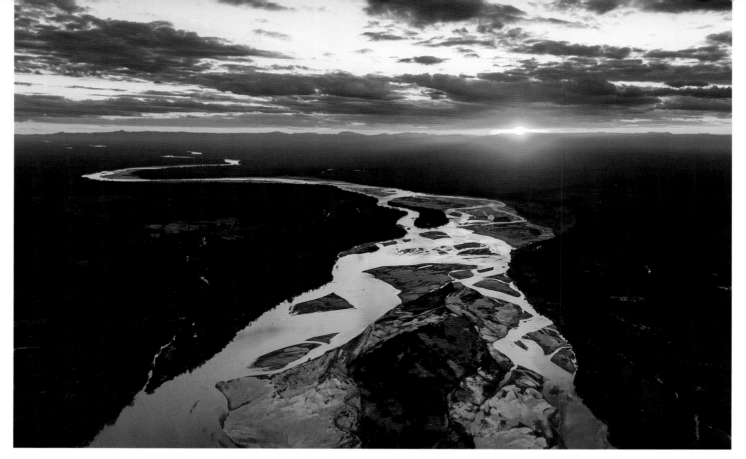

ABOVE TOP TO BOTTOM The Luangwa River at sunset; Puku at dusk.

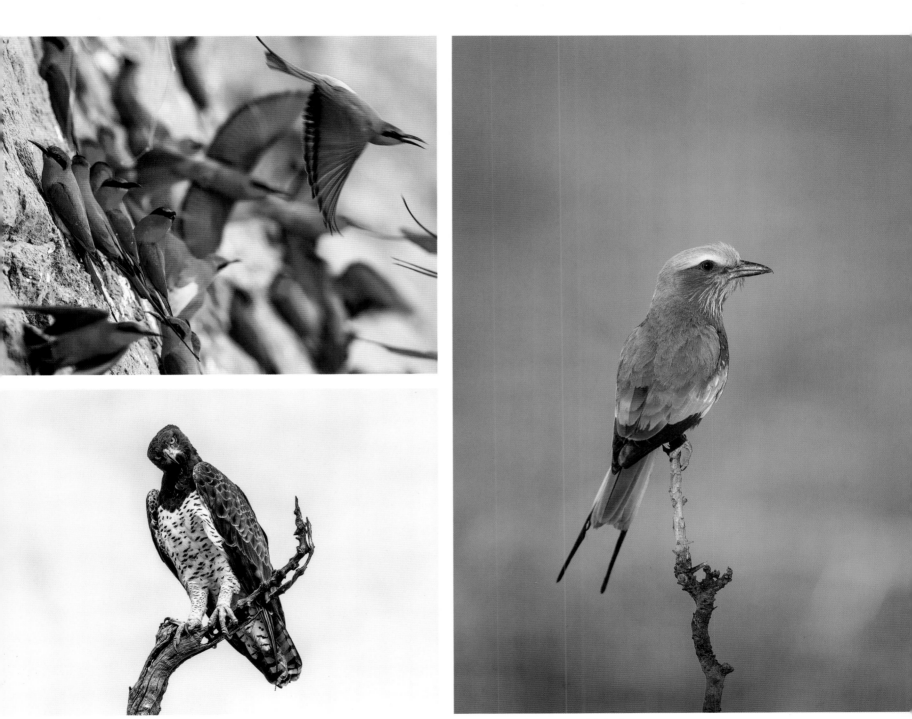

ABOVE CLOCKWISE FROM TOP LEFT Southern Carmine Bee-eaters nesting in a riverbank; Lilac-breasted Roller; Martial Eagle.

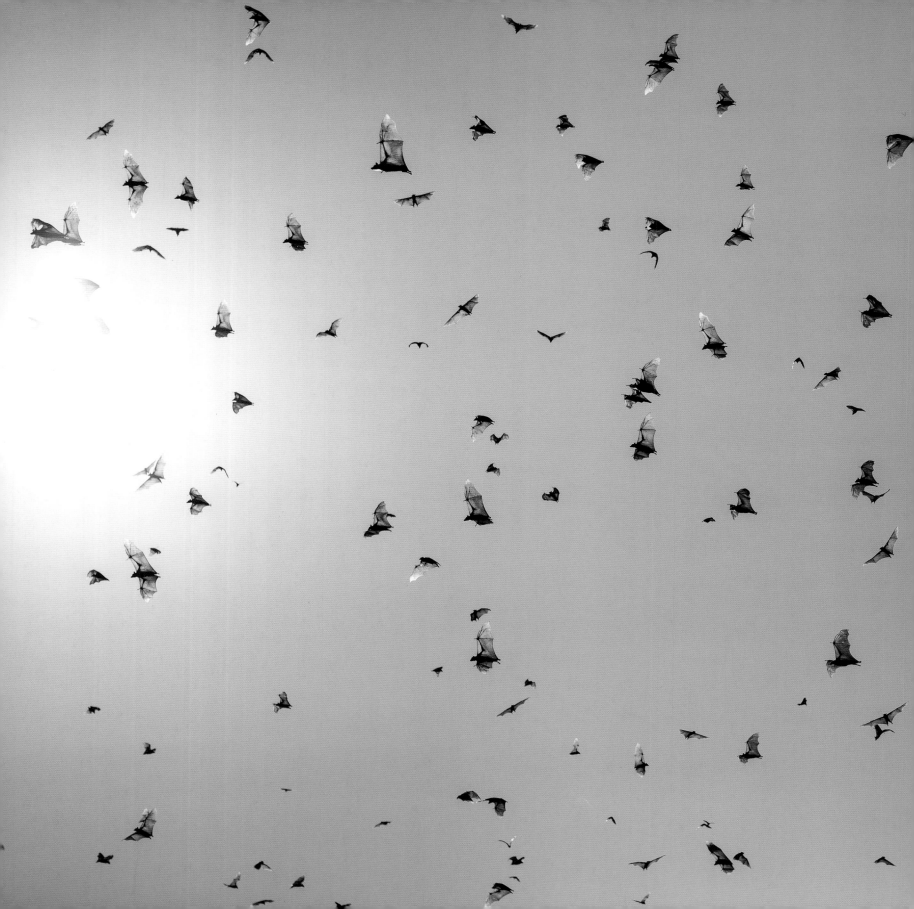

ZAMBIA: KASANKA NATIONAL PARK

"The sheer number of fruit bats was mind-blowing, peppering the sky in every direction as they rose from their roost to start their night-time feeding. The cacophony of sounds and the fluttering shapes in organised chaos against the red, dappled sky made me feel like I was bearing witness to a science fiction aerial invasion."

KASANKA NATIONAL PARK in Zambia's Central Province is one of the smallest national parks in the country, but what it lacks in size, it more than makes up for in wildlife opportunities. It has a wide variety of habitats, including miombo woodland, mushitu evergreen forests, chipya woodland, dambos (grassy drainage channels and basins) and papyrus swamps, as well as rivers and lakes. The diverse habitats support a variety of game. The park is one of the best places in the world to spot the usually elusive Sitatunga (a swamp-dwelling antelope) and is also a great place to see the magnificent Sable Antelope and the rare Blue Monkey. It is also a prime destination for bird enthusiasts, with over 450 species of bird in the park and the chance to see Pel's Fishing Owl, Wattled Crane and other species that can be hard to find elsewhere.

However, Kasanka's true claim to fame is that every year in October, millions of Straw-coloured Fruit Bats start arriving for the largest migration of mammals in Africa. By the middle of November, some 8 million fruit bats have arrived to roost in one small area of mushitu forest. Each bat weighs approximately 0.25 kg (0.5lb) with a wingspan of around 75cm (30in). They roost in a 0.4ha (1 acre) patch of forest with each tree holding around ten tonnes of bat; it is said to be the highest density of mammal biomass anywhere on Earth. Their arrival coincides with the first rains and the ripening of many local fruit and berry species which are devoured by the bats. The forest canopy bows under the sheer weight of bats, actually deforming and collapsing down on itself.

OPPOSITE Straw-coloured Fruit Bats.

NOTABLE SPECIES

Straw-coloured Fruit Bat
Sitatunga
Sable Antelope
Roan Antelope
Cape Clawless Otter
Blue Monkey
Pel's Fishing Owl

WHEN TO GO

The bat migration occurs between October and November each year.

TIPS

It is well worth combining this trip with a visit to the nearby Bangweulu wetlands, which is a great place to see the magnificent Shoebill. You can also combine this with a visit to South Luangwa National Park (see previous chapter).

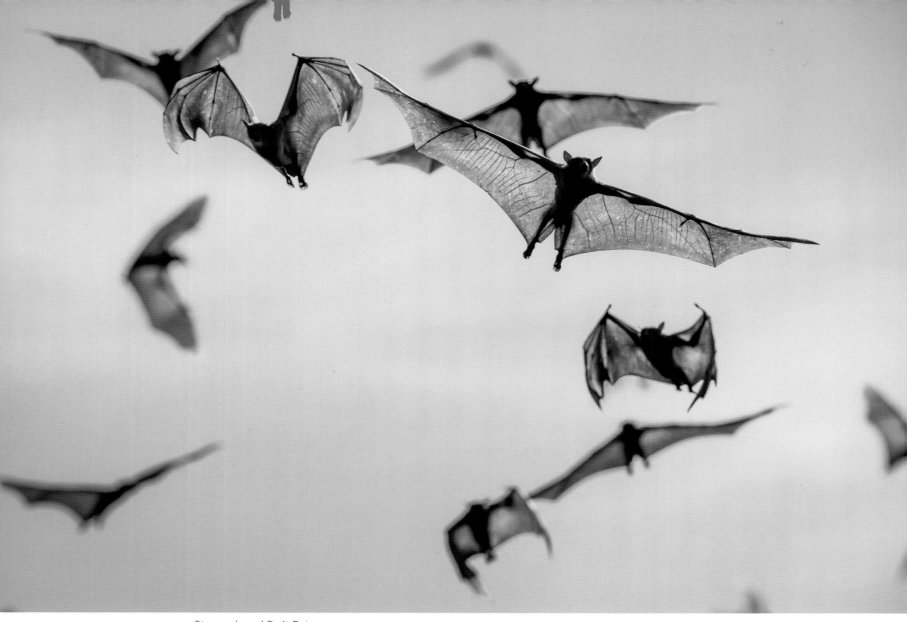

ABOVE AND OPPOSITE Straw-coloured Fruit Bats.

Every evening, for around 30 to 40 minutes, the sky literally fills with bats as they fly off into the twilight to feed in the surrounding forests. Every morning, the sky fills again as the bats return to the roost. It really is a sight to behold. The bat colony draws predators and scavengers including raptors such as Martial Eagles, fish-eagles, kites and falcons. During the daytime, when a bird of prey swoops on the colony, the disturbed bats take to the air in a raucous explosion filling the sky with frenzied activity.

Vultures, Leopards, crocodiles and monitor lizards help to clean up any bats that may drop to the forest floor.

Wildlife activities during the bat migration involve spending time viewing and photographing the bats from various canopy towers around the colony. There are plenty of other game-viewing opportunities including walks, drives and boating activities to see the other game and birdlife of the park.

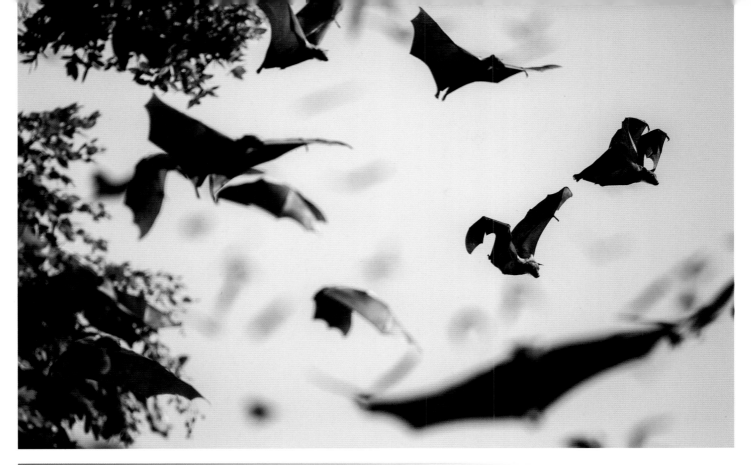

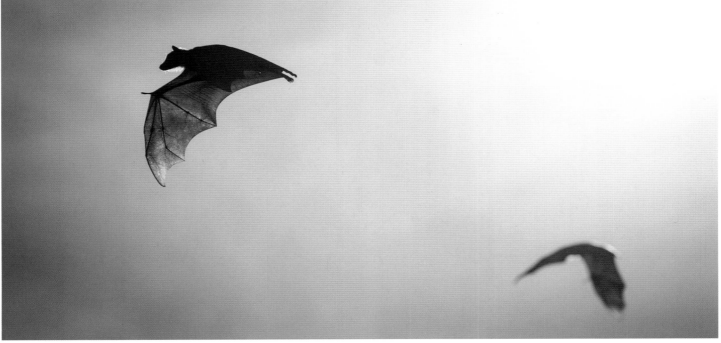

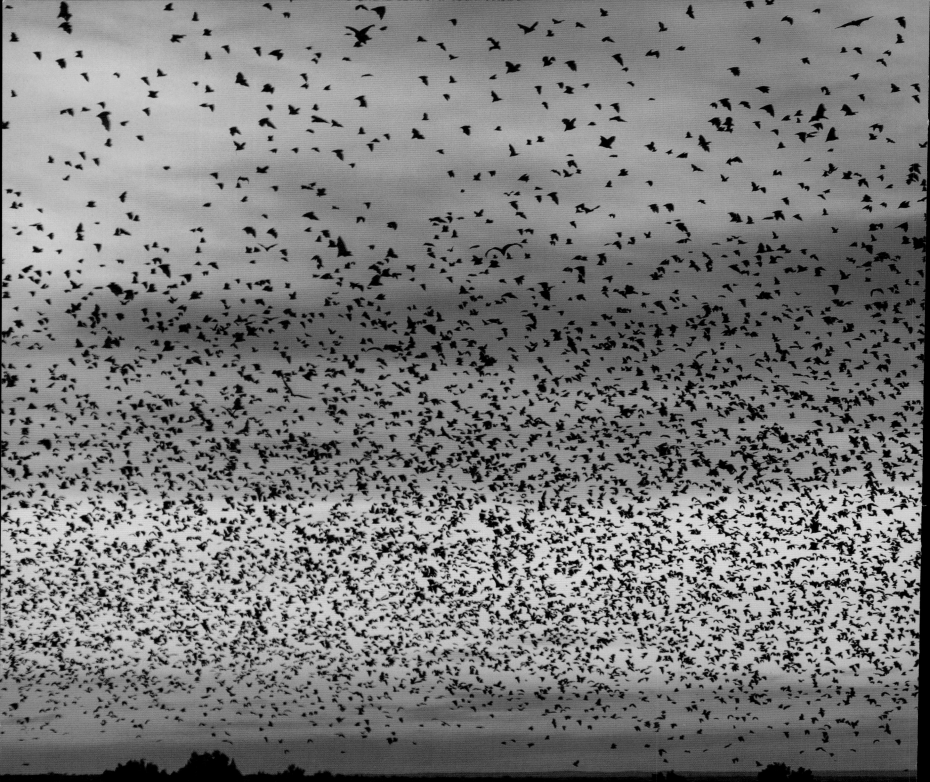

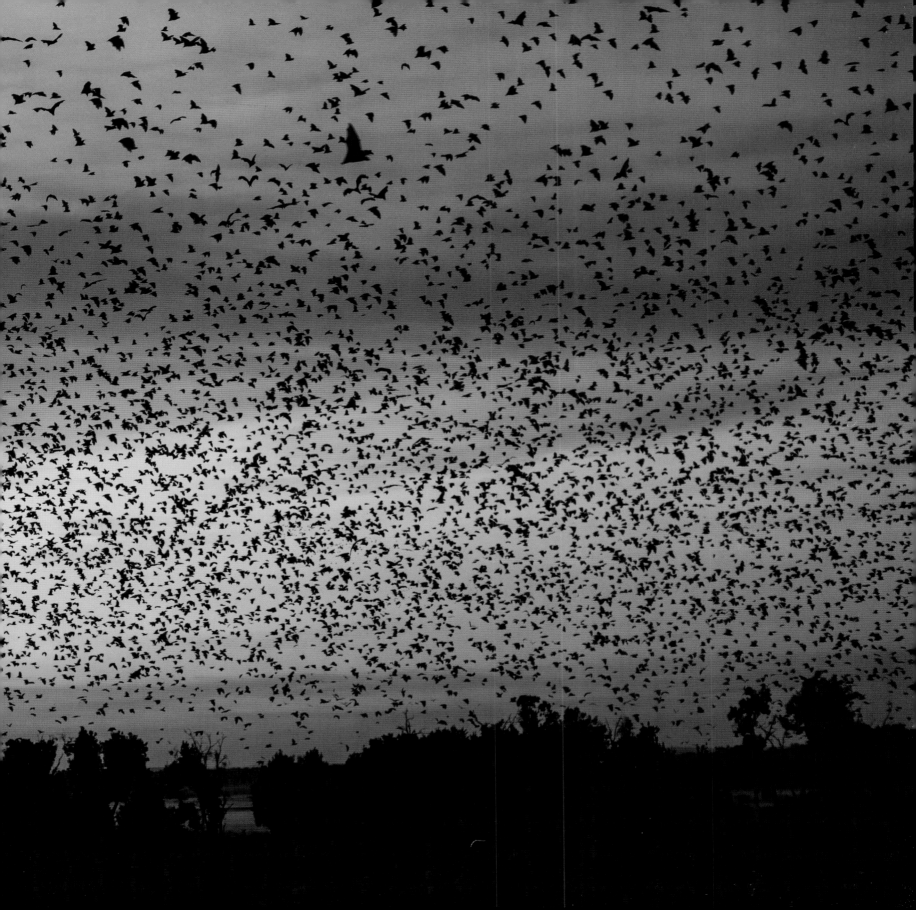

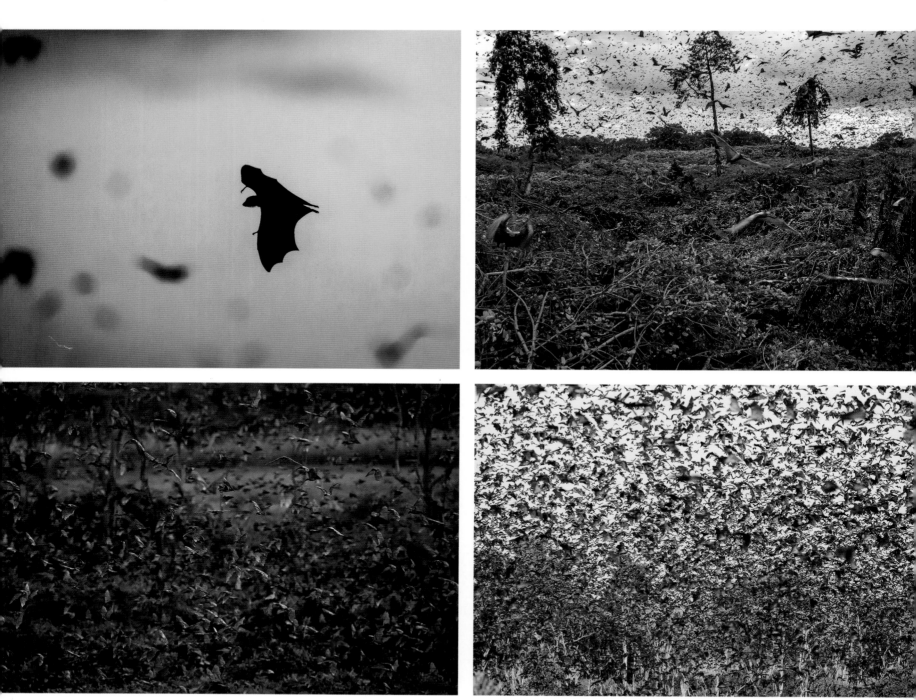

ABOVE Straw-coloured Fruit Bats.
OPPOSITE Shoebill, photographed in the nearby Bangweulu Wetlands.

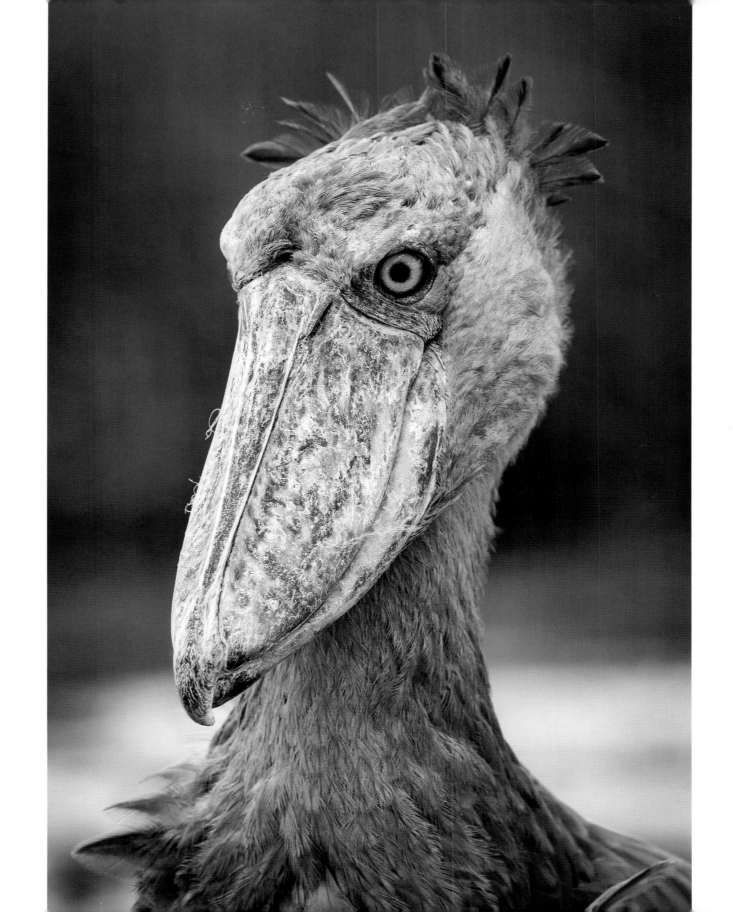

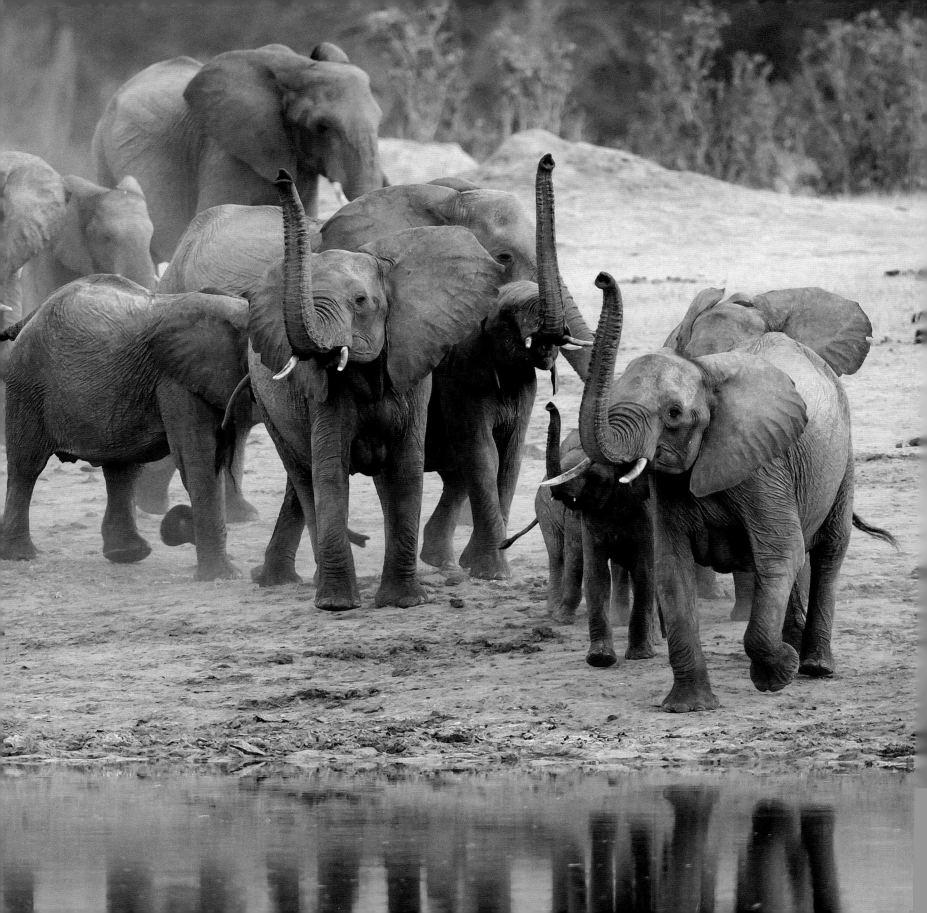

ZIMBABWE: HWANGE NATIONAL PARK

"There were too many elephants to count… the waterhole was teeming with them. Some very small elephants perched at the edge of the water, using their trunks clumsily to draw a tepid drink. The older elephants were wading knee-deep, enjoying hosing water over themselves. Occasional joyful trumpets accompanied the constant sloshing and spraying noises."

HWANGE NATIONAL PARK is the largest game reserve in Zimbabwe, occupying almost 15,000 sq km (5,800 sq miles) in the north-west of the country between Victoria Falls and Bulawayo. With over 100 species of mammals resident in the park, Hwange is said to have the highest diversity of mammals of any national park in the world. This, along with the fact that the park's elephant population is one of the largest in the world, helps to secure Hwange's spot as one of the top national parks in Africa for sheer numbers and variety of game. The park is on the edge of the Kalahari desert and historically this dry area with sparse vegetation did not support the same concentration of game seen today. It wasn't until 1929 when the national park was founded and the new warden of the park set upon the task of drilling boreholes to create permanent water supplies at watering holes that wildlife populations, in particular those of elephant, started to grow.

African Elephants are the largest land mammal on Earth. Fully grown they can range between 2–4m (6.5–13ft) in height and can weigh over 6,000kg (13,225lb). Their large size comes with a large appetite; an adult elephant can consume over 100kg (220lb) of food daily, with a diet consisting of roots, grasses, fruit and bark. They will roam great distances to seek out their daily food requirements and to find water sources. They require large quantities of water for drinking and for cooling off. It is a joy to see elephants when they are happily located around and within a water source. Female elephants and their young live and move around in herds, such as the large ones seen in Hwange. Adult male elephants are called bulls and tend to roam alone.

OPPOSITE African Elephants approaching a watering hole.

NOTABLE SPECIES

African Elephant
Lion
African Wild Dog
Cheetah
Brown Hyena
Roan Antelope
Gemsbok

WHEN TO GO

The park can be visited year-round, but the dry winter months (August to November) provide the best game-viewing opportunities as wildlife concentrates around watering holes.

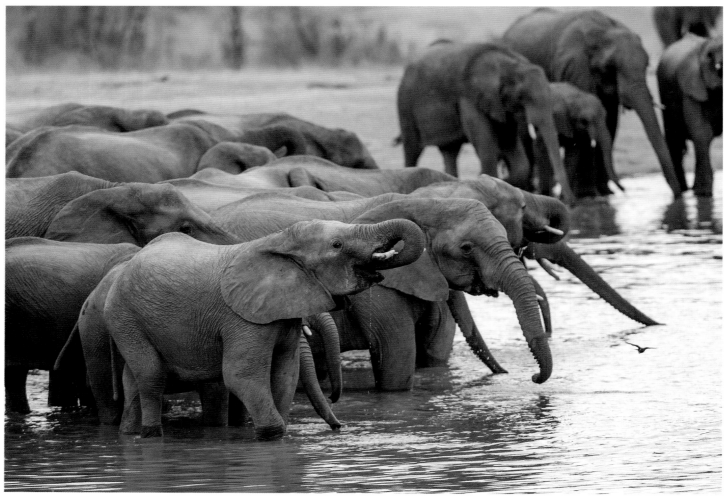
Elephants in watering hole.

Large elephant herds can have damaging effects on the habitats in which they live, as they can destroy vegetation faster than it can regenerate. There are different schools of thought on whether Hwange's elephant population is too large for the park to support. Making the debate even more difficult is the fact that nobody knows exactly how many elephants are in the park. Without any fences, the elephants are free to move in and out of the park as they please, crossing into Chobe and the Okavango in Botswana, thus the number of elephants at any one time is in constant flux.

For visitors, the large number of elephants is impressive and makes for enjoyable game-viewing. However, for the wildlife authorities, it remains a difficult management issue with no easy answers.

The park supports notable populations of African Wild Dog. This species is also known as the 'Painted Dog' owing to its multicoloured coat with splodges of brown, white, black, yellow and rust-coloured fur. Their other distinctive feature is that they have big, round ears, resembling satellite dishes, which help them to hear other pack members' vocalisations

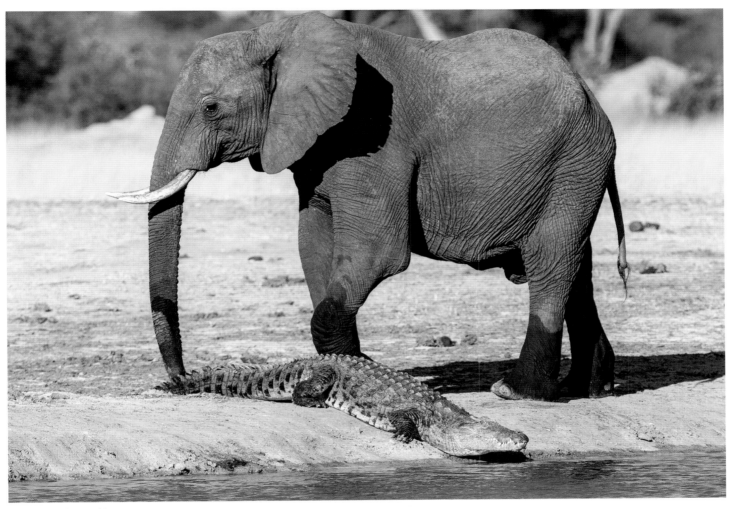

Elephant and crocodile.

from far away. They are highly social animals living in packs up to 20 strong. Whenever I see these beautiful creatures, I am always moved by how caring and supportive they are of each other, sharing food, assisting injured members of the group and constantly looking around when on the move to check that everyone is keeping up. They hunt as a pack and are very successful predators, using teamwork, stamina and speed to ensure that 80 per cent of their hunts end in a kill. Apart from during denning season, these dogs are always on the move, never normally staying in one place for more

than a day. Because they cover such large ranges, even in a park the size of Hwange, the dogs find themselves suffering from habitat loss and encroaching human settlement. They are also vulnerable to diseases spread by domestic animals. Fortunately, the Painted Dog Conservation is based in Hwange and their tireless research and conservation work, as well as their education initiatives for local communities, is making a huge difference to this special and endangered animal. They have a visitor centre opposite Hwange National Park Airport which is well worth a visit.

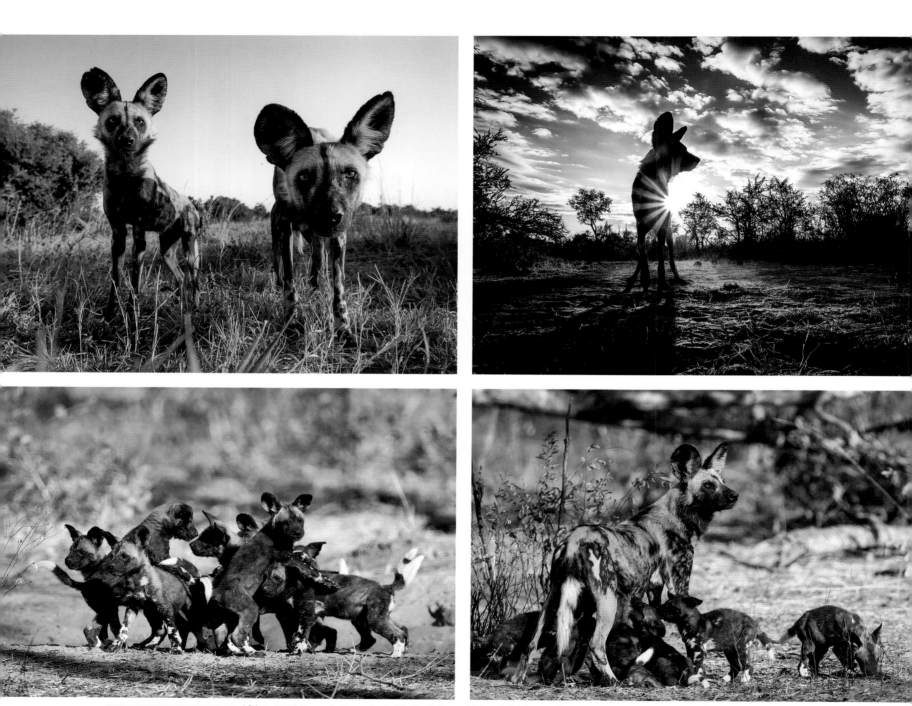

ABOVE CLOCKWISE FROM TOP LEFT African Wild Dogs, photographed with BeetleCam; African Wild Dog at dawn; African Wild Dog with pups; African Wild Dog pups.
OPPOSITE TOP TO BOTTOM Giraffes at watering hole; Cape Buffalo.

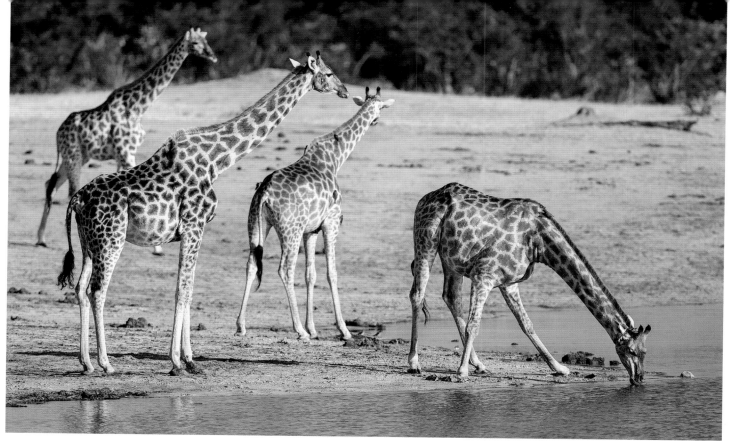

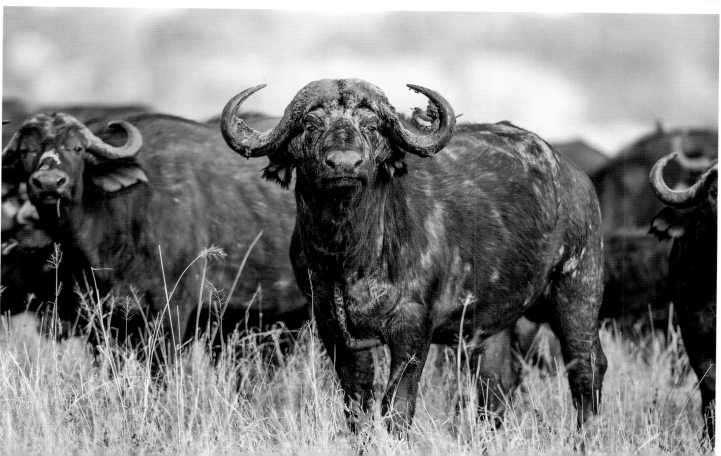

ABOVE Glossy starling.
OPPOSITE Pearl-spotted Owlet.

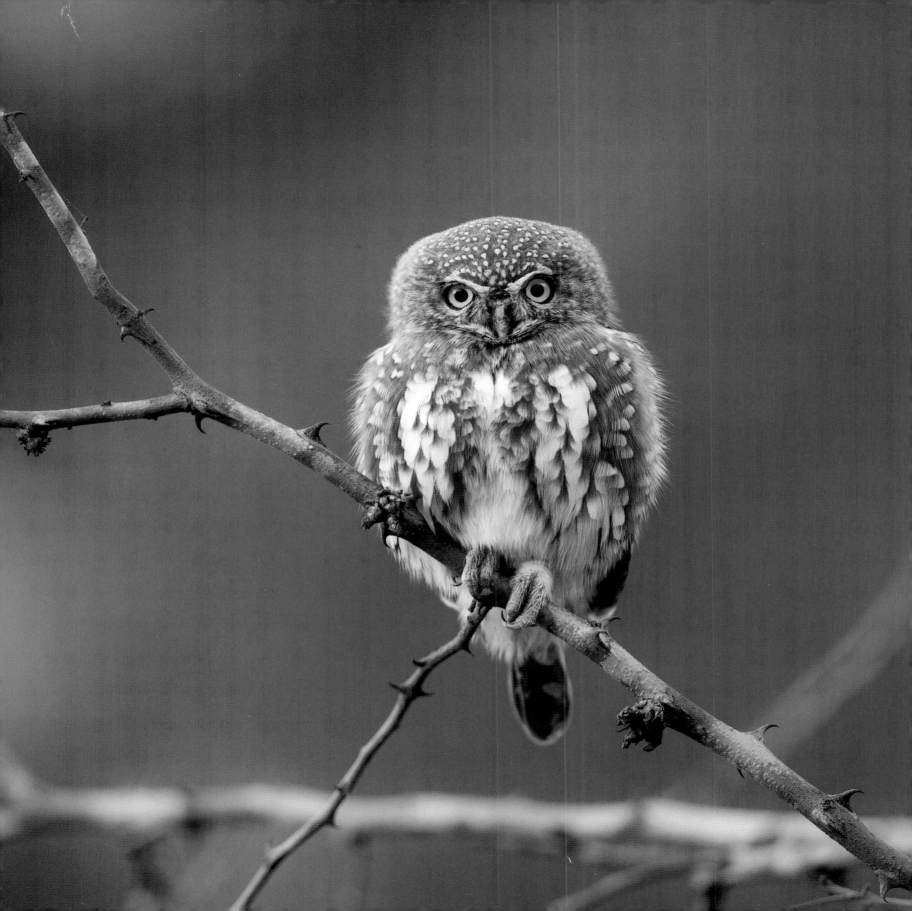

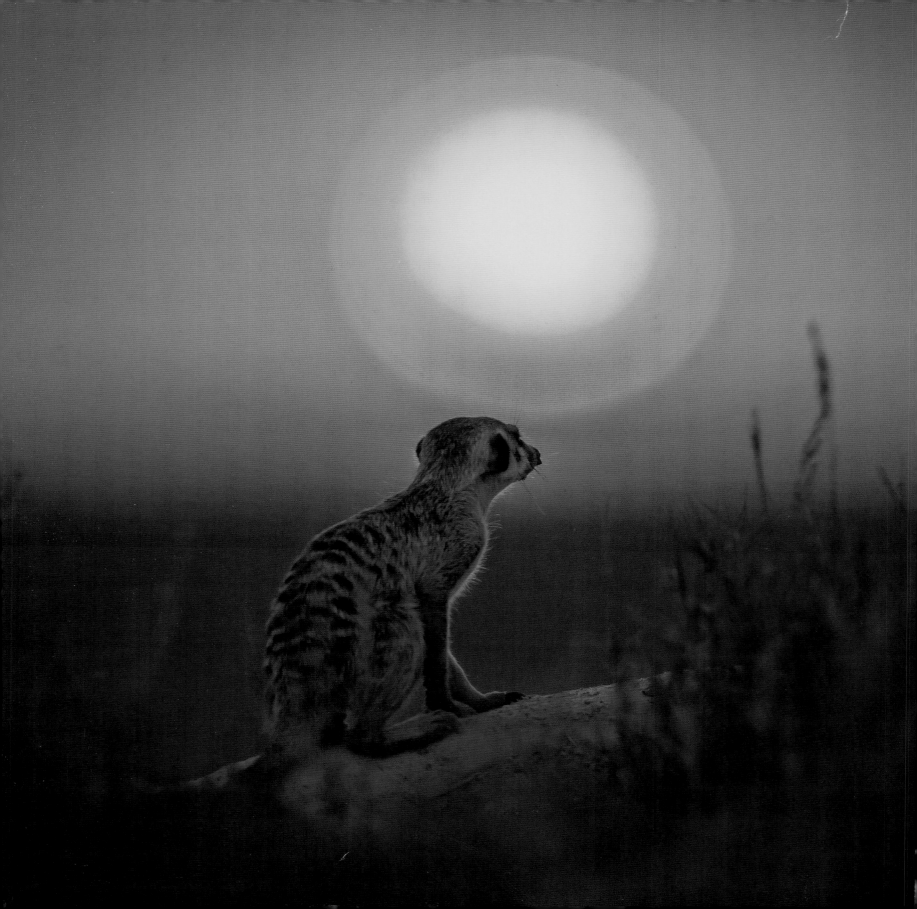

BOTSWANA: MAKGADIKGADI PANS NATIONAL PARK

"In the dim light of dawn, you may hear them before you see them. Their little squeaking noises start up, followed by sleepy Meerkats emerging to scout the area above ground as the sun rises. In the flatness of the Makgadikgadi Pans National Park, a human being can make an excellent look-out post. I was more than happy to oblige as these charismatic creatures clambered onto me to improve their view."

THE MAKGADIKGADI PAN is made up of numerous salt pans within the Kalahari Desert in Botswana, to the south-east of the Okavango Delta. It is one of the largest salt flats in the world, covering over 16,000 sq km (6,180 sq miles). On first appearance, it looks barren and lifeless, a white expanse as far as the eye can see. However, sandy desert lies between the individual pans, and at the fringe is the grassland and shrubby savannah of the Makgadikgadi Pans National Park, which is where the Meerkats call home. The Meerkats in this area are wild, but over time have been studied and visited by tourists so they have become habituated to humans. This means it is possible to get close to them, and they may even make use of you as a look-out post in their vigilant surveillance of the surroundings.

Meerkats live in large groups (called mobs or clans) that can be made up of several families living together. They sleep and raise their young in underground burrows. A group may move regularly between several different burrows. Some of the Meerkats in the group act as sentries, standing on their hind-legs for long periods of time on the lookout for birds of prey and other sources of danger, making squeaks to the group should trouble arise. Meanwhile, the other members of the group spend their time foraging for food, such as scorpions and beetles.

Other wildlife activities in the area include game drives, with the chance to see desert species such as Aardwolf, Bat-eared Fox, Brown Hyena and possibly Aardvark on a night drive. You can also go on bush walks with the Kalahari Bushmen, where you can learn about the flora and fauna of the desert. Between February and April, after the December rains, you are likely to catch the spectacular zebra migration, when the plains become inundated with up to 30,000 Burchell's Zebra.

OPPOSITE Meerkat at sunset.

NOTABLE SPECIES
Meerkat
Brown Hyena
Bat-eared Fox
Lion
Burchell's Zebra
Aardwolf
Aardvark

WHEN TO GO
The park can be visited year-round.
Visit between February and April for the best chance of seeing the zebra migration in full swing.

TIPS
Combine with a trip to the Okavango Delta.

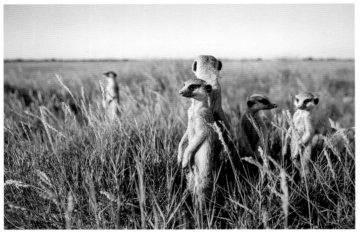

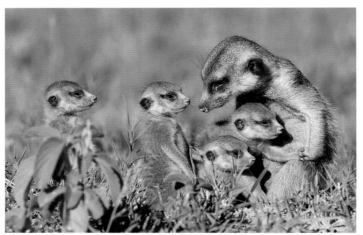

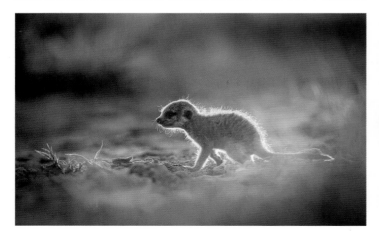

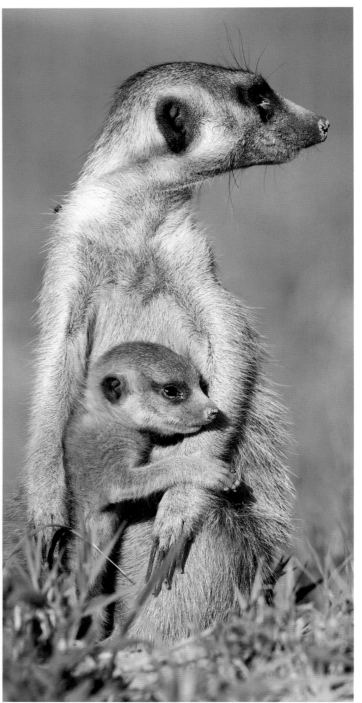

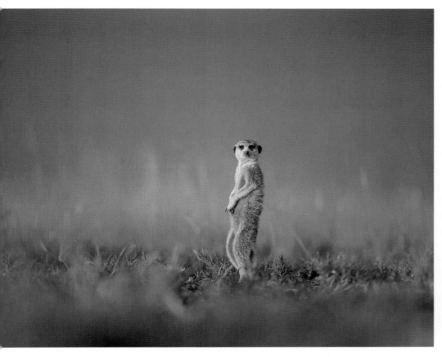
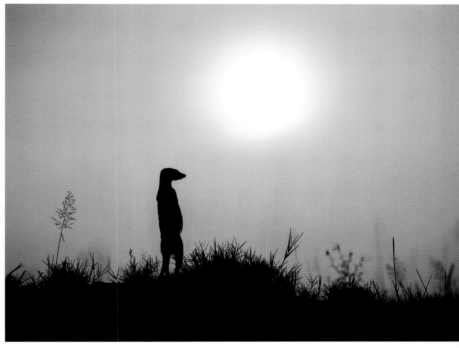
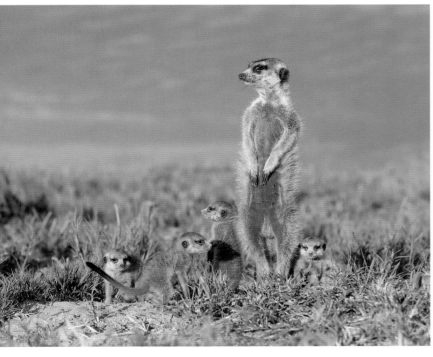
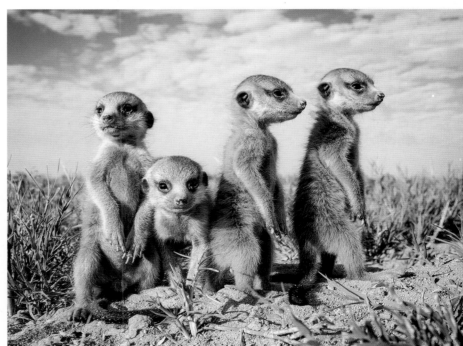

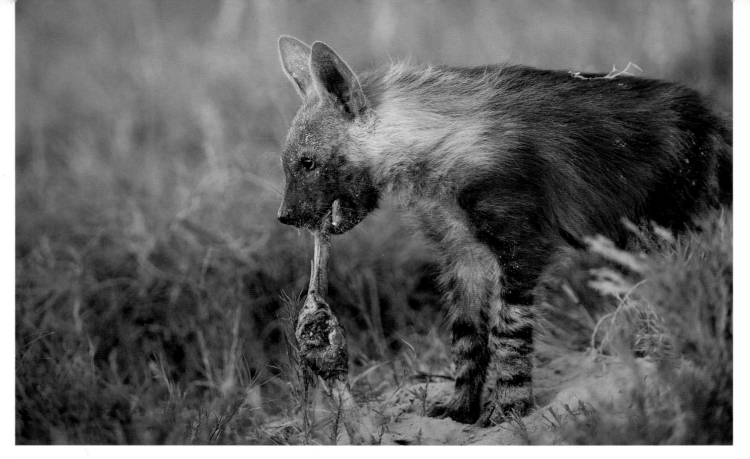

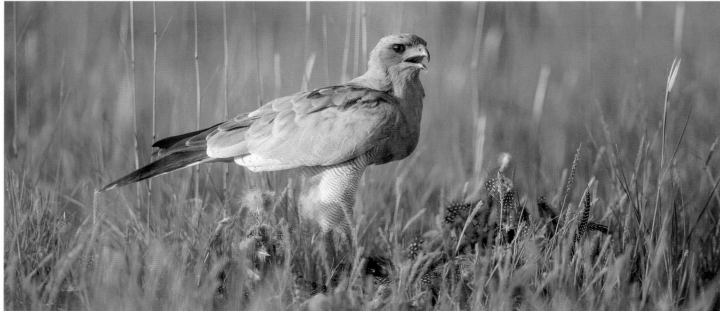

ABOVE FROM TOP TO BOTTOM Young Brown Hyena; Goshawk tucking into a freshly killed guineafowl.

OPPOSITE Aardvarks greeting each other.

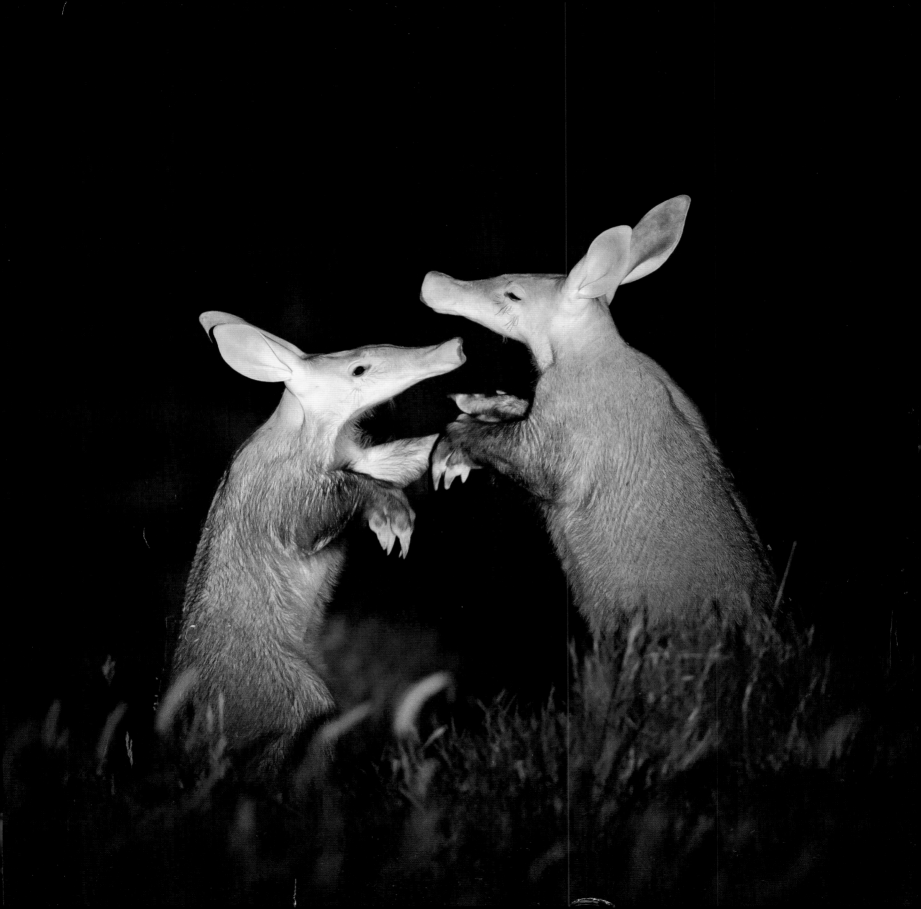

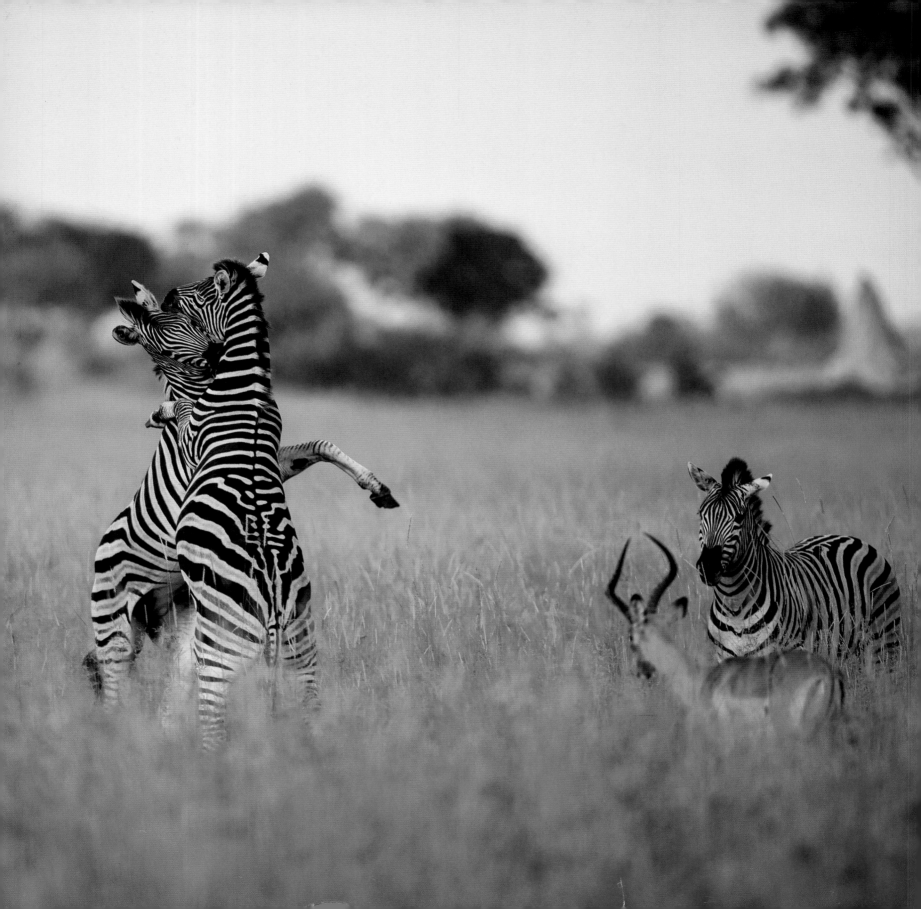

BOTSWANA: OKAVANGO DELTA

"I spent an entire afternoon watching two small Leopard cubs play around their relaxed mother's feet, making brave, exploratory forays into the small tree that they were sat beneath. Glistening pools of water twinkled sunlight onto the cubs, with lush foliage providing the perfect backdrop."

THE OKAVANGO DELTA in Botswana is a very large inland delta. The water of the delta comes from the Okavango River, the source of which lies in Angola and flows over 1,600km (1,000 miles) into Botswana. The delta is formed where the Okavango River empties itself into a basin in the Kalahari Desert. None of the water from the Okavango River ever flows into any sea or ocean. The delta floods each year after the Okavango River drains the rainfall from the Angolan highlands. The water spreads over the delta from March onwards, peaking between June and August (ironically Botswana's driest months). This huge increase in water volume causes the delta to swell to three times its usual size, attracting a phenomenal abundance of wildlife, creating a land of plenty that is truly one of the most spectacular places on Earth.

Approximately one third of the delta lies within the Moremi Game Reserve, a national park on the eastern side of the delta. This is where Chief's Island is located (the largest island of the delta) and is a prime wildlife-viewing area where many safari lodges are situated. Game drives are available and boating activities including serene wildlife-viewing aboard a traditional mokoro (dug-out canoe). Luxurious camps and world class guiding are some of the other aspects that make this destination so famed. Lion,

OPPOSITE Fighting Zebras.

NOTABLE SPECIES

Lion
Leopard
Cheetah
Hippopotamus
African Elephant
Cape Buffalo
Red Lechwe
Tsessebe
Sitatunga
Sable Antelope
Burchell's Zebra
African Wild Dog
Nile Crocodile

WHEN TO GO

The delta is in flood between June and August, which is Botswana's dry season and is the coldest time of year (cool nights, but sunny days with cloudless skies). It is a popular time to visit because of the high density of game and the opportunity to undertake boating activities on the waterways.

From September to October, the temperatures start to rise and afternoon thunderstorms become more commonplace.

The water-level in the flooded delta starts to drop, but it is still an enjoyable time to visit and it is often referred to as 'green season'.

TIPS

Try to get a window seat on the flight into the delta; from the air you can really appreciate the sheer size and geography of the impressive Okavango Delta.

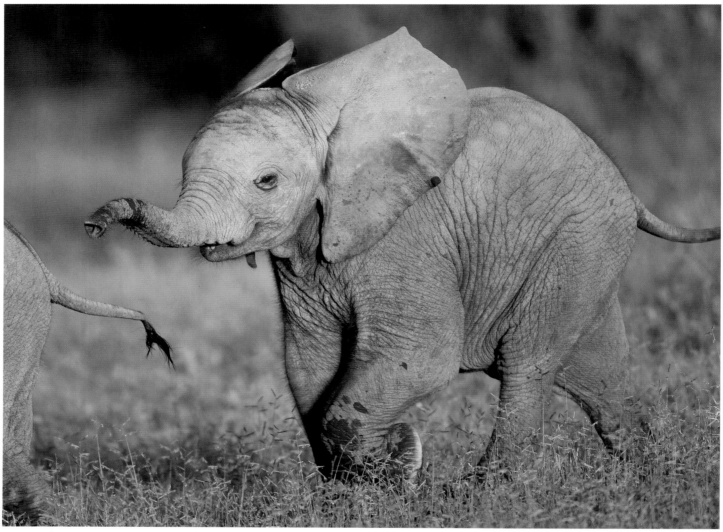

ABOVE Baby African Elephant.

Leopard, Cheetah, African Wild Dog, Cape Buffalo, African Elephant, Hippopotamus, Red Lechwe, Tsessebe, Sitatunga, Nile Crocodile and abundant birdlife are all here.

The Red Lechwe antelope is adapted to live in marshy, waterlogged areas. They have long hind-legs, elongated hooves and a water-repellent substance on their legs which enables them to run at speed and for long distances through water. They are a common sight in the delta.

The Sitatunga is another marsh-dwelling antelope with a water-resistant, shaggy coat and long, splayed hooves which can give them a clumsy gait on dry land, but mean that they can move gracefully through muddy swamps. They can be found throughout central Africa but they are usually a very elusive creature. The delta is one of the best places to catch a glimpse of this unique antelope.

ABOVE CLOCKWISE FROM TOP LEFT Red Lechwe; Hippopotamus at dusk; young Burchell's Zebra; Sitatunga mother and calf.

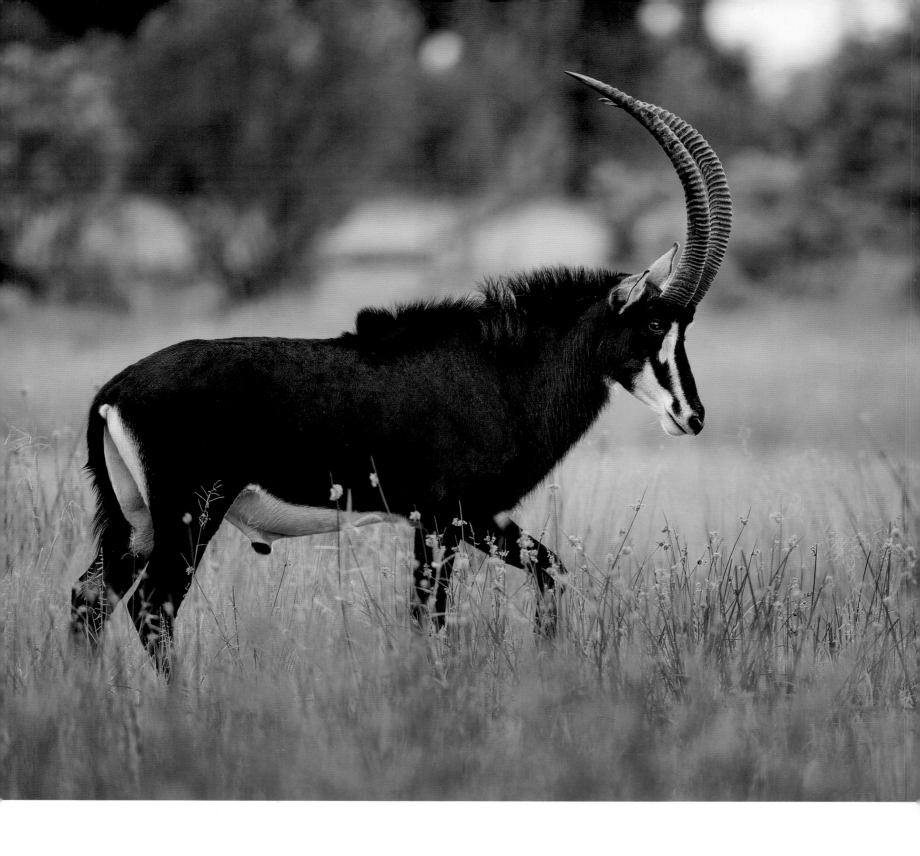

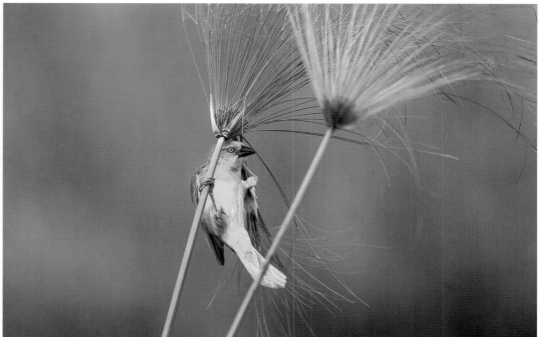
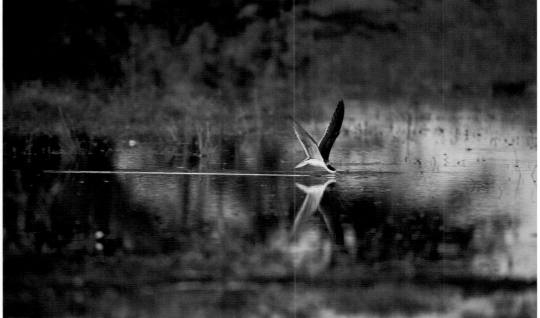

CLOCKWISE FROM LEFT Male Sable Antelope; Golden Weaver; African Skimmer.

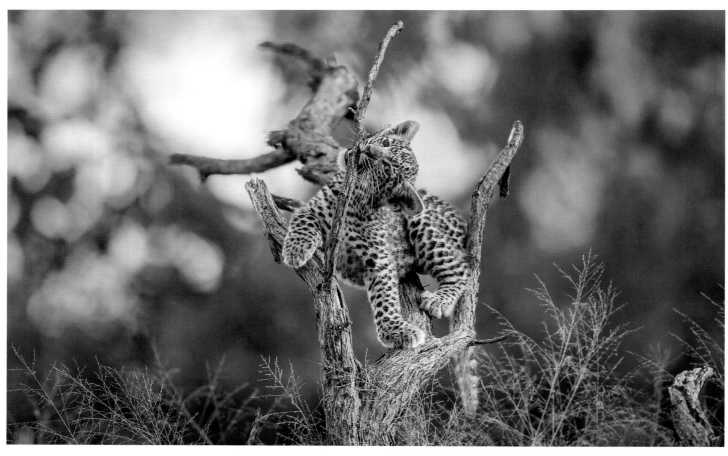

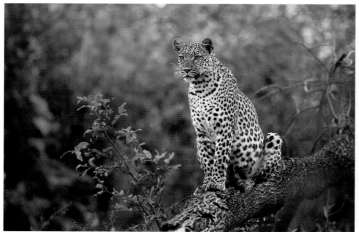

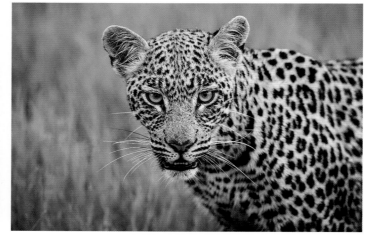

ABOVE Leopards, including Leopard cub playing in a tree.

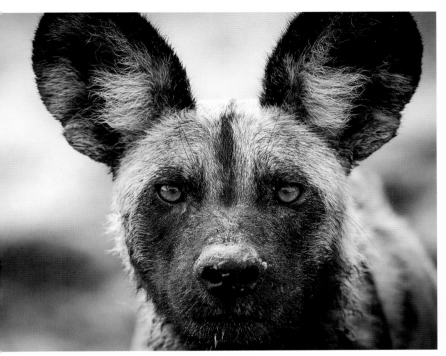

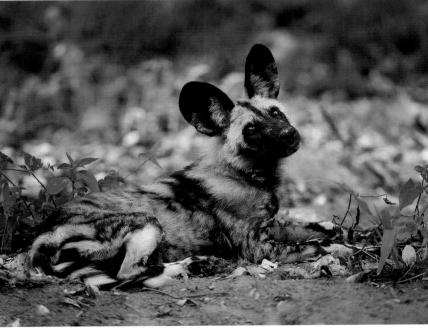

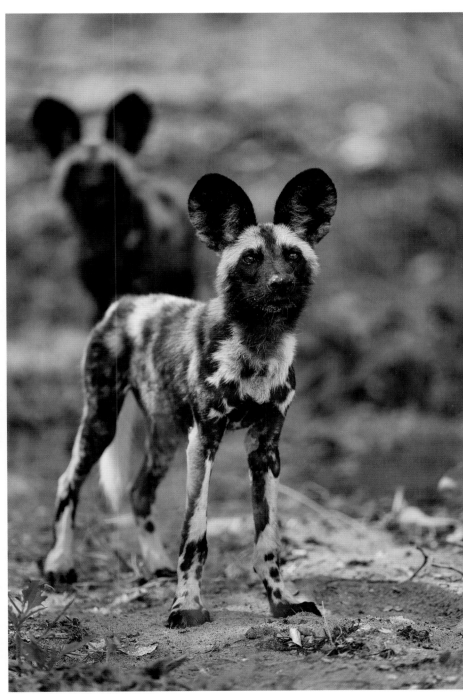

 ABOVE African Wild Dogs.

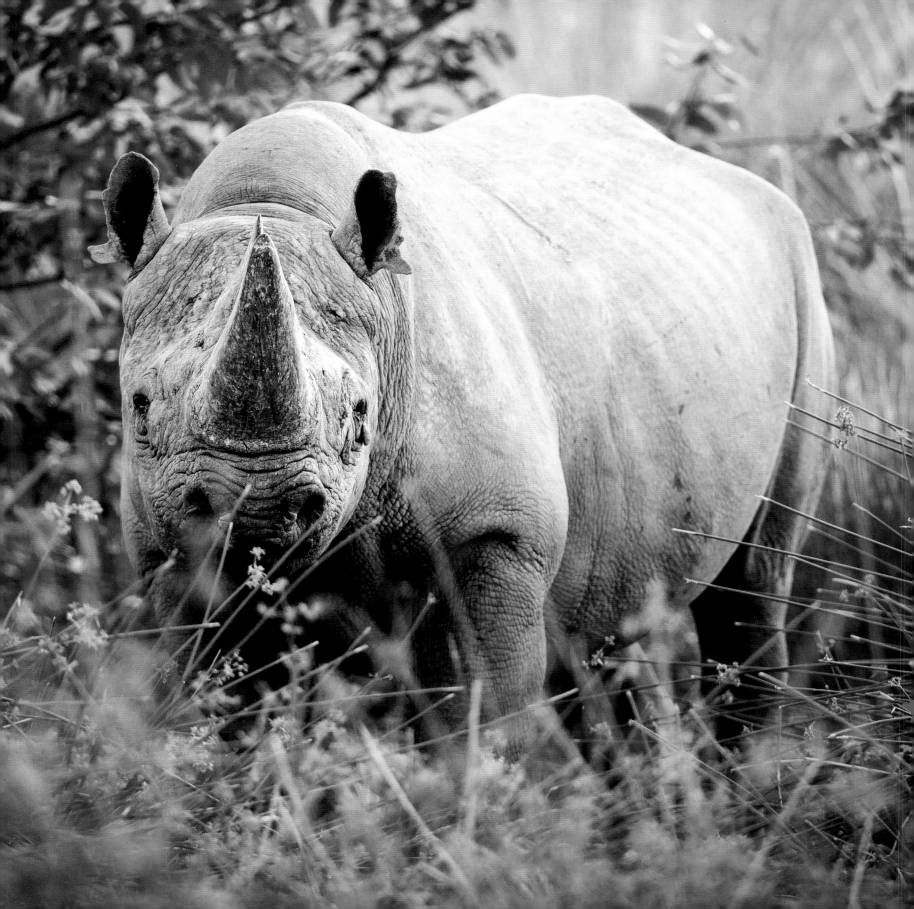

NAMIBIA: PALMWAG CONCESSION, KUNENE REGION

"We followed behind the tracker quietly in single file over the uneven, parched ground. Every now and then, he pointed out seemingly imperceptible spoor on the ground to show us evidence that we were following in a rhino's footsteps. Then, we heard rustling behind the dry vegetation ahead and saw a large, dark outline. The tracker hurriedly moved us to the left, to ensure the rhino didn't catch our scent on the faint breeze. We stood in awe, watching this quiet and calm giant go about his morning business."

THE PALMWAG CONCESSION is a conservation area in the Kunene region of north-west Namibia, covering over 5,000 sq km (1,930 sq miles) and stretching up from northern Damaraland between the Skeleton Coast to the west and rolling hills of the escarpment to the east, beyond which lies Etosha National Park. The semi-desert region has a rugged landscape, very few landmarks and little signage on tracks, turning it into a true, remote wilderness. The Kunene region is the only desert area in the world that supports the full complement of mega-herbivores and large carnivores such as the desert-adapted African Elephant, Lion, Cheetah, Leopard and Brown Hyena. It is also home to healthy populations of Giraffe, Mountain Zebra, Springbok, Gemsbok and kudu. However, the area is most famed for supporting the largest free-roaming (i.e. not within a national park) population of Black Rhinoceros in the world.

The Kunene region is home to the Save The Rhino Trust, with one of its operational bases located in Palmwag. The trust was established in the early 1980s following a huge decline in the rhino population of the region due to a sudden rise in poaching in the country. The trust set about trying to protect the remaining rhinos as well as offering protection to the other wildlife of the area. Their approach was to involve members of the local community, including ex-poachers, who had excellent knowledge of the area and the wildlife. Although poaching is an ongoing problem, the trust has so far been successful in protecting the rhinos and their presence continues to benefit local communities through conservation and tourism.

OPPOSITE Black Rhinoceros.

NOTABLE SPECIES
Desert-adapted Black
 Rhinoceros
Desert Lion
Mountain Zebra
Gemsbok
Brown Hyena

WHEN TO GO
A year-round destination.

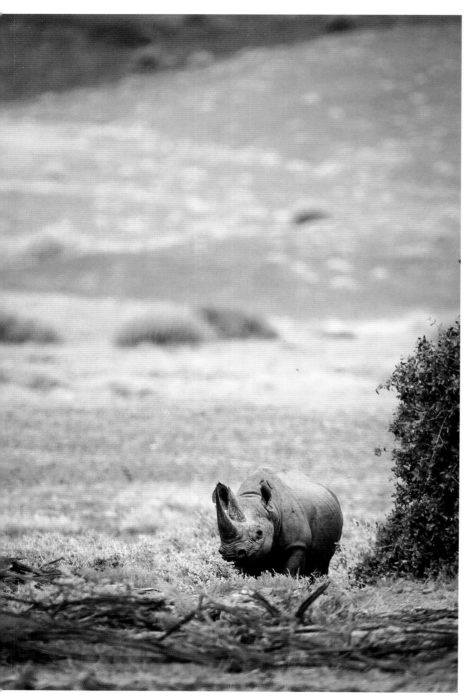

Black Rhinoceros.

Black Rhinoceroses are in fact grey in colour, as is the White Rhinoceros. The difference between the two is actually in their lip-shape, owing to the differences in their feeding habits. Black Rhinos browse trees, shrubs and other plants and have a pointed lip for the task, whereas White Rhinos graze on grass and have squared lips. Black Rhinos have two horns, with the front one being the larger and more prominent. Their distinctive and magnificent horns are sadly what makes them so appealing to poachers. Despite the fact that their horns are made of keratin, which is what our own hair and fingernails are made of, it fetches a high price on the black market for its imagined medicinal qualities.

The Black Rhinos in Namibia are a desert-adapted subspecies with larger footprints, smoother skin and more agility in mountainous terrain than other Black Rhino subspecies. Living in the desert means that food is more scarce and, as a result, these rhinos have large home ranges of up to 600 sq km (230 sq miles). They spend so much time seeking out food that they only have time to drink every three days or so. They are solitary animals, except for rhino calves and their mothers, who will spend over two years together before the calf is weaned. During these two years, the calf will learn the whereabouts of water sources and various plants upon which to feed.

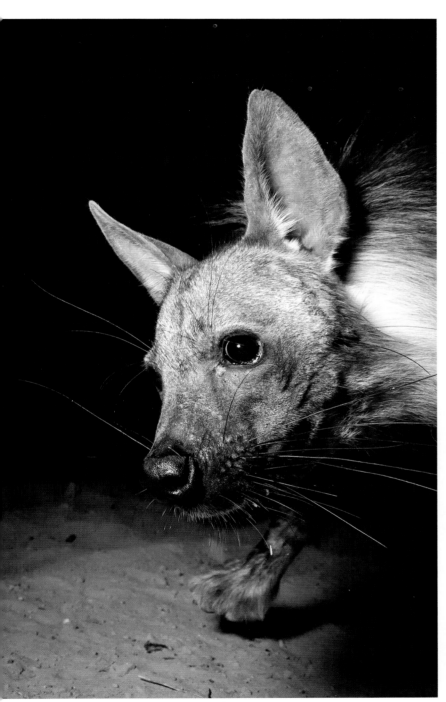

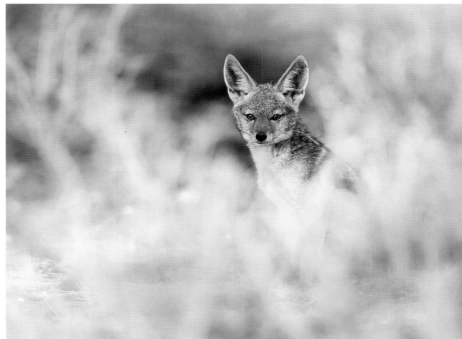

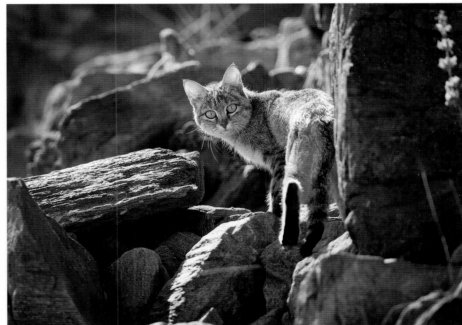

ABOVE CLOCKWISE FROM LEFT Brown Hyena, photographed with a camera trap; Black-backed Jackal; African Wild Cat.

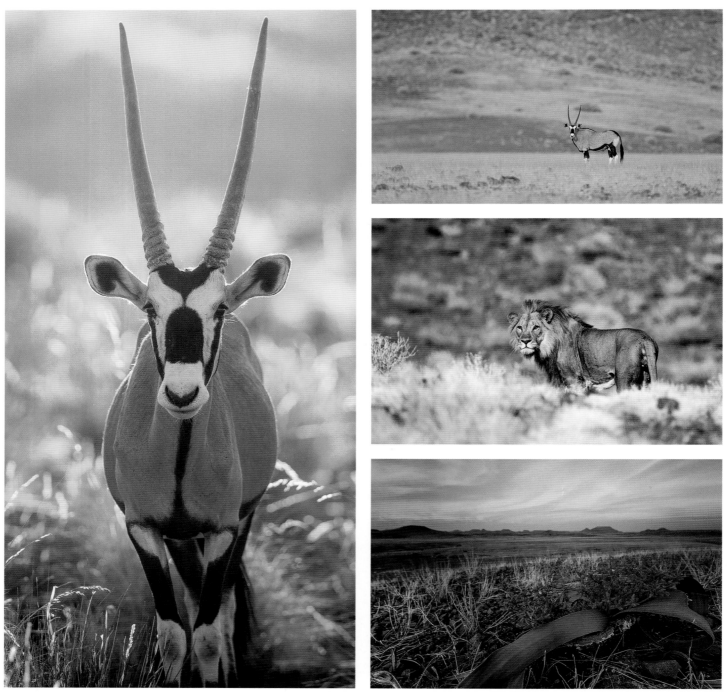

ABOVE CLOCKWISE FROM LEFT Gemsbok; Gemsbok; Desert Lion; the Palmwag Concession.

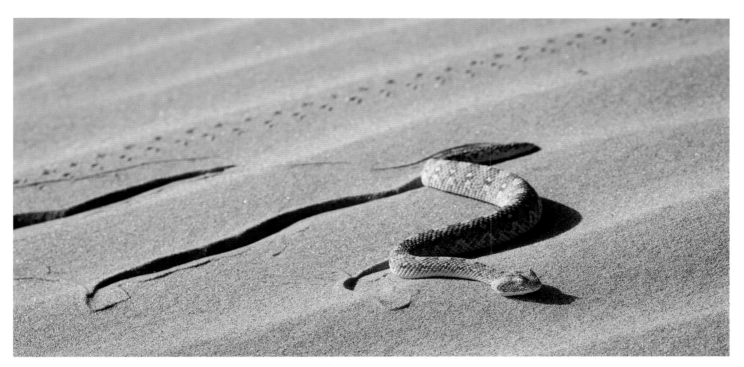

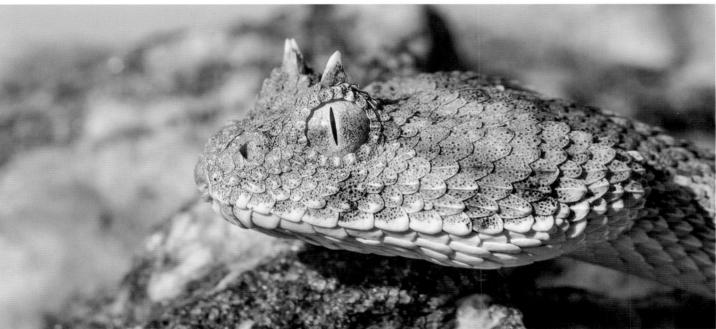

ABOVE Horned Adder. Its 'sidewinding' method of locomotion is an adaptation to the desert environment that allows it to move easily over loose sand.

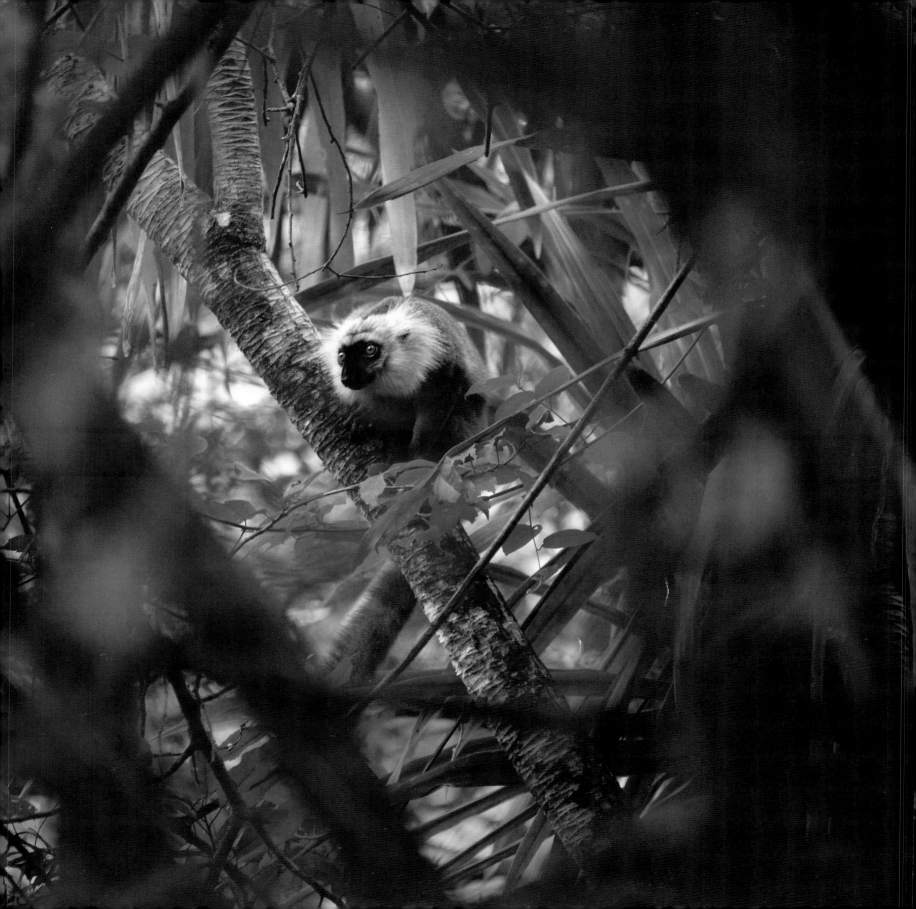

MADAGASCAR: AMBER MOUNTAIN NATIONAL PARK

"Of all of the wondrous creatures that I had encountered in Madagascar, perhaps this was the most remarkable. My guide was pointing to a mossy tree-trunk and peering back at us was a pair of eyeballs. As I studied further, gradually the form of the leaf-tailed gecko pressed flat against the bark became apparent."

THE ISLAND OF MADAGASCAR split away from mainland Africa around 160 million years ago and has stood completely alone for over 80 million years. This isolation created a place where animals could evolve in wonderful ways in order to fill different ecological niches. Today, the unique animals of Madagascar have become well-known around the world and have found international fame in a blockbuster animated film.

Madagascar's animals bear little resemblance to the animals of mainland Africa, with no herds of grazing animals, no big carnivores, and no great apes or monkeys. However, that doesn't mean that Madagascar is lacking in biodiversity. It is home to 5 per cent of the world's plant and animal species, of which more than 80 per cent are endemic. It is a must-visit destination for any wildlife aficionado. However, Madagascar's unique and fragile ecosystems face increasing threats due to habitat loss and deforestation.

Amber Mountain National Park is one of the most biologically diverse places in Madagascar with some 75 species of birds, 25 species of mammals and 59 species of reptiles. It was the first national park on the island, created in 1958. Located in the north of Madagascar, it covers 185 sq km (115 sq miles) of tropical forest within which visitors will find fascinating endemic flora and fauna, as well as scenic waterfalls and lakes. At altitudes between 800–1,470m (2,625–4,825ft), the park has a pleasant, cooler climate than the country's lower lying areas. It receives more rainfall than the areas surrounding the park, creating a lush oasis of rainforest. The three main habitats of the park are montane rainforest, mid-altitude rainforest and dry deciduous forest. These habitats are home to a large proportion of the quintessential wildlife of Madagascar, including numerous lemur species, Ring-tailed Mongoose, leaf-tailed geckos and the tiny Amber Mountain Leaf Chameleon.

OPPOSITE Male Sanford's Brown Lemur.

NOTABLE SPECIES
Crowned Lemur
Sanford's Brown Lemur
Lesser Bamboo Lemur
Ring-tailed Mongoose
Fossa
Leaf-tailed geckos
Amber Mountain Leaf
 Chameleon

WHEN TO GO
The best time to visit is between September and November when the weather is warm and drier, making the animals more active.

TIPS
Although it is the only park in Madagascar that can be visited without an accompanying nature guide, it could be worth hiring a guide. Some of the wildlife can be nearly impossible to spot by untrained eyes, especially minuscule chameleons and highly camouflaged leaf-tailed geckos.

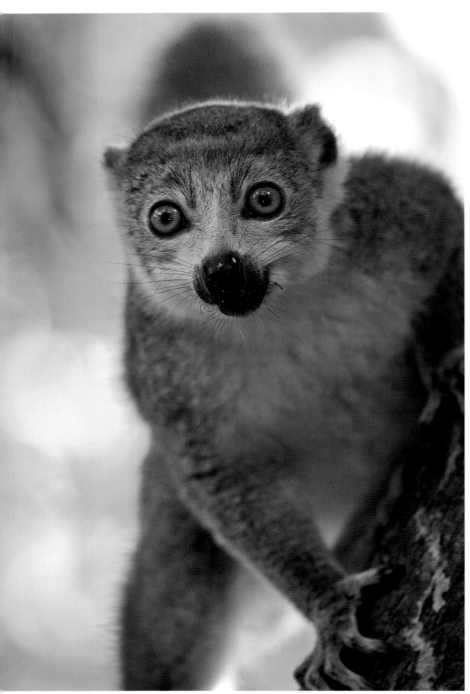

Female Crowned Lemur.

Madagascar's most famous family of animal is the lemurs. From an evolutionary perspective, lemurs are an 'older' primate than monkeys, known as prosimians (meaning 'pre-monkey'). They are from the same suborder as bushbabies, pottos and lorises. The first lemur-like, early primate fossils date to around 60 million years ago from mainland Africa. Madagascar had already broken away from the mainland by this point, and it is thought that the lemur-like ancestors reached Madagascar by surviving on floating rafts of vegetation. Monkeys only appeared around 20 million years ago and never made the journey to Madagascar. Monkeys are more intelligent than lemurs and more adaptive, therefore on mainland Africa they slowly drove the lemurs' ancestors to extinction (save for the bushbaby and potto, which found nocturnal, solitary lives eating insects and therefore avoided competing with monkeys). On Madagascar, without competition or predators, lemurs survived and evolved to fill a wide variety of ecological niches. There are close to 100 recognised species of lemur and despite all coming from a handful of original prosimian ancestors, they have diversified impressively. This is demonstrated by their varying size, with the smallest lemur (the Mouse Lemur) weighing a mere 30g (1oz), whereas the Indri weighs 9.5kg (21lb).

As well as having unique mammals, Madagascar is also teeming with fascinating reptiles. Amber Mountain National Park, with its warm, tropical climate, is one of the best places for spotting the wide range of different reptiles. Various species of endemic leaf-tailed geckos live in trees and have tails that look like an old, decaying leaves. The leaf-tail and mottled brown colouring helps the geckos to blend perfectly into their surroundings. They are nocturnal reptiles which feed on insects. As well as the leaf camouflage, the gecko also manages to avoid predators by flattening its body to reduce any shadow. The geckos are under threat from habitat loss and the illegal pet trade.

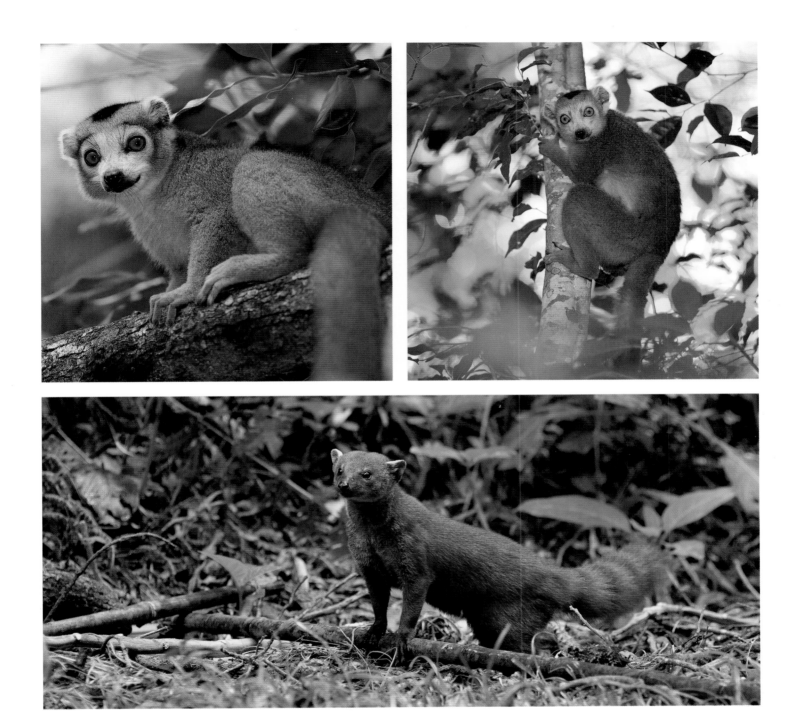

TOP Male Crowned Lemur.
ABOVE Ring-tailed Mongoose.

ABOVE FROM TOP TO BOTTOM Waterfall in Amber Mountain National Park; the Amber Mountain Rock Thrush is endemic to this region.

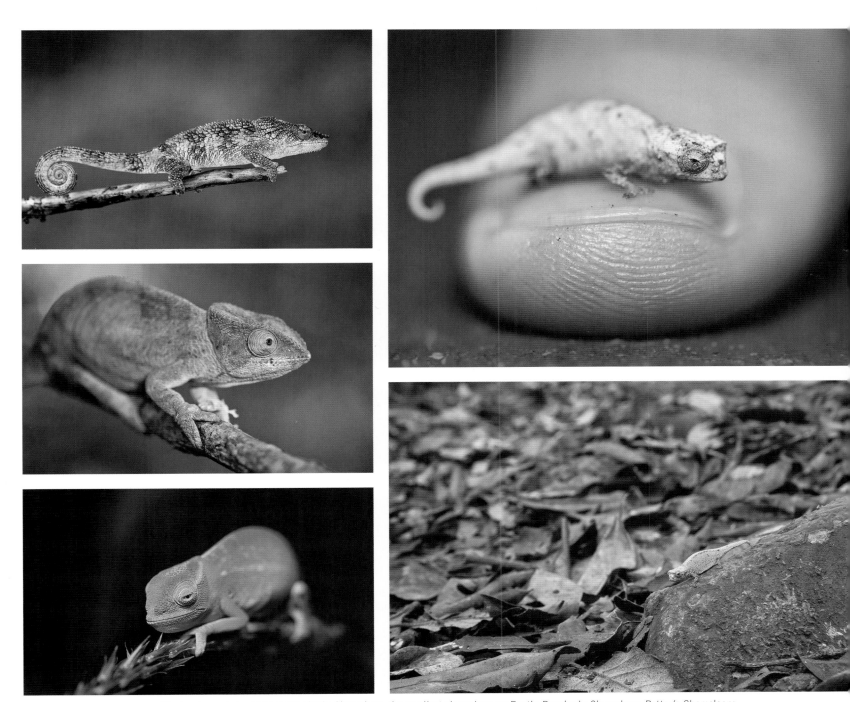

ABOVE CLOCKWISE FROM TOP LEFT Elephant-eared chameleon; Brookesia Chameleon, the smallest chameleon on Earth; Brookesia Chameleon; Petter's Chameleon; Amber Mountain Leaf Chameleon.

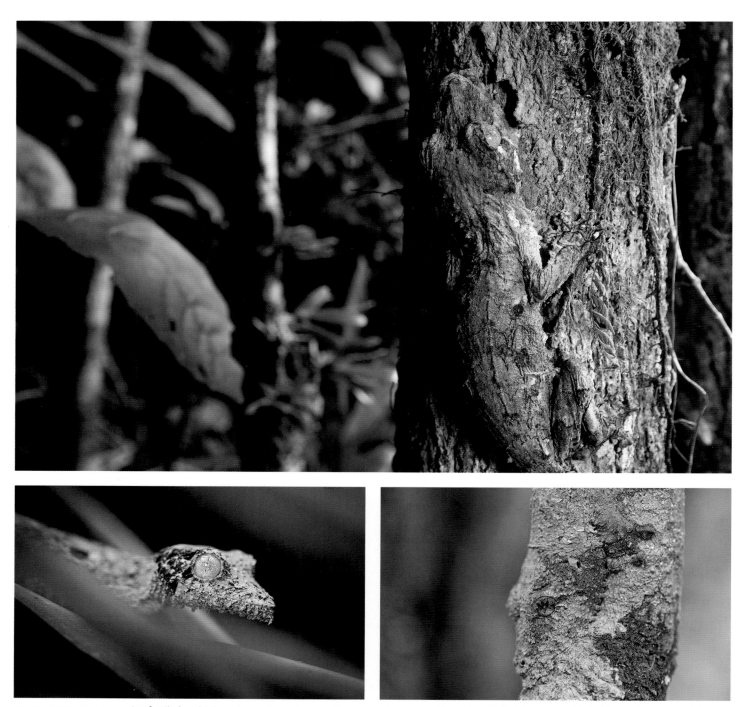

ABOVE CLOCKWISE FROM TOP Leaf-tailed gecko (*Uroplatus sikorae*) camouflaged on a tree; camouflaged Leaf-tailed Gecko; Leaf-tailed Gecko hunting at night.

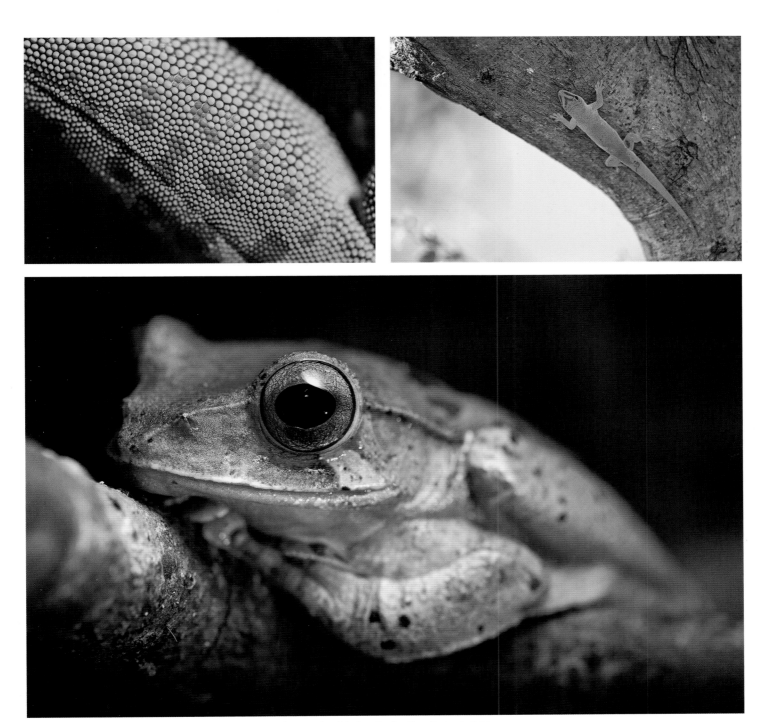

ABOVE CLOCKWISE FROM TOP LEFT Day Gecko (*Phelsuma madagascariensis*); Day Gecko; Tree Frog at night.

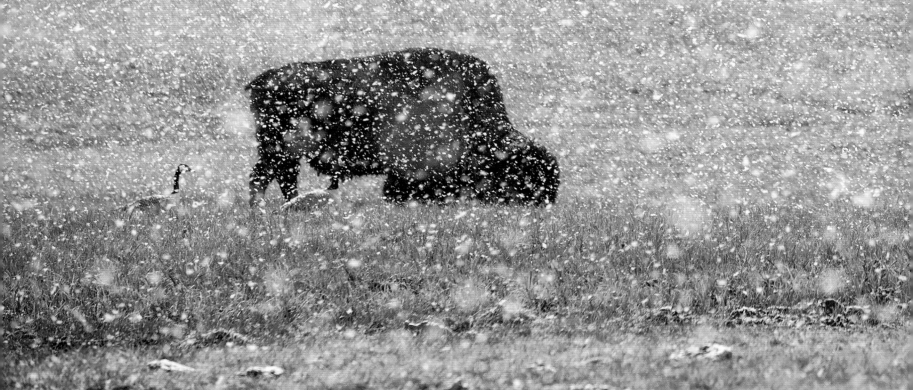

AMERICAS

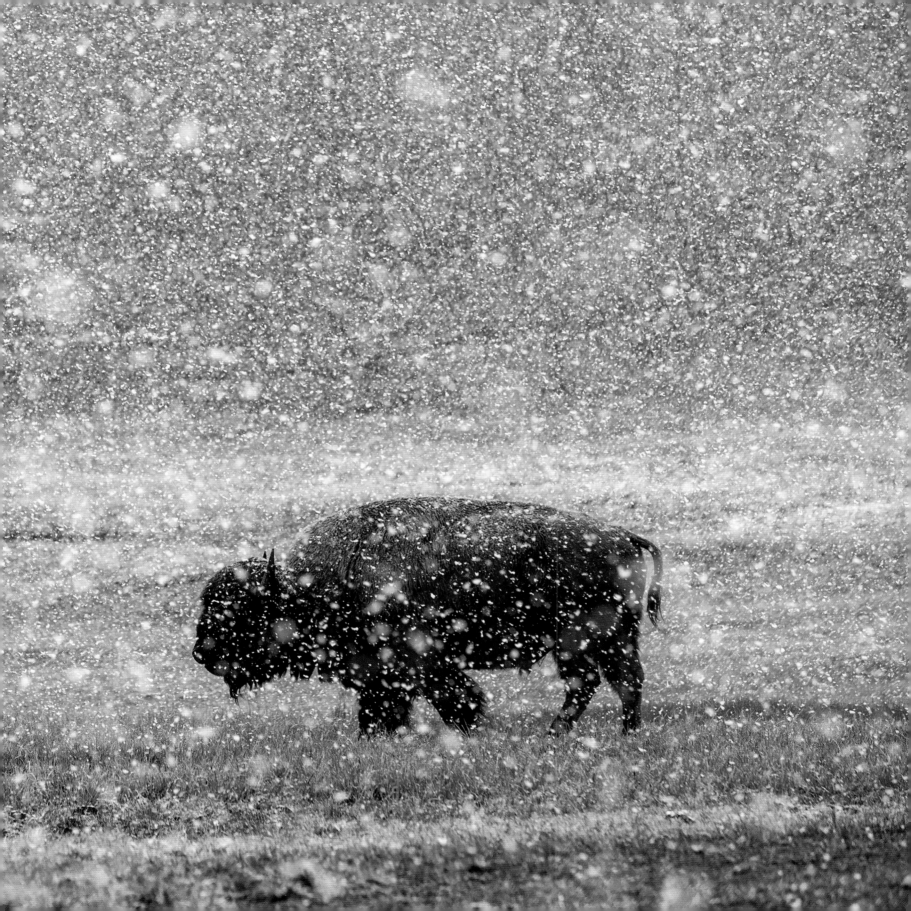

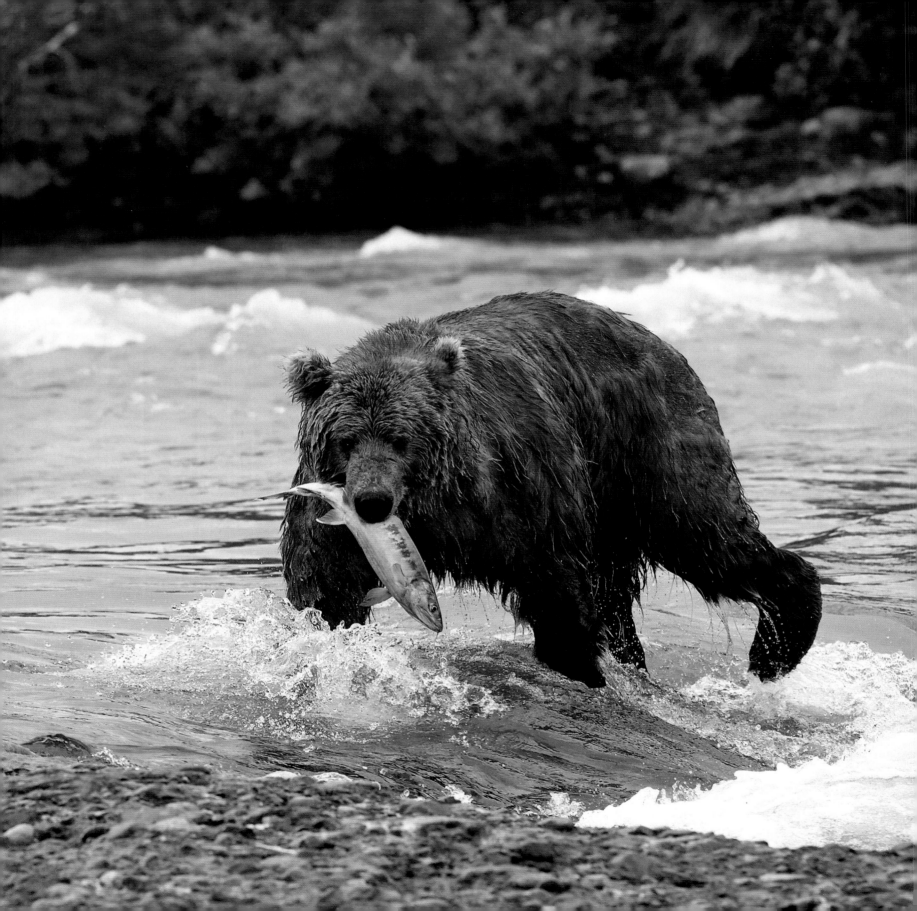

USA: KATMAI NATIONAL PARK, ALASKA

"To the lover of pure wilderness Alaska is one of the most wonderful countries in the world."

– John Muir from *Travels in Alaska* [1915]

KATMAI NATIONAL PARK AND PRESERVE in southern Alaska covers over 16,500 sq km (6,370 sq miles) of wilderness on the Pacific Ocean side of the Alaska Peninsula. As national parks go, it has it all, with stunning mountainous scenery, 15 volcanoes (some of which are active) and abundant wildlife.

In 1912, Novarupta Volcano erupted violently with a force ten times greater than the 1980 Mount St Helen's eruption. The eruption and subsequent earthquakes shaped the landscape in the area within today's Katmai National Park and Preserve's boundaries, leaving behind ash-covered mountains and a cracked valley floor with escaping smoke, steam and gases, which was aptly named 'The Valley of Ten Thousand Smokes'. The resulting ash and pumice cloud was so vast, blocking out so much sunlight, that it lowered average temperatures in the Northern Hemisphere by 2°C that summer. The area was turned into a national monument in 1918 and became a national park in 1980.

Today, the valley floor no longer steams as it did in the early 20th century, but the park has other natural marvels to draw in visitors. Katmai has over 2,000 Brown Bears and each summer dozens gather to feast on Sock-eye Salmon during the annual salmon run. Sock-eye Salmon spawn once in their lifetime. After spending two to three years living in the northern Pacific Ocean, mature salmon make an incredible journey navigating from the ocean, up rivers and lakes, to return and lay eggs in the same freshwater gravel bed where they hatched. The newly hatched baby salmon live under the gravel before growing into small fry. After a year or so, the fry make the journey to the ocean. On reaching the river mouth, they undergo a remarkable transformation that allows them to survive in salt water

OPPOSITE Brown Bear fishing.

NOTABLE SPECIES

Alaskan Brown Bear
Sock-eye Salmon
Bald Eagle
Moose
American Beaver
American Marten
Grey Wolf

WHEN TO GO

Although it is the busiest time, it is with good reason, because June to July is when the salmon run creates a feeding frenzy for the Brown Bears.

TIPS

Read about bear safety.

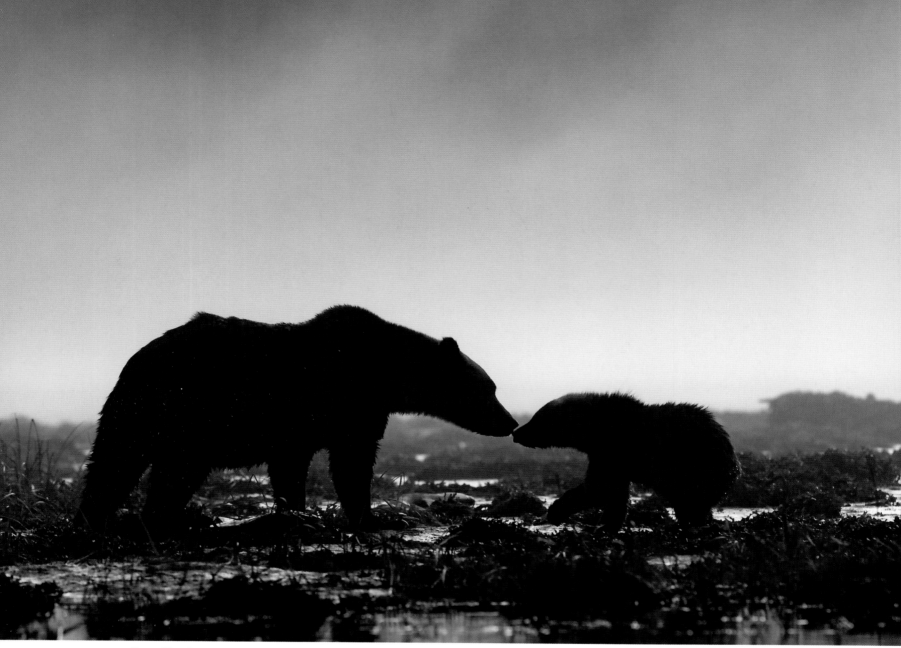

ABOVE Bear with cub.
OPPOSITE CLOCKWISE FROM TOP Brown Bears playing; Brown Bear; Brown Bear with salmon.

and live in the ocean until the time comes to complete the cycle and return home to spawn. This mass migration of salmon from Bristol Bay into the freshwater of the Naknek system begins in June, with over a million salmon having moved into the Brooks River area by the end of July. The Brown Bears, alongside other predators such as the Bald Eagle, enjoy feasting on the salmon at this time. Visitors come from far and wide to watch this spectacle. A second wave occurs in August and September when the mature salmon which have spawned begin to die, becoming easy prey for the bears.

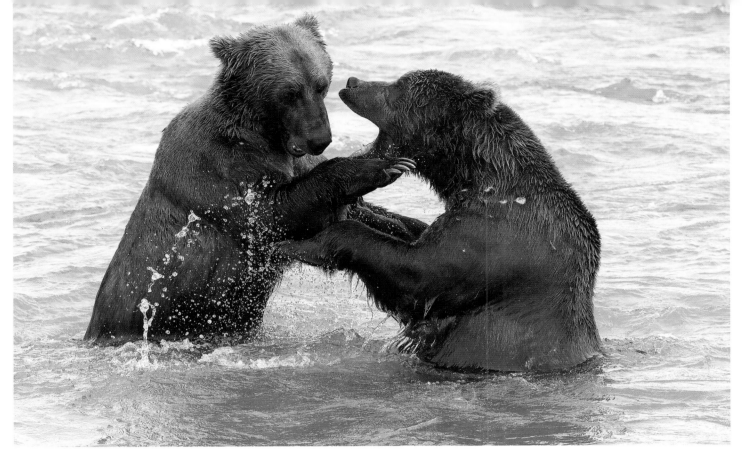

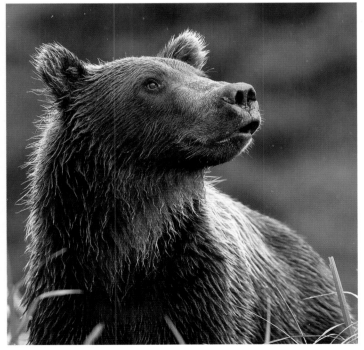

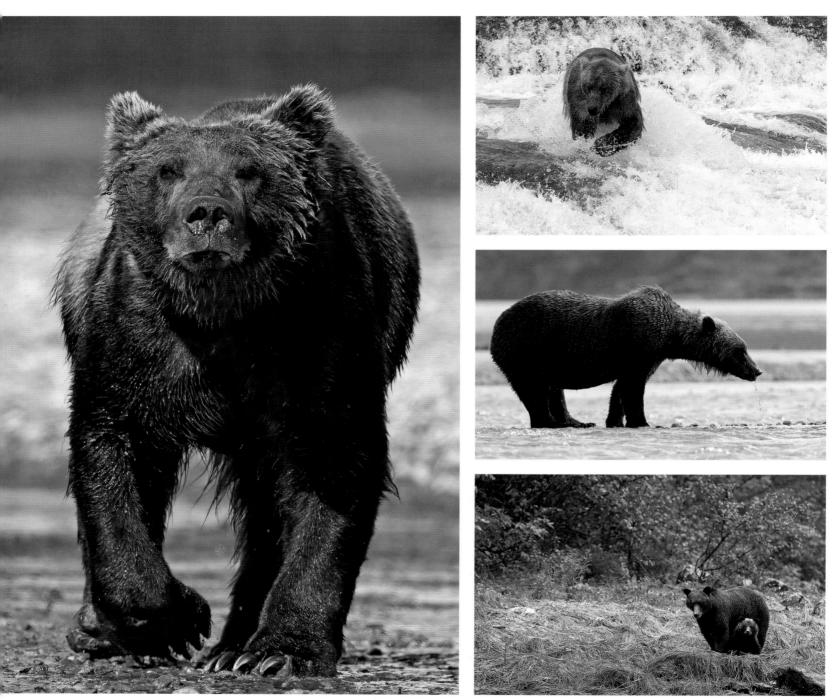

ABOVE CLOCKWISE FROM LEFT Brown Bear; Brown Bear fishing; Brown Bear; Brown Bear with cub.

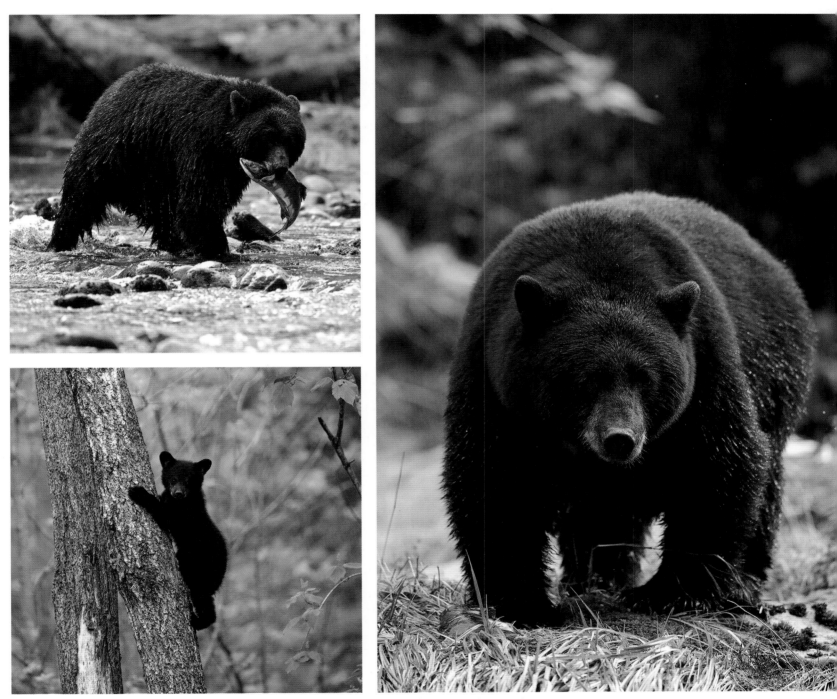

ABOVE CLOCKWISE FROM TOP LEFT American Black Bear with salmon; American Black Bear; American Black Bear cub.

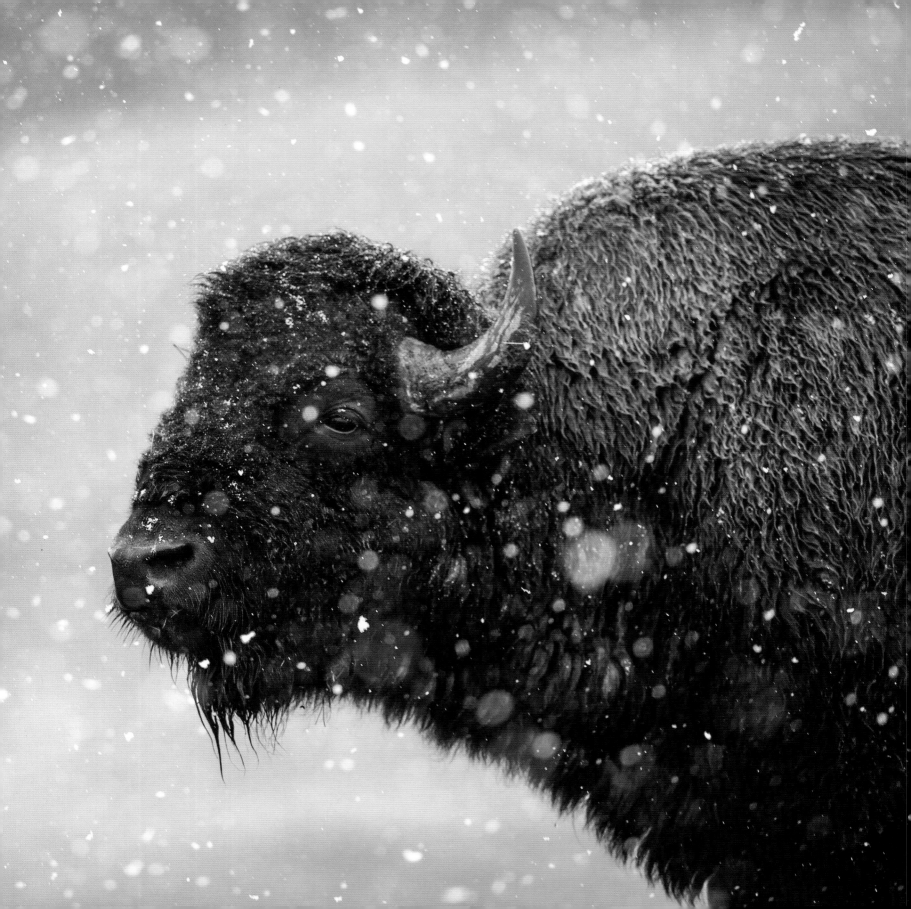

USA: YELLOWSTONE AND GRAND TETON NATIONAL PARKS

"It is a big, wholesome wilderness on the broad summit of the Rocky Mountains, favoured with abundance of rain and snow… a place of fountains where the greatest of the American rivers take their rise."

— John Muir from *Our National Parks* [1901]

YELLOWSTONE NATIONAL PARK, established in 1872, is the oldest national park in the world. The majority of the 8,983 sq km (3,468 sq miles) of the park is located in Wyoming, with a small area extending into Idaho and Montana. Just 16km (10 miles) south of Yellowstone National Park are the jagged peaks of the 64km (40 mile) long Teton Range within Grand Teton National Park, also located within Wyoming. These two parks showcase some of America's most spectacular wildlife and natural treasures. Geothermal wonders, magnificent lakes, precipitous peaks and animals such as bears, American Bison, Moose, Elk, American Beaver, Bald Eagle and Grey Wolf entice visitors from far and wide.

Yellowstone is situated atop a slumbering supervolcano. This supervolcano has erupted three times in the last three million years. The last eruption 630,000 years ago was catastrophic, around 1,000 times bigger than the 1980 Mount St Helen's eruption. The land above the volcano collapsed leaving behind a huge caldera with dimensions of 55km by 80 km (34 miles by 50 miles), which now lies beneath Yellowstone Lake. Fast-moving pyroclastic flows containing volcanic gases, rock, glass and pumice covered thousands of square kilometres, destroying everything in their path. Geysers, hot springs, mud pools and fumaroles are littered around Yellowstone, providing evidence that volcanic activity persists today. However, 630,000 years is plenty of time for the decimated landscape to recover and today 80 per cent of the land area of the park is forested, providing ample habitat for the diverse fauna.

Neighbouring Grand Teton National Park is named after Grand Teton, the tallest mountain in the Teton range with an altitude of 4,199m (13,776ft). Nine other peaks within

OPPOSITE American Bison in snow.

NOTABLE SPECIES

Brown Bear	River Otter
American Black Bear	Yellow-bellied Marmot
American Bison	American Beaver
Grey Wolf	Bald Eagle
Canada Lynx	Golden Eagle
Moose	
Pronghorn	
Elk	

WHEN TO GO

The parks can be visited year round, with highlights in each season. However, spring and autumn visits will help to avoid the large crowds of summer and the harsh temperatures of winter.

TIPS

If you plan to go hiking, make sure you read about bear safety.

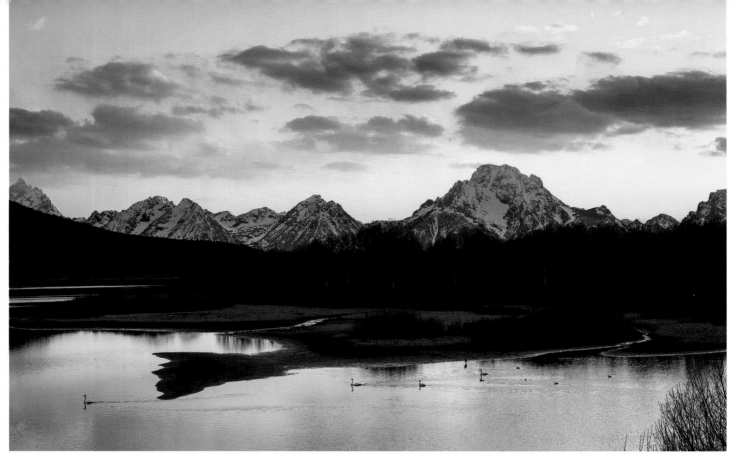

The Teton range.

the range rise above 3,700m (12,000ft). These peaks stand over 2,000m (6,560ft) above the valley floor, rising steeply to create a precipitous and imposing mountain landscape. Lakes, wetlands fed by the Snake River, mountain streams, forested areas, sage brush and aspen groves are among the varied habitats.

Grazing bison are a common sight in these two parks. American Bison are the heaviest land animals in North America, with some individuals weighing up to one ton, or over 900kg (1,985lb). They have dark, shaggy winter coats, and paler lightweight coats in the summer. Despite their large size, they are surprisingly fast, reaching a top speed between 50–60 km per hour (31–37 miles per hour). They are grazers, feeding mainly on the grasses, herbs and shrubs. These formidable creatures once covered the plains of North America in very large herds, but the effects of hunting throughout the 19th century, along with diseases introduced from domestic cattle, managed to push the

species to the brink of extinction. Numbers are fortunately recovering, but the distribution is limited to a few national parks and reserves, including Yellowstone and Grand Teton National Parks.

The population of Grey Wolves in Yellowstone National Park was eradicated in the 1920s due to loss of habitat and extermination programs. The park remained wolf-free until 1995 when 41 animals were reintroduced to the area. Today there are over 300 descendants of these 41 wolves living in the Greater Yellowstone area. The reintroduction served as a fascinating study for biologists, showing the impact of reintroducing a top predator on other fauna of the region as well as on the landscape itself. For example, the presence of wolves has kept Elk numbers in check and forced them to remain mobile around the park rather than staying in one area. This has had a positive effect on vegetation, enabling regeneration of flora such as willow trees, and in turn has had positive effects on the beaver population and bird numbers.

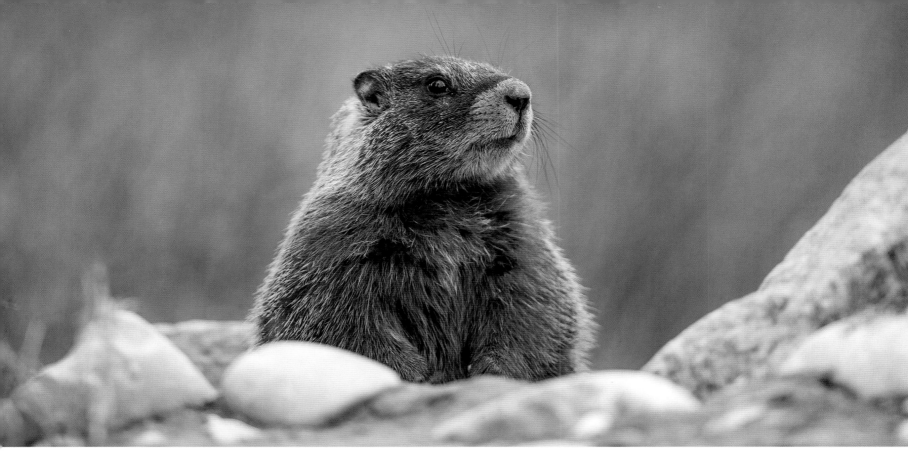

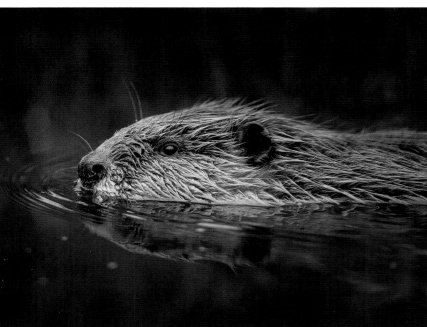

ABOVE CLOCKWISE FROM TOP Yellow-bellied Marmot; American Beaver; American Beaver.

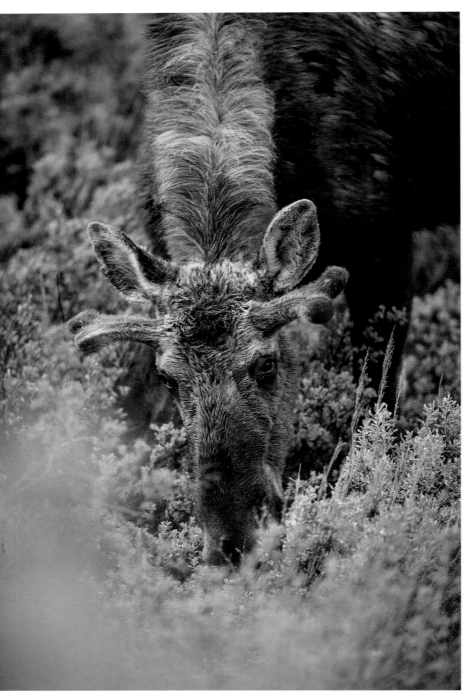

ABOVE LEFT TO RIGHT Moose; Brown Bear in the woods.

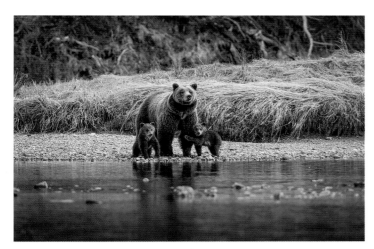

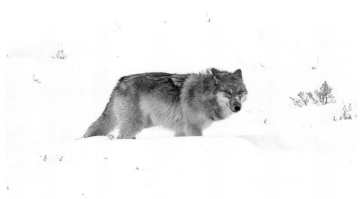

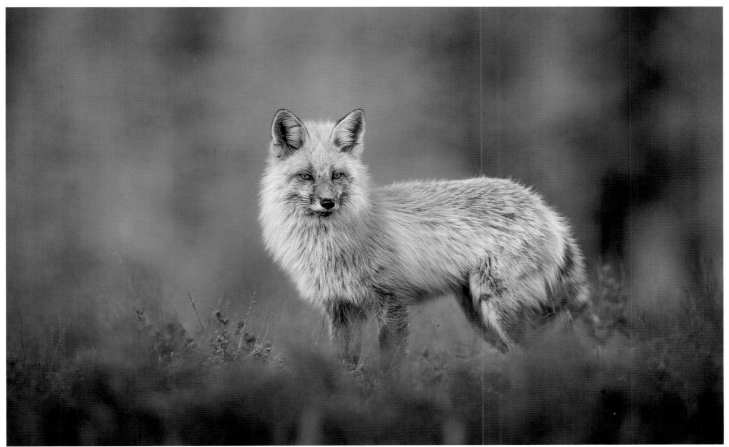

ABOVE CLOCKWISE FROM TOP LEFT Brown Bear with cubs; Grey Wolf; Red Fox.

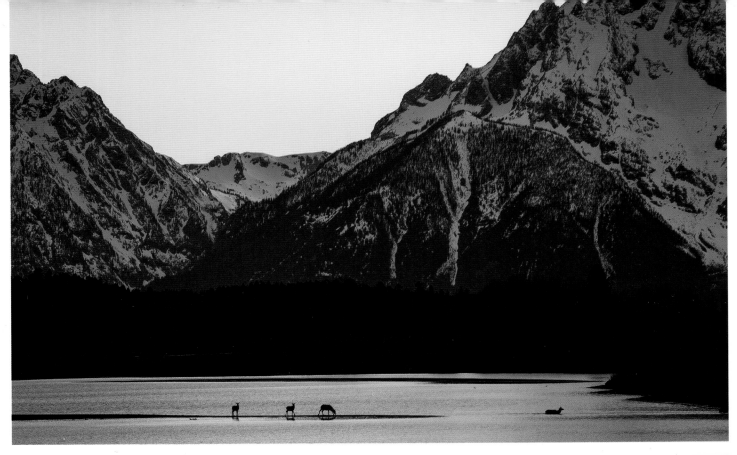

ABOVE TOP TO BOTTOM Elk at dusk in front of the Tetons; Osprey.
OPPOSITE Great Grey Owl.

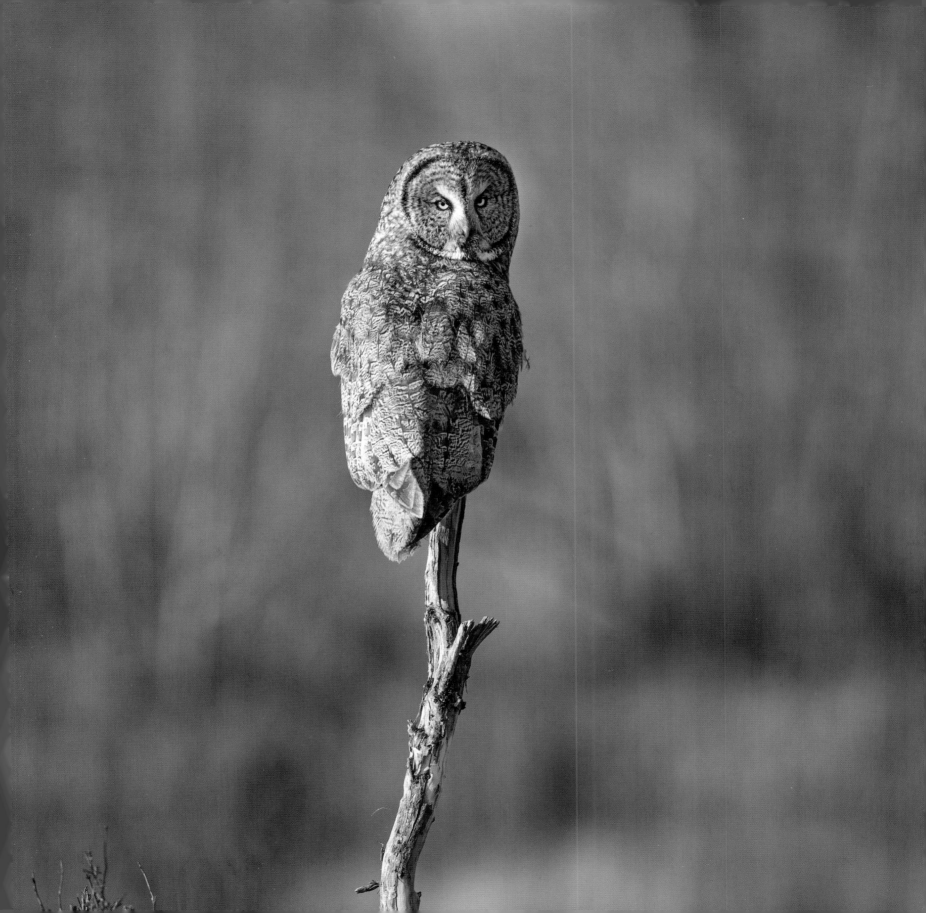

CAYMAN ISLANDS

"His blueness was the first thing that struck me as he stepped out from the foliage. He bobbed his head and looked quizzically at me with his striking red eyes. He was like no other reptile I had ever seen."

THE CAYMAN ISLANDS is made up of three islands in the western Caribbean Sea, to the south of Cuba and north-west of Jamaica. The three islands – Grand Cayman, Little Cayman and Cayman Brac – are the peaks of an underwater mountain range. They formed around 10 million years ago and over time have been populated by castaway flora and fauna. Today, as well as being popular with people seeking a tax haven or a beach holiday, they also have a lot to offer wildlife enthusiasts. There are 26 species of herpetofauna (amphibians and reptiles), most of which are endemic to the islands, including the famous Grand Cayman Blue Iguana. The islands are also an important wintering site for migratory birds and the underwater world is equally renowned for wildlife lovers.

Cayman Brac and Little Cayman are much smaller and wilder than Grand Cayman, with human populations of 2,000 and 150 respectively. Cayman Brac is home to the Cayman Brac Parrot (a subspecies of the Cuban Parrot) and impressive colonies of Brown Boobies and Magnificent Frigatebirds. Little Cayman has its own iguana, the Sister Isles Rock Iguana, as well 20,000 Red-footed Boobies and Hawksbill Turtle breeding sites.

The Grand Cayman Blue Iguana is an endemic endangered lizard that is only found on the island of Grand Cayman. They can grow to over 150cm (60in) in length and, true to their name, can be impressively blue. The iguanas can change from a greyish blue to a powder blue during mating season and in the presence of other iguanas to establish territory. The blue colour is more pronounced in male iguanas than females. As with many reptiles, they drag themselves along ungracefully and are lovely to watch as they go about their day munching on vegetation.

Even more impressive than their shade of blue is the fact that these iguanas have managed to pull themselves back

OPPOSITE Blue-throated Anole displaying.

NOTABLE SPECIES
Grand Cayman Blue Iguana
Sister Isles Rock Iguana
Brown Booby
Red-footed Booby
Grand Cayman Parrot
Cayman Brac Parrot

WHEN TO GO
December to April is peak season due to the more pleasant temperatures, lower rainfall and lower humidity.

TIPS
Be sure to include visits to Cayman Brac and Little Cayman in order to see the full range of wildlife.

ABOVE Sunset on Grand Cayman Island.
OPPOSITE Grand Cayman Blue Iguana.

from the very brink of extinction. In 2003, there were just 15 individuals left in the wild and they were deemed to be functionally extinct as no young iguanas were surviving to reproductive age in the wild. Domestic cats and dogs, feral rats and other introduced species, as well as habitat loss, were huge threats to the survival of the species. The iguanas evolved in a world without predatory mammals and therefore had no natural fear of man or other animals. In addition, their striking blue colour made them appealing in the illegal pet trade, further hastening their decline. Fortunately, the Blue Iguana Recovery Program stepped in and managed to prevent these animals from disappearing. A captive-breeding program along with efforts to protect iguana habitat have worked. The captive iguanas that were released into the wild bred successfully and the wild-born iguanas are also breeding. By 2012 the wild population had risen to 750 individuals, making this a true conservation success story.

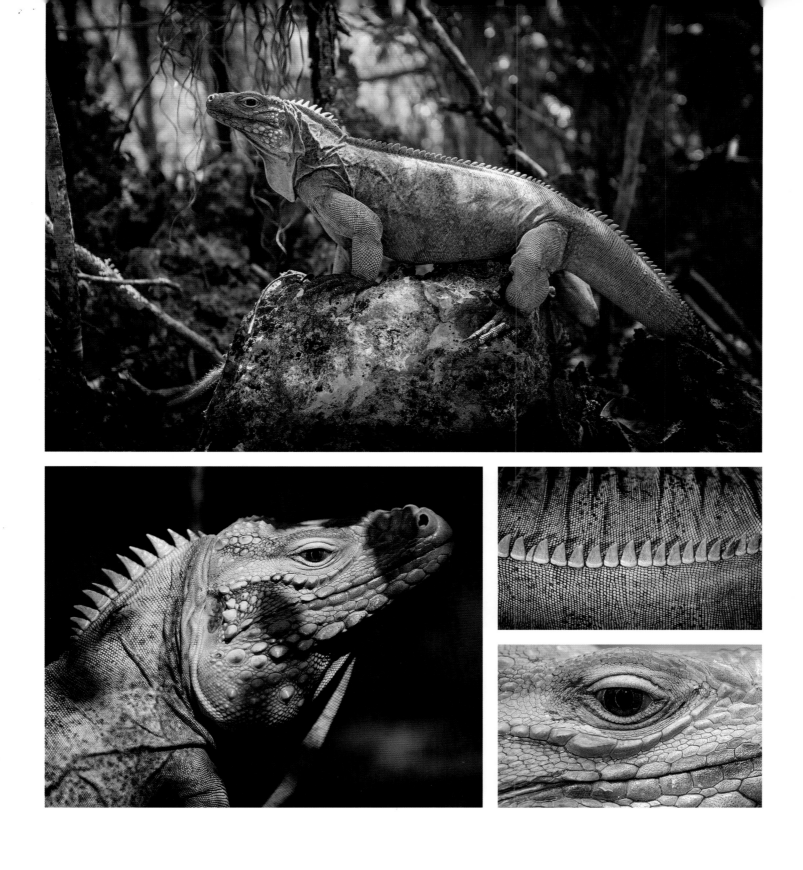

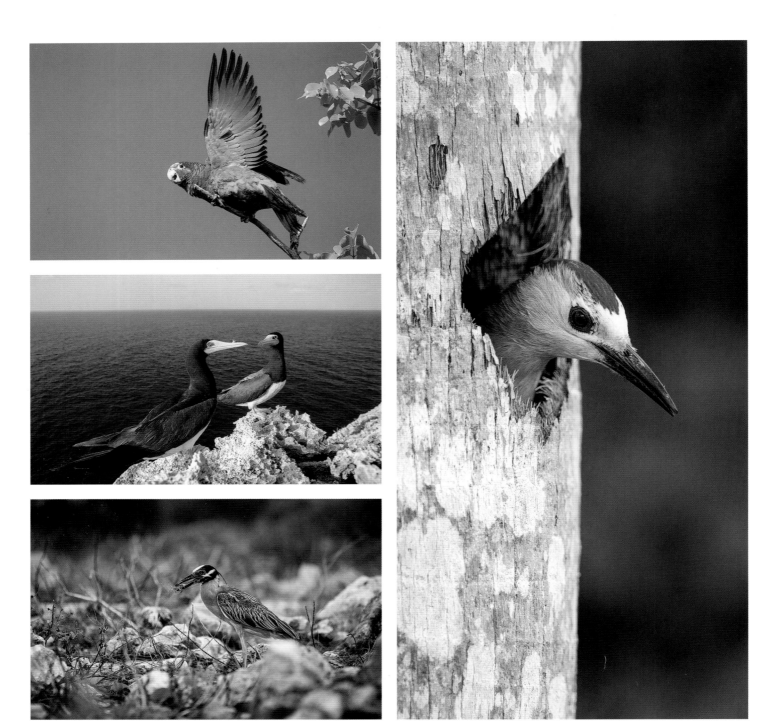

ABOVE CLOCKWISE FROM TOP LEFT A Grand Cayman Parrot taking flight; West Indian Woodpecker; Yellow-crowned Night Heron eating a crab; Brown Boobies.

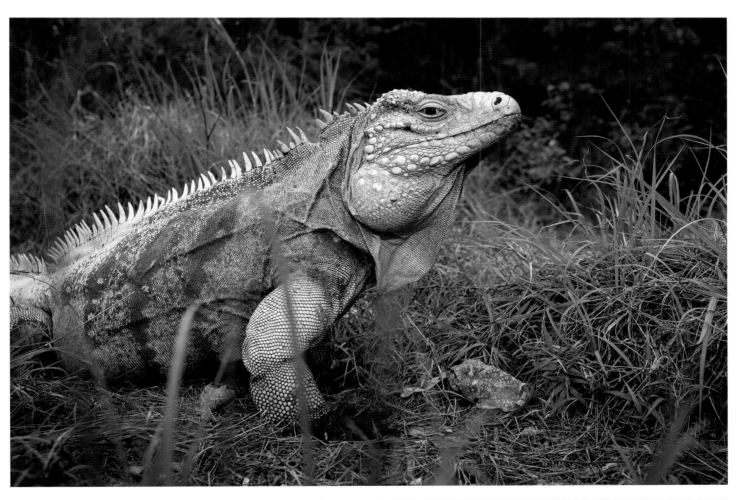

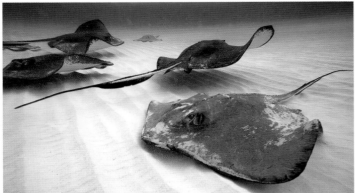

ABOVE CLOCKWISE FROM TOP LEFT Sister Isles Rock Iguana; Little Cayman Anole; Southern Stingrays.

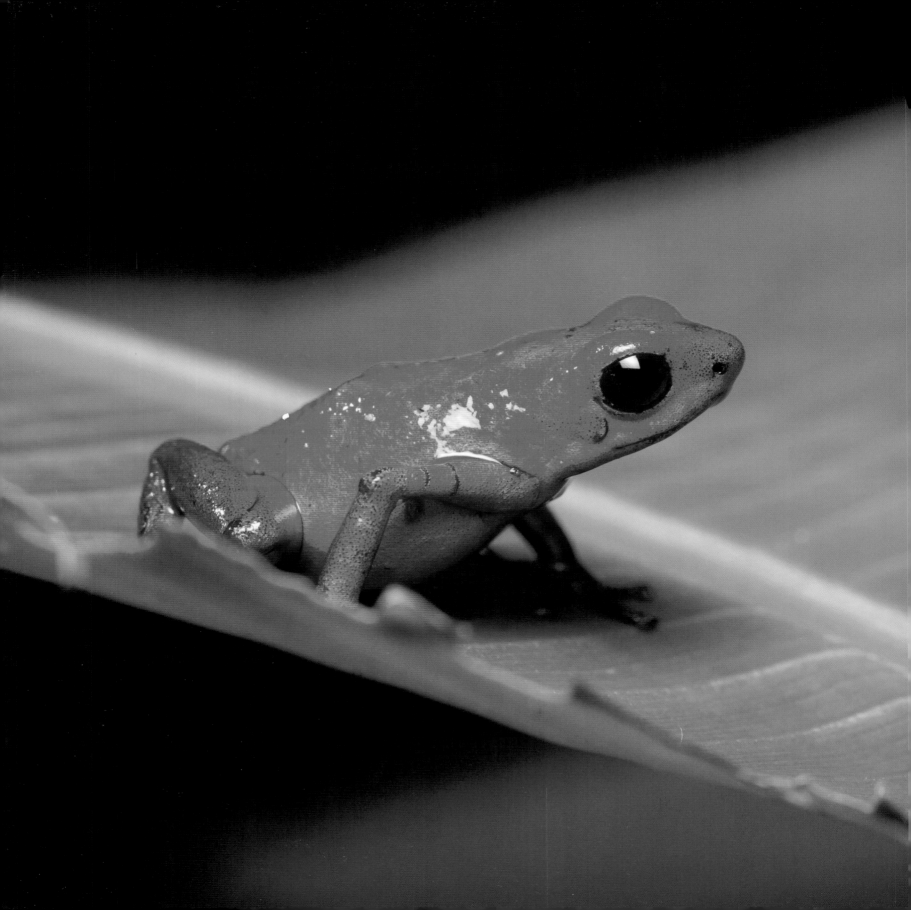

COSTA RICA: CORCOVADO NATIONAL PARK

"From the thick and steamy rainforest, I emerged onto the wildest stretch of beach I have ever seen. The dark sand, crashing waves and towering trees all added to this primitive paradise. Just then, a coati darted out of the thick vegetation onto the sand to chase scuttling moon crabs as Scarlet Macaws flew overhead."

CORCOVADO NATIONAL PARK is located on the Osa Peninsula in south-western Costa Rica. It covers a third of the peninsula and at 425 sq km (165 sq miles) is the largest national park in Costa Rica. There are at least 13 vegetation types in the park, including montane forest, mangrove swamps, primary and secondary tropical rainforest and low-altitude cloud forest. The park also has 50km (30 miles) of sandy coastline. These diverse habitats support an abundance of wildlife and the park has been famously labelled by *National Geographic* as "the most biologically intense place on earth."

Costa Rica is a popular destination for wildlife enthusiasts as there is nowhere else in the country that can offer the same broad experience as Corcovado, where you stand the chance to see all four native species of monkey in one outing, these being Central American Squirrel Monkey, White-faced Capuchin, Mantled Howler Monkey and Geoffrey's Spider Monkey. You are also likely to encounter species such as Baird's Tapir which are hard to spot elsewhere. Tracks of Jaguar on the sandy shore remind you that this park is one of the last Central American strongholds for these big cats. The park supports other smaller cats, including Ocelot and Margay, which are easier to spot than their larger cousins. Peccaries, sloths, coatis and anteaters are frequently sighted and the park has the largest population of Scarlet Macaws in the country as well as other abundant birdlife. Its rivers are home to crocodiles and caiman, and there have even been Bull Shark sightings in the mouth of the Rio Sirena.

As often occurs with me in the rainforest, I found myself spending a lot of time fascinated by the smaller creatures of the undergrowth including the numerous varieties of poison-dart frogs, tree frogs, beautiful and venomous snakes including the Fer-de-lance and the Eyelash Pit Viper, and invertebrates such as army ants, bullet ants and golden orb spiders.

OPPOSITE Strawberry Poison-dart Frog.

NOTABLE SPECIES
Baird's Tapir
Central American
 Squirrel Monkey
White-faced Capuchin
Mantled Howler
 Monkey
Geoffrey's Spider
 Monkey

White-nosed Coati
Silky Anteater
Northern Tamandua
Two-toed Sloth
Three-toed Sloth
Jaguar
Ocelot
Poison-dart frogs
Fer-de-lance
Scarlet Macaw

WHEN TO GO
The park is more accessible in the drier season between December and May.

TIPS
If you are planning to hike in Corcovado, travel light with lightweight clothes, sun protection, mosquito protection and plenty of water – it is true rainforest out there.

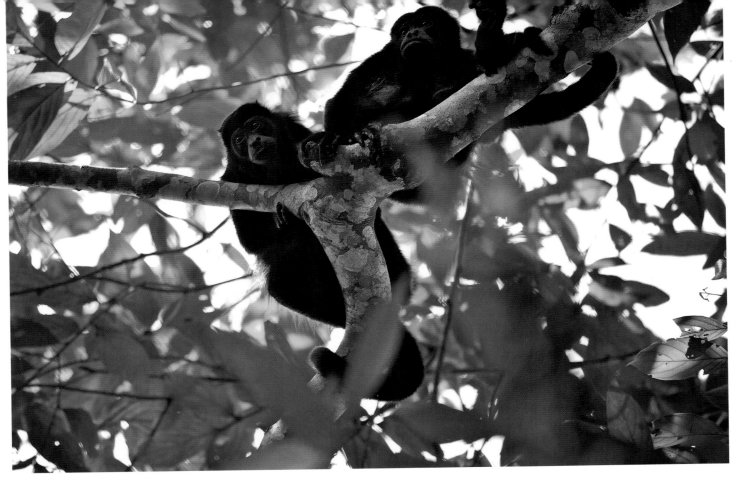

ABOVE Mantled Howler Monkey.
OPPOSITE TOP TO BOTTOM Coati on the beach; Two-toed Sloth.

Waking up in Corcovado National Park will likely be to the sound of the Mantled Howler Monkey's distinctive howl. They are one of the largest monkeys in Central America, with adult males weighing up to 10kg (22lb). They live in troops of up to 40 animals and rarely come down to the ground. They have a golden-brown fringe of hair on their flanks, hence the name 'mantled', and they have a specialised vocal chamber which enables them to make their distinctive 'howl'. Howling sessions often involve several members of the troop in the early morning or at dusk and can be heard over 2km (1.25 miles) away. They are commonly seen and heard in the park.

If you take the time to look in the undergrowth lining the trails, you are likely to spot the small but colourful poison-dart frogs. The frogs are typically between 2–5cm (0.8–2in) in length depending on the species. There are many different species of poison-dart frogs in the area but one thing they have in common is their brightly coloured and patterned bodies with a mixture of vivid reds, yellows, greens and blues. Their bright colours serve as a warning to predators that they are toxic and should not be eaten. The frogs take their name from the fact that indigenous tribes would use the toxic secretions of the frogs to tip their blowgun darts when hunting.

All visitors to the park must be accompanied by certified guides. Arrangements for day trips and overnight visits can be made in Puerto Jimenez before entering the park. The park headquarters are based at Sirena Ranger Station, which is one of the best wildlife-viewing areas and where you have the best chance of seeing Baird's Tapir. The coastal trails also provide prime wildlife-viewing opportunities and are the best places to see Scarlet Macaws flying overhead.

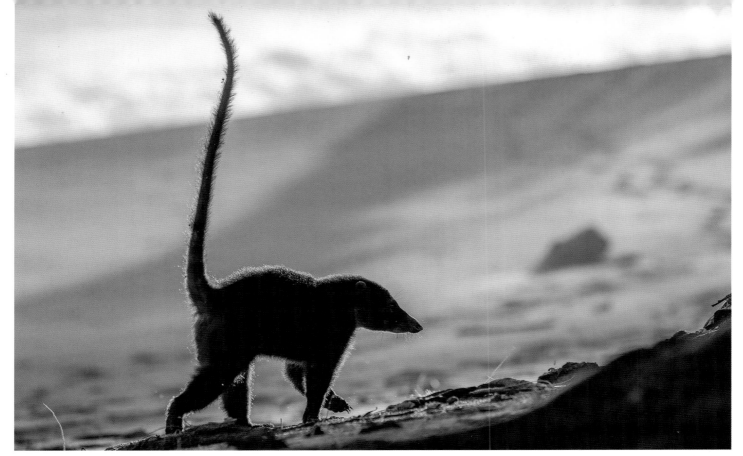
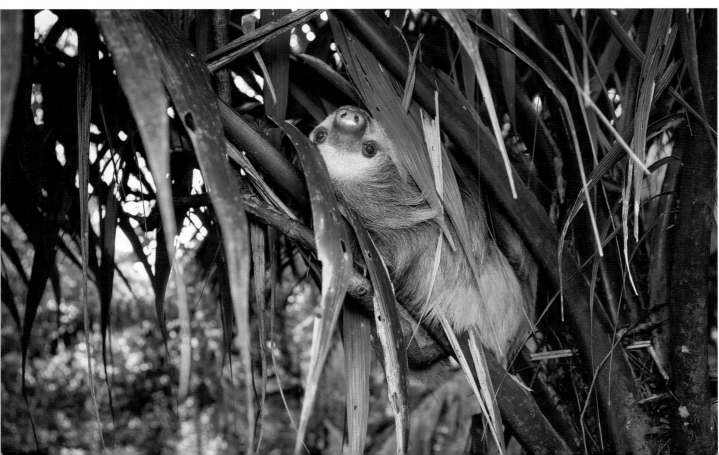

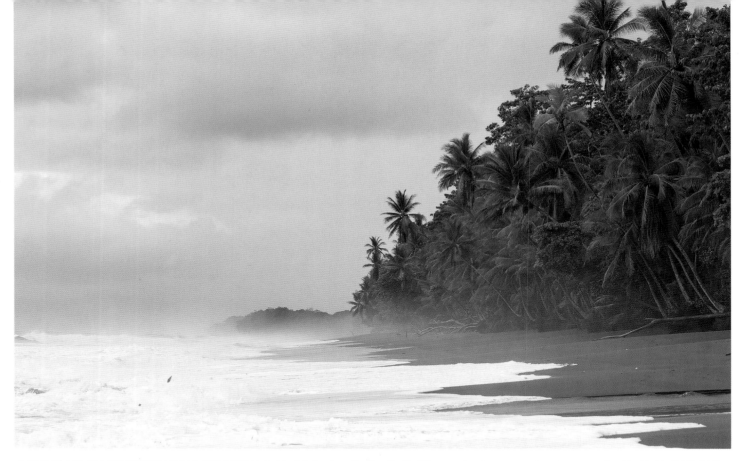

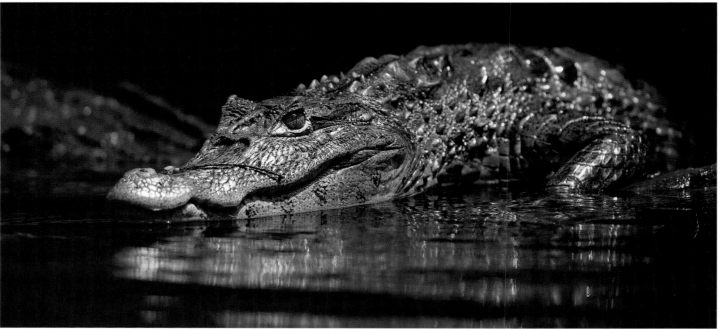

ABOVE TOP TO BOTTOM The Osa Peninsula; Caiman.

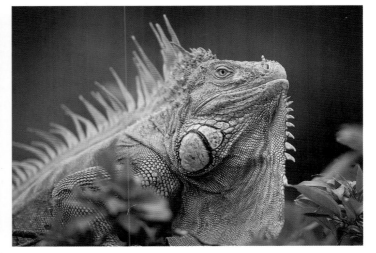

ABOVE CLOCKWISE FROM TOP Ctenosaur on a beach; Green Iguana; Basilisk Lizard.

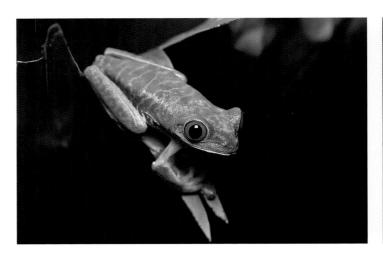
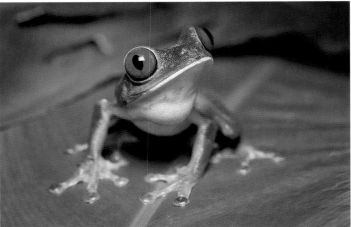
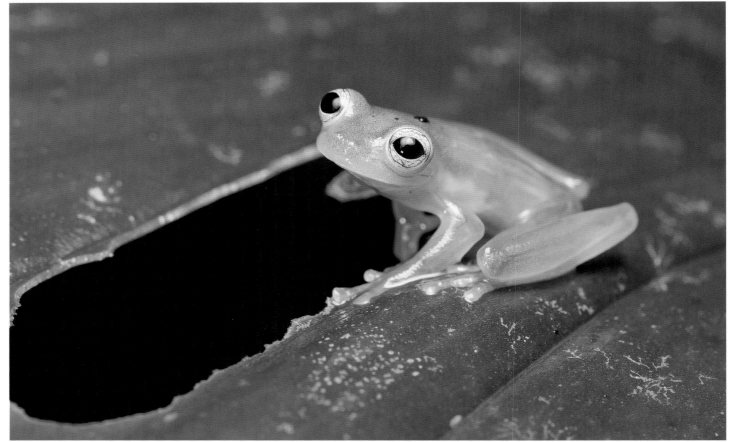

ABOVE CLOCKWISE FROM TOP LEFT Red-eyed Tree Frog; Red-eyed Tree Frog; Glass Frog.

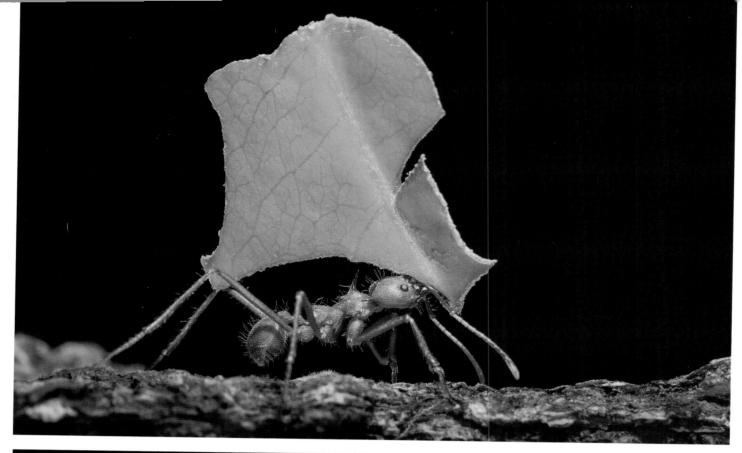

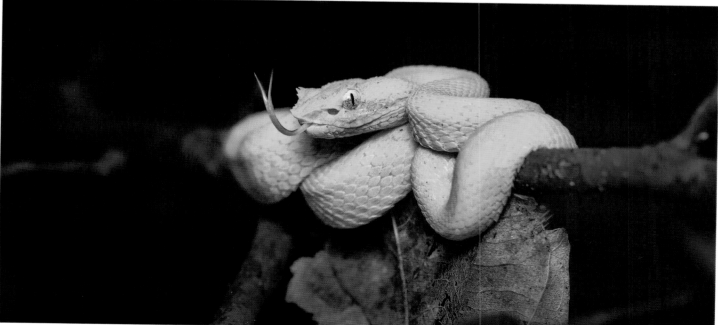

ABOVE TOP TO BOTTOM Leafcutter ant; Eyelash Pit Viper.

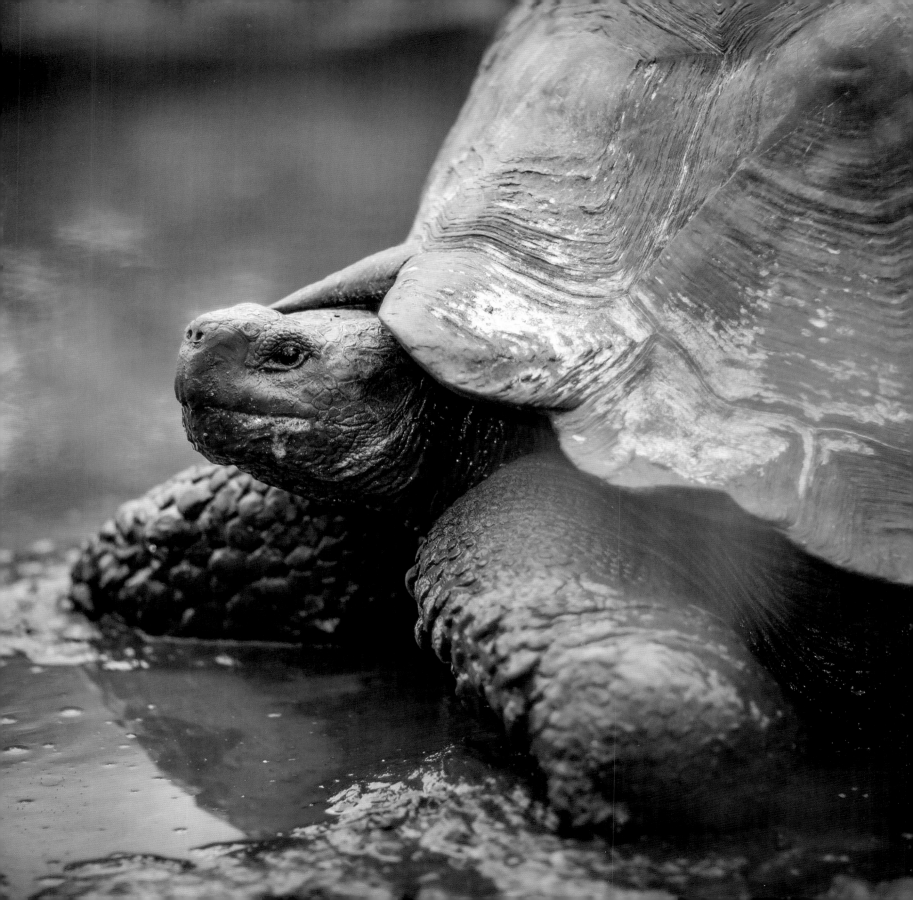

ECUADOR: GALÁPAGOS ISLANDS

"Extreme tameness is common to all the terrestrial species... A gun here is superfluous; for with the muzzle I pushed a hawk off the branch of a tree."

— Charles Darwin from *Voyage of the Beagle*

ON THESE ISLANDS, you are able to get face-to-face, or nose-to-nose, with the very creatures, such as Marine Iguana, Galápagos Giant Tortoise, mockingbirds and numerous finches, that led Charles Darwin to conceive his theory of evolution by natural selection following his visit in 1835. For wildlife enthusiasts, there are few places on Earth that will give you such guaranteed and up-close access to the creatures you want to see. The islands and their waters are brimming with charismatic, fearless and unique creatures.

The Galápagos Islands are an archipelago of 19 volcanic islands and numerous small islets and rocks located in the Pacific Ocean, about 900km (560 miles) off the coast of Ecuador. Surrounding the islands is the Galápagos Marine Reserve which covers over 130,000 sq km (50,200 sq miles) and is one of the largest marine reserves in the world. The islands lie at the confluence of three ocean currents, creating a diverse mix of marine life. They are also located at the meeting point of three major tectonic plates (Nazca, Cocos and Pacific) and are atop a 'hotspot' where

OPPOSITE Galápagos Giant Tortoise.

NOTABLE SPECIES

Galápagos Sea-lion
Galápagos Fur Seal
Galápagos Giant
 Tortoise
Marine Iguana
Blue-footed, Red-footed
 and Nazca Boobies
Swallow-tailed Gull
Frigatebirds
Galápagos Mockingbird
Flightless Cormorant
 (on Isabela or
 Fernandina)
Waved Albatross (on
 Española between
 April and December)
Galápagos Penguin

Galápagos Short-eared
 Owl
Galápagos Hawk
Hammerhead Shark
 and Whale Shark
 (divers only — off
 Darwin and Wolf
 Island)

WHEN TO GO

There is a warm and wet season from January to June when there can be rains, but it is typically sunny with warmer water, and the cool and dry season from July to December when the water temperatures drop and a misty precipitation called 'garua' occurs. The sea is rougher during the cool and dry season, which can worsen seasickness.
 Certain wildlife spectacles such as the mating dance of the Waved Albatross only occur at certain times of year (April to December in that case).

TIPS

It would be a shame to travel all the way to the Galápagos Islands and miss seeing some of the fascinating species, so it is worth choosing a longer tour to ensure you reach the wildlife on the more isolated islands.

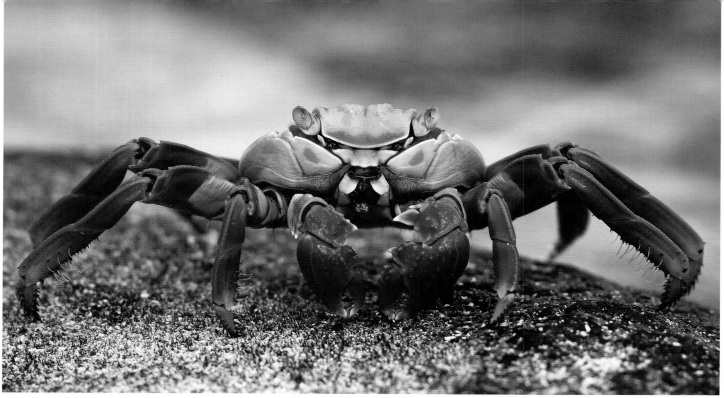

Sally Lightfoot Crab.

the Earth's crust is being melted from below by a mantle plume. Ongoing volcanic activity continues to show us how the islands were formed; as the Galápagos Islands move slowly in a south-easterly direction over the stationary hotspot, the older islands in the east gradually disappear into the sea and the younger islands in the west, such as Fernandina (approximately one million years old), continue to be formed.

Only four islands in the archipelago are inhabited. Visitors can choose to stay on an inhabited island and arrange day-trips, although this option will rule out travelling to the more distant islands and will mean missing certain species. The alternative is to sleep aboard a boat on a trip ranging in duration from three days to several weeks, visiting the various islands and taking in the wildlife offered at the different sites. There are over 60 designated visitor sites across the archipelago. All sites must be visited with a licensed guide. Some species will only be found on one island and choosing tours that include travel to some of the more remote sites will lead to rewards such as seeing the Waved Albatrosses' mating dance (on Española between April and December) or Flightless Cormorants (on Isabela or Fernandina) that cannot be seen elsewhere.

Most tours will include a morning and an afternoon walk in small groups with a guide around a designated visitor site on the islands. Visitors are likely to see Marine Iguanas emerging from the cold water and climbing across jagged rocks to seek out a sunny spot in which to warm up, slow but graceful Galápagos Giant Tortoises that can weigh up to 250kg (550lb) and be over 100 years old, fearless Galápagos Fur Seals, Galápagos Sea-lions, Blue-footed, Red-footed and Nazca Boobies, frigatebirds and a whole host of species of Darwin's finches to name but a few.

Some boats also have the options of snorkelling or diving, which are well worth doing. The underwater world is as fascinating as the wildlife on dry land. To see Galápagos Penguins gracefully darting by and playful Galápagos Sea-lions doing loop the loops around you are noteworthy experiences. Divers can also be rewarded with spectacularly large schools of Hammerhead Sharks and Whale Sharks off Darwin and Wolf Islands in the north-west.

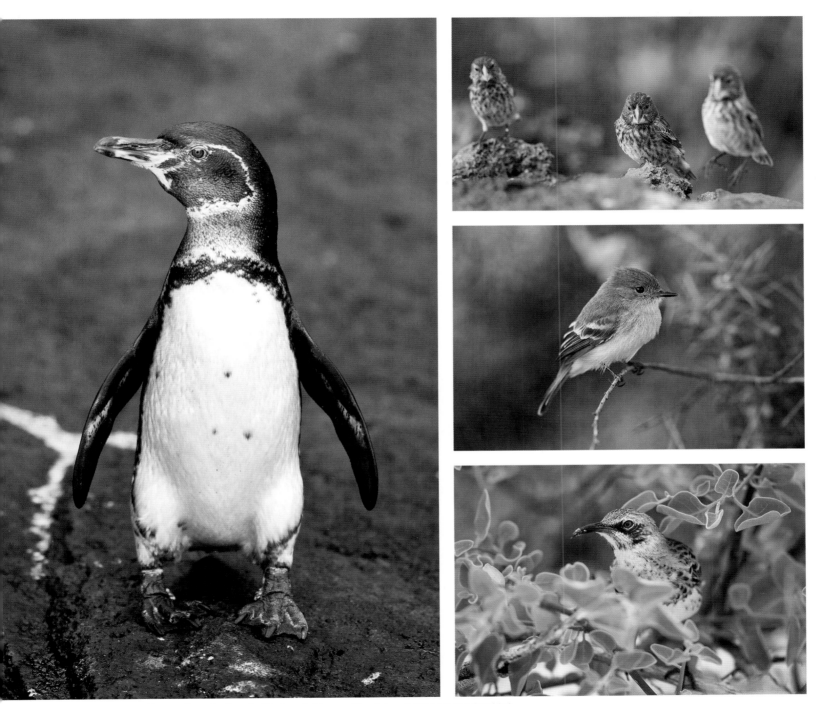

DIRECTION Galápagos Penguin; Darwin Finches; Galápagos Flycatcher; Galápagos Mockingbird.

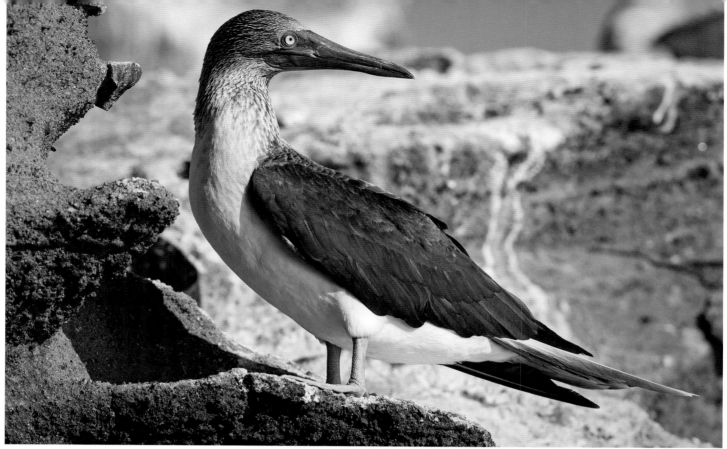

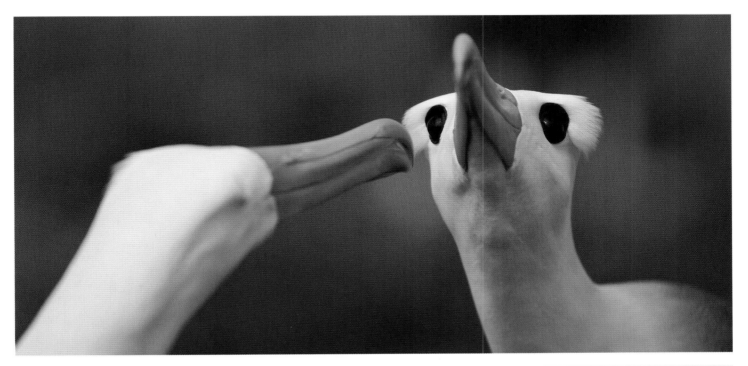

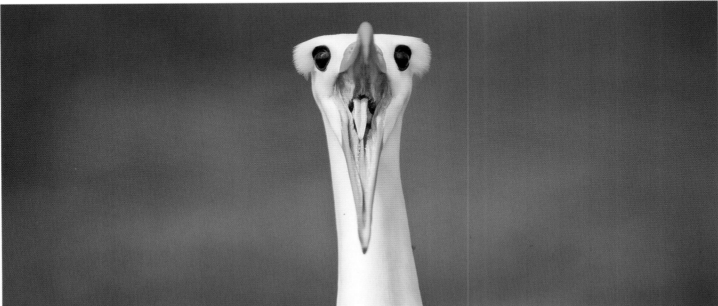

ABOVE Waved Albatross courtship ritual.
OPPOSITE Blue-footed Booby.

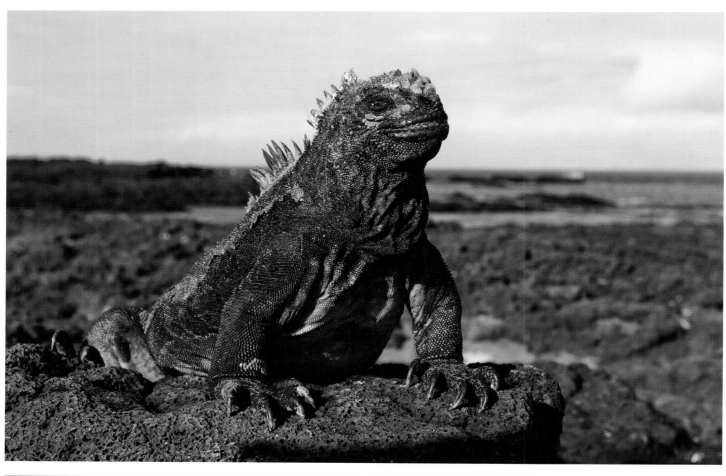

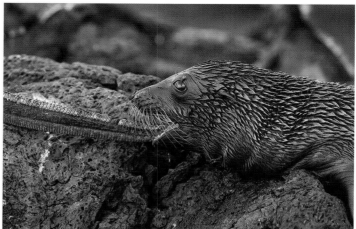

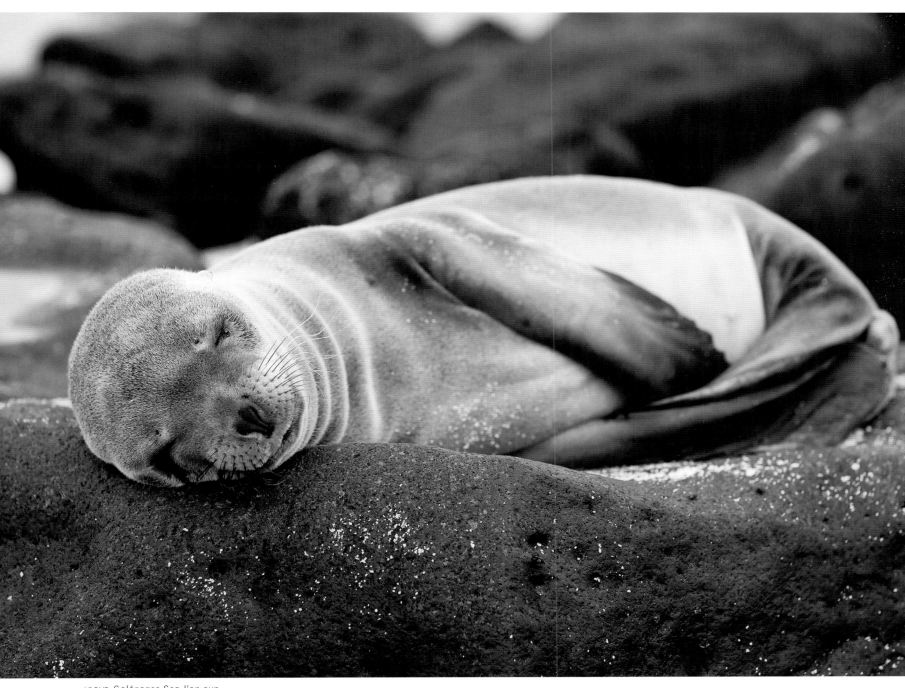

ABOVE Galápagos Sea-lion pup.
OPPOSITE CLOCKWISE FROM TOP Marine Iguana; young Sea-lion playing with a Marine Iguana; Finch eating parasites on a Marine Iguana.

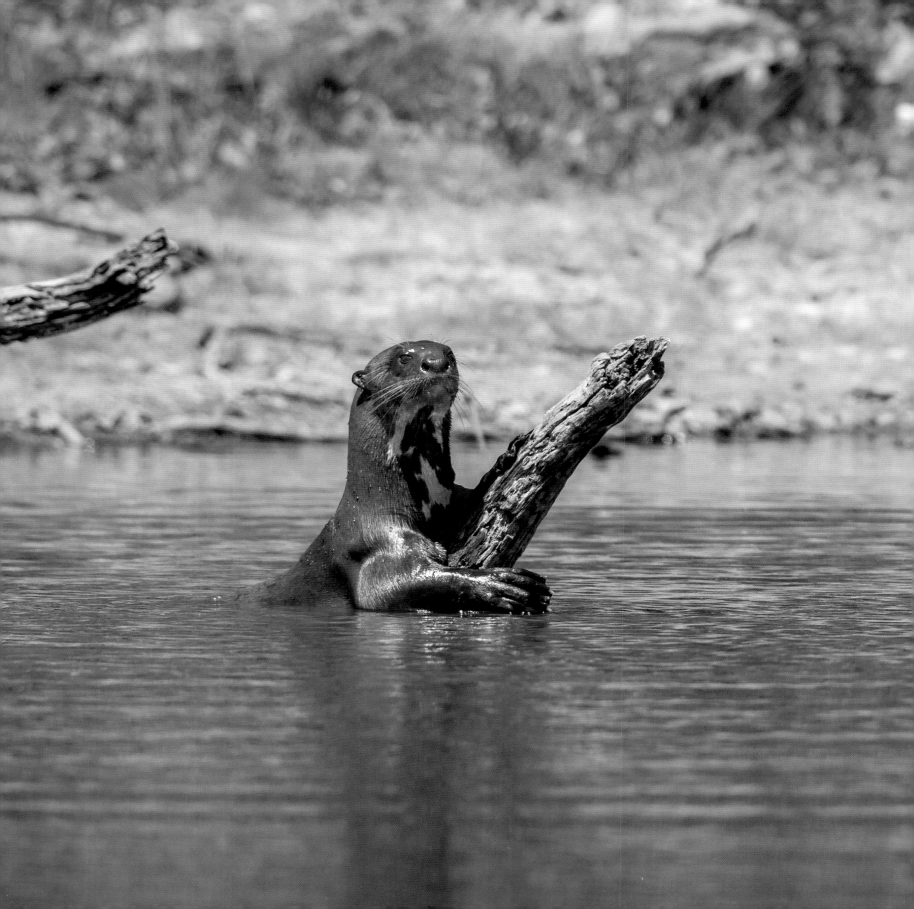

PERU: MANÚ NATIONAL PARK

"A ripple appeared on the still water of the oxbow lake, then a sleek head emerged to look at the boat. Three more heads appeared in quick succession and before I knew it, I was confronted by a family of inquisitive Giant Otters."

PARQUE NACIONAL MANÚ is Peru's largest national park, located in the Madre de Dios and Cusco regions, covering over 15,000 sq km (5,800 sq miles). It lies in the Amazon River basin, with the entire watershed of the River Manú and the tributaries of the River Alto Madre de Dios within its boundaries. The altitude within the park ranges from just 150m (490ft) above sea level up to 4,000m (13,125ft). This large variation in altitude results in varied vegetation throughout the park, including tropical lowland rainforest, tropical montane rainforest and puna grasslands, affording one of the highest levels of biodiversity of any park in the world. With almost 1,000 species of birds and 200 species of mammals, it is a special place that attracts birdwatchers and wildlife enthusiasts from around the globe. Jaguar, Giant Otter, Brazilian Tapir, Black Caiman, Harpy Eagle and seven species of macaw are just some of the animals that can be seen. It was declared a Unesco Biosphere Reserve in 1977 and a World Natural Heritage Site in 1987. The fact that the park is remote with limited access has helped to provide protection from loggers and oil companies, enabling vast areas of primary rainforest to remain relatively untouched by man.

Giant Otters are found in the freshwater rivers and waterways of the Amazon, Orinoco and La Plata rivers in South America, including within Manú National Park's waterways. Fully grown adults can exceed 170cm (67in) in length, making them the largest of the family Mustelidae (weasels and allies). They are carnivorous, feeding mostly on fish, and are well designed for an amphibious lifestyle with webbed feet, water-repellent fur and wing-like tails. Sadly, the dense velvety fur of their coats made the otters a target for poachers and they have been hunted extensively over the past century. Habitat loss along with poaching means that population numbers have fallen significantly, with only a few thousand individuals surviving in the wild.

OPPOSITE Giant Otter.

NOTABLE SPECIES

Giant Otter
Red-and-green Macaw
Brazilian Tapir
Caiman
Jaguar

WHEN TO GO

The dry season from June to November offers the best chance for wildlife sightings. The park often closes during the wet season (from January to April).

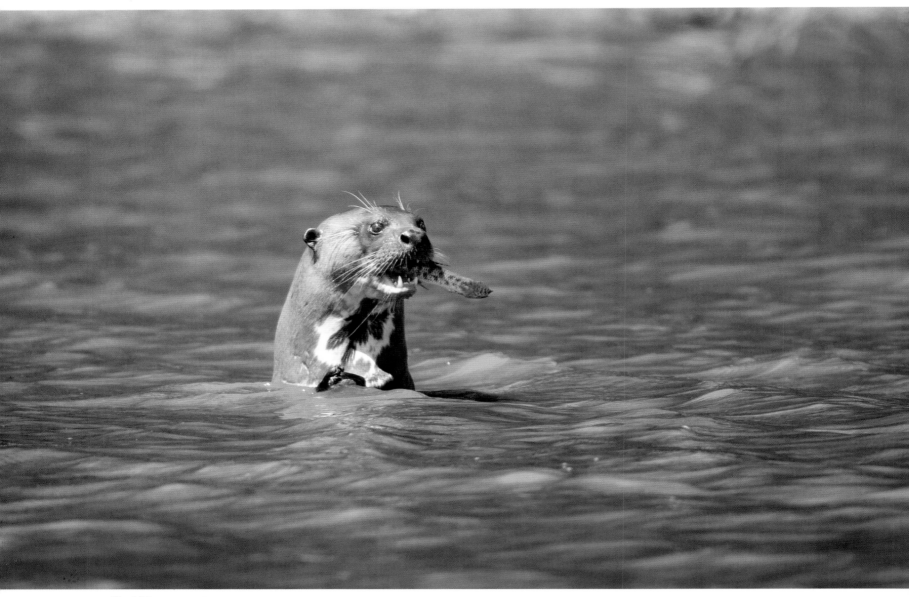

Giant Otter.

The national park is home to a famous clay lick where hundreds of Red-and-green Macaws, along with many other species of brightly coloured macaws and parrots, gather to eat clay. Many of the rainforest plants, fruits and seeds that the birds feast upon contain alkaloids and other toxins. By eating the clay, the toxicity is neutralised. The raucous noise and bold splashes of colour at the clay lick are a true assault on the senses and make for a magical wildlife experience.

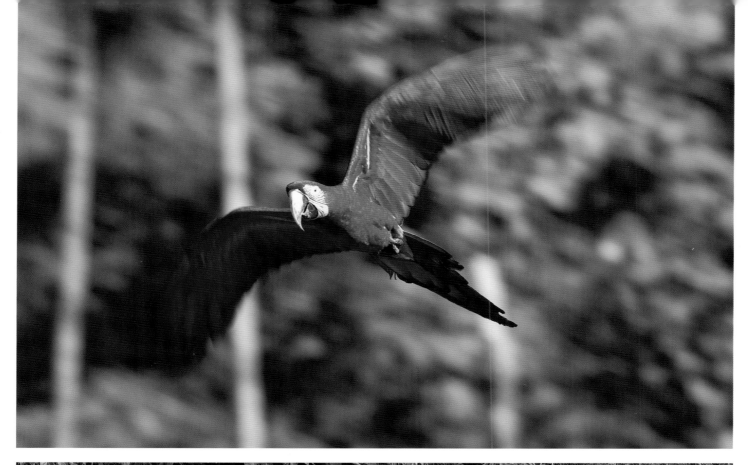

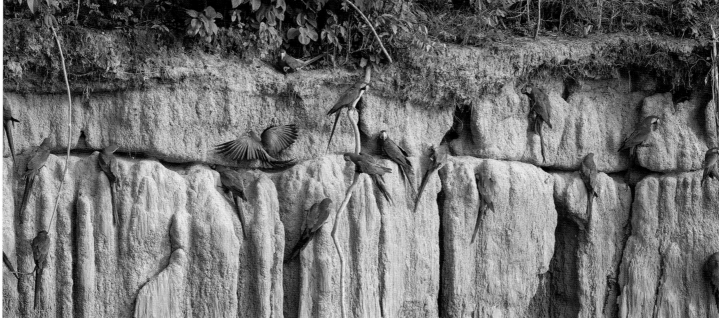

Red-and-green Macaws at a clay lick.

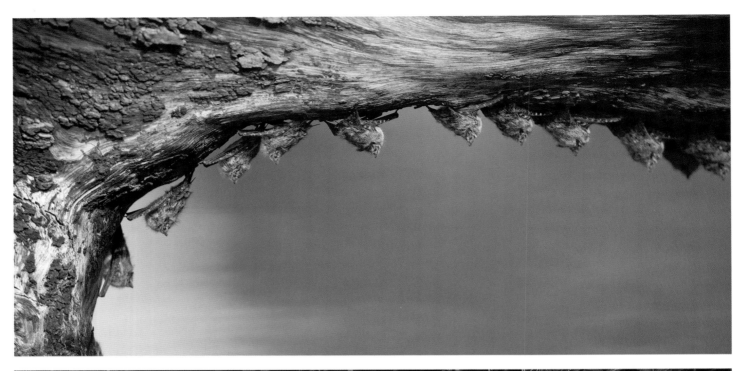

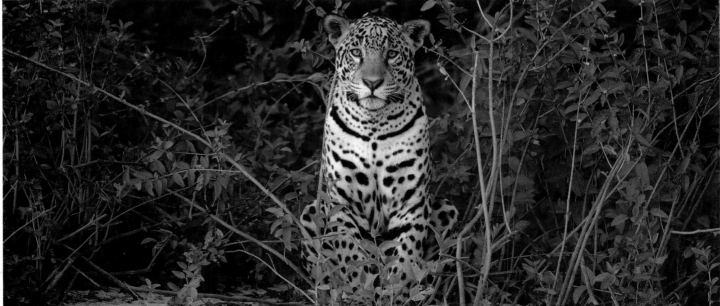

ABOVE TOP TO BOTTOM Bats on the underside of fallen tree; Jaguar.
OPPOSITE Male Andean Cock-of-the-rock.

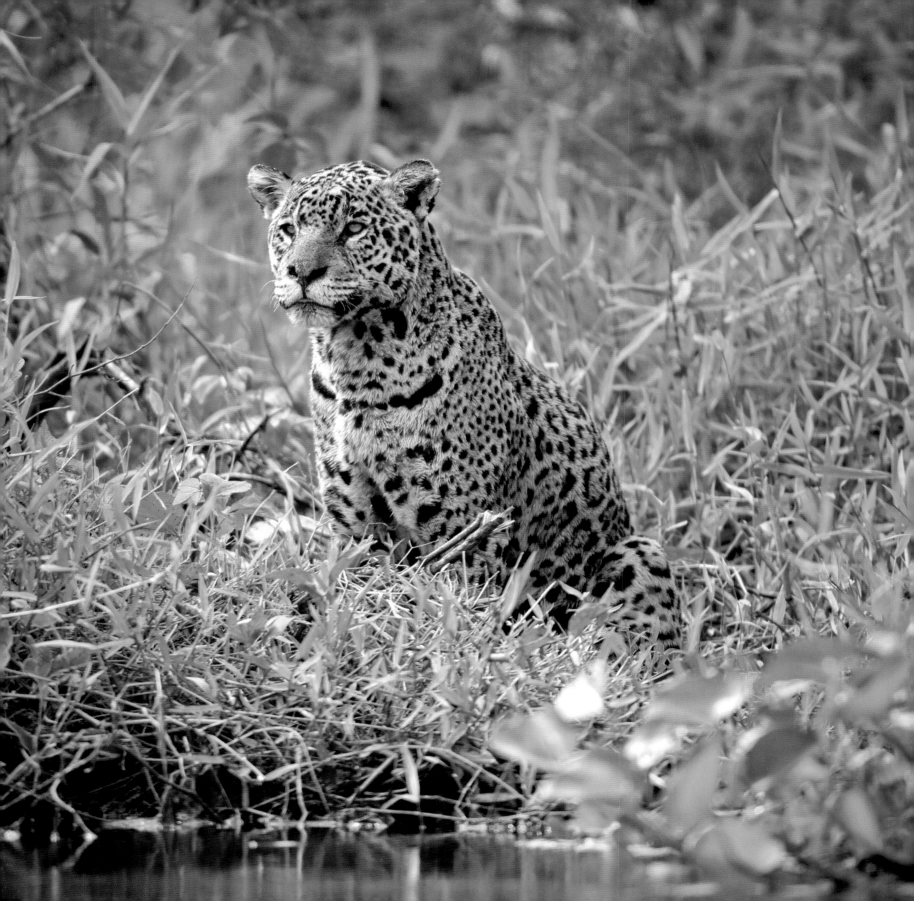

BRAZIL: PANTANAL

"The stars twinkled overhead and in the shallow water the eyes of a caiman reflected brightly in my torch beam. As the caiman lay motionless waiting for fish to pass by, I waded closer and set up my tripod for a long exposure. In the darkness, my senses were heightened to the sounds of the swamp. It was eerie to share the night with this prehistoric predator."

THE PANTANAL is the world's largest inland wetland. It covers 210,000 sq km (81,080 sq miles), making it around 18 times the size of the Florida Everglades. The name 'Pantanal' comes from the Portuguese word 'pantano', which means swamp or marsh. Over half of the flooded grasslands, savannah and tropical forests of the Pantanal lies in central-western Brazil, with the remainder extending into Bolivia and Paraguay. The wetlands may not be as famous as the Amazon rainforest to the north, but they boast the greatest concentration of wildlife in South America and the open marshes make it much easier for visitors to spot animals here than in the dense foliage of the Amazon. The biggest wildlife attractions of the area include Jaguar, Hyacinth Macaw, Giant Otter and Giant Anteater, but it is also wonderful to watch the less glamorous creatures in this lush environment, such as herds of Capybara (the world's largest rodent) and basking caiman. For wildlife enthusiasts, the Pantanal should not be missed.

The Pantanal is a huge basin that relies on a yearly flood cycle. It receives water from the Planalto highlands and releases it slowly into the Paraguay river. Therefore, during the rainy season, the basin fills faster than it can drain, creating a saturated, flooded land. The water-level can rise by up to 5m (16ft) during this time and around 80 per cent of the floodplains become submerged. The water slowly trickles out of the basin, leaving a landscape of open savannah, patches of forest and brackish lakes during the dry season. The fish get trapped in the remaining bodies of water and animals congregate around these shrinking waterholes to feast on the marooned fish. These waterholes are home to the highest density of caiman in the world, with over 150 caiman per square kilometre.

OPPOSITE Jaguar.

NOTABLE SPECIES

Jaguar
Ocelot
Capybara
Giant Anteater
Giant Otter
Marsh Deer
Maned Wolf
Caiman
Hyacinth Macaw

WHEN TO GO

The dry season from June to November offers the best chance of sightings of Jaguar and other wildlife as the water levels are low and the animals can be seen on exposed river banks. The temperature is more pleasant at this time too.

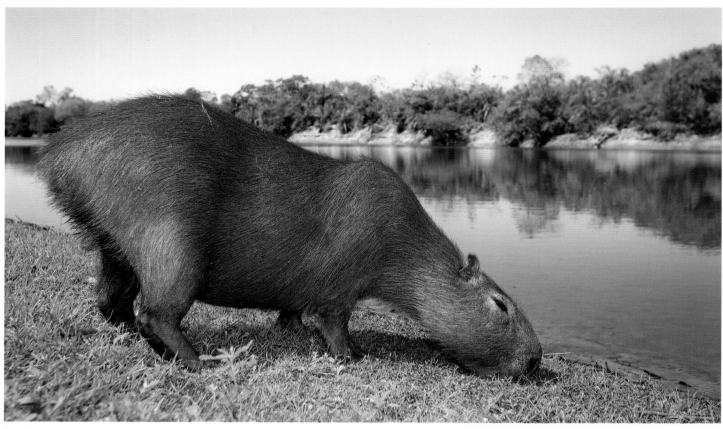
Capybara.

There is a national park and some private nature reserves within the Pantanal area, but much of the wetlands are actually privately owned. The landowners, mostly cattle ranchers, are fortunately working closely with ecotourism and conservation ventures in an attempt to ensure sustainable conservation of the flora and fauna of the area. There are very few roads in the Pantanal, therefore most transportation is in small airplanes or motorboats. Visitors to the region can stay at private fazendas (working ranches) and experience the wildlife on forest walks and boat rides.

Jaguars were once commonplace throughout much of South and Central America, but have faced habitat loss from deforestation and human encroachment as well as persecution and poaching over the years. They now occupy less than half of their original range. The Pantanal is one of their remaining strongholds, along with the Amazon rainforest. Jaguar is the third largest feline after Tiger and Lion, and the largest cat of the Americas. They typically have tawny-yellow coats with distinctive dark rosettes and spots, giving them a similar appearance to a Leopard. However, they are stockier and have rounder heads than Leopards. Jaguars are often found near water and are excellent swimmers. They are ambush predators with extremely powerful bites and will prey on anything that comes their way. Apart from mothers with cubs, they are solitary creatures, most active at dusk and dawn. Seeing these beautiful animals stalking along the banks of a river in the Pantanal is simply breathtaking.

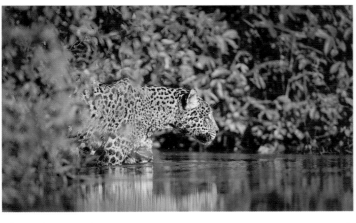

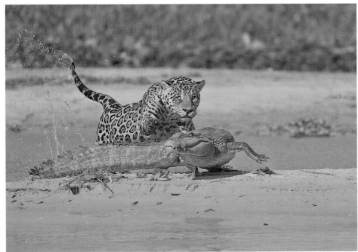

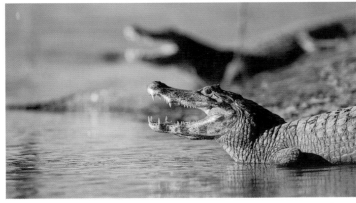

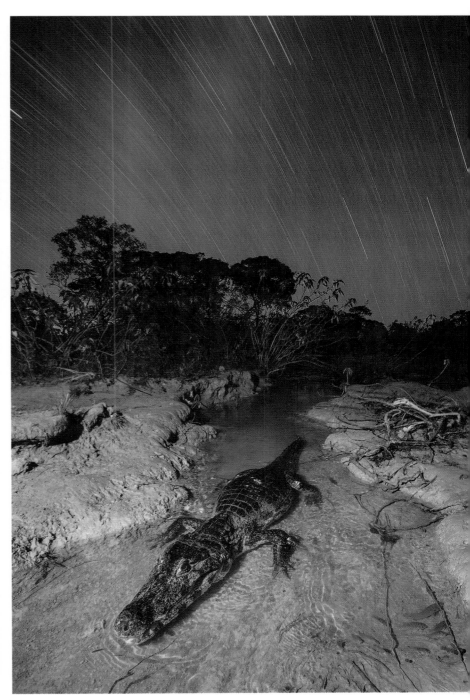

ABOVE CLOCKWISE FROM TOP LEFT Jaguar; Caiman at night; Caiman; Jaguar hunting Caiman.

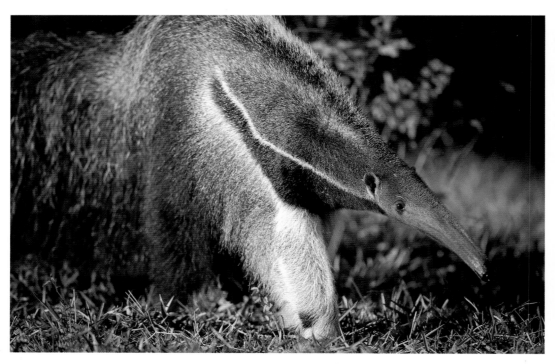
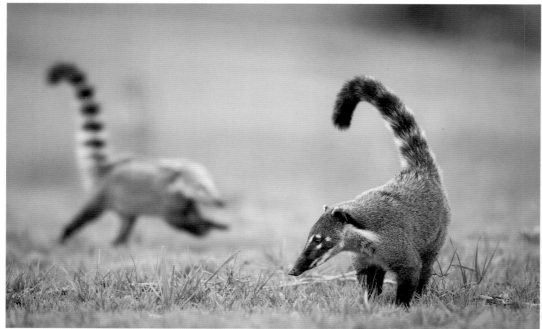

ABOVE CLOCKWISE FROM TOP Giant Anteater; Giant Anteater mother with baby; Coatis.

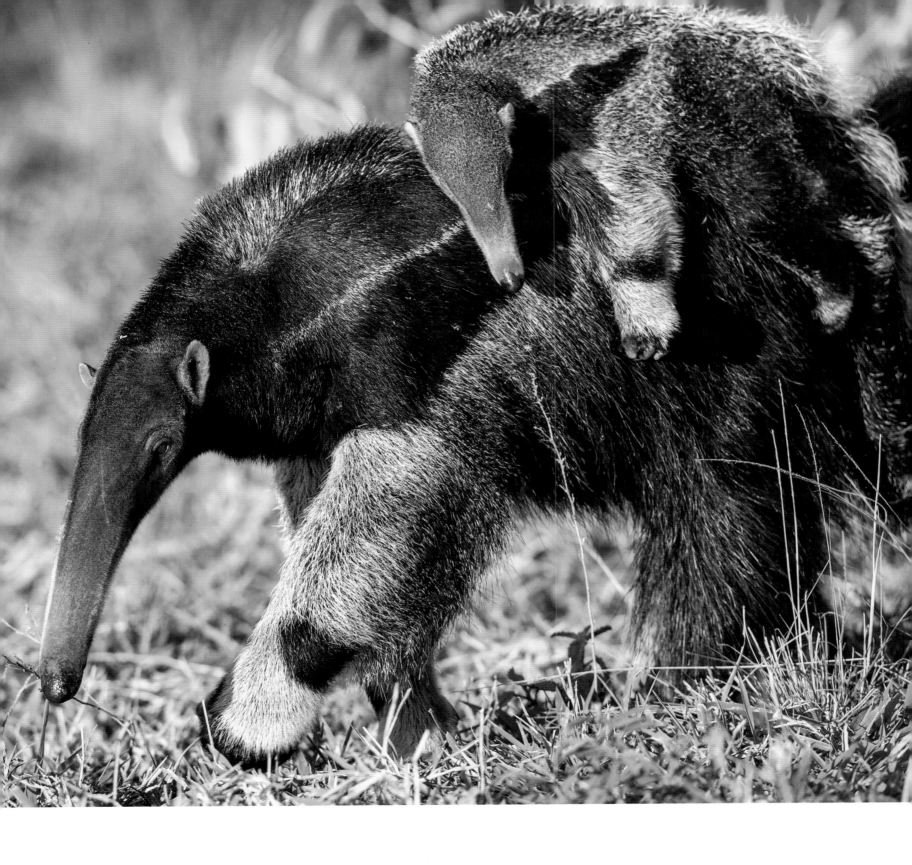

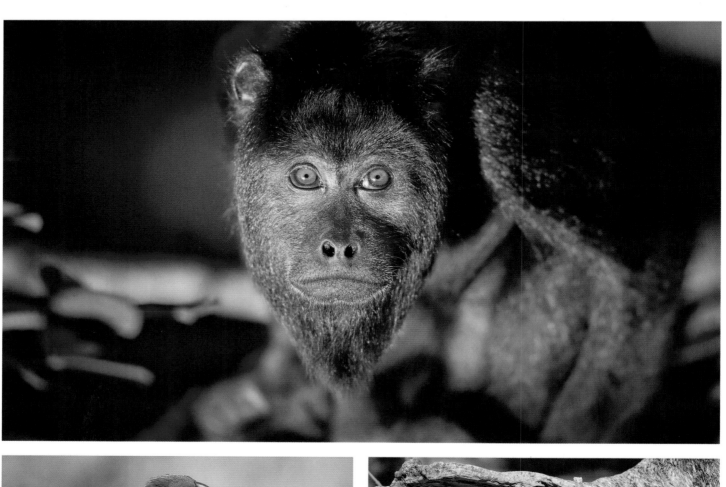

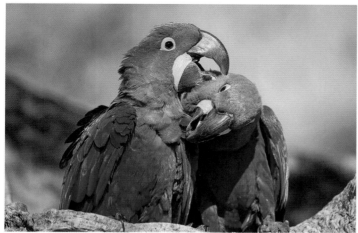

ABOVE CLOCKWISE FROM TOP Black Howler Monkey; Hyacinth Macaw at nest; Hyacinth Macaws preening.
OPPOSITE TOP TO BOTTOM Jabiru Stork returning with nesting material; Toco Toucan.

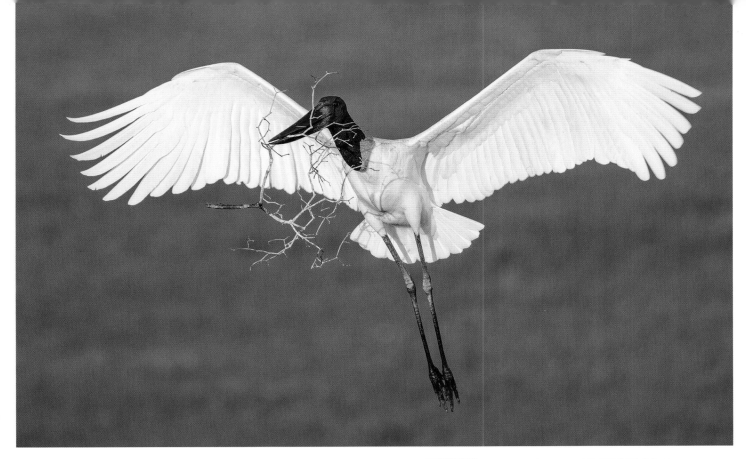

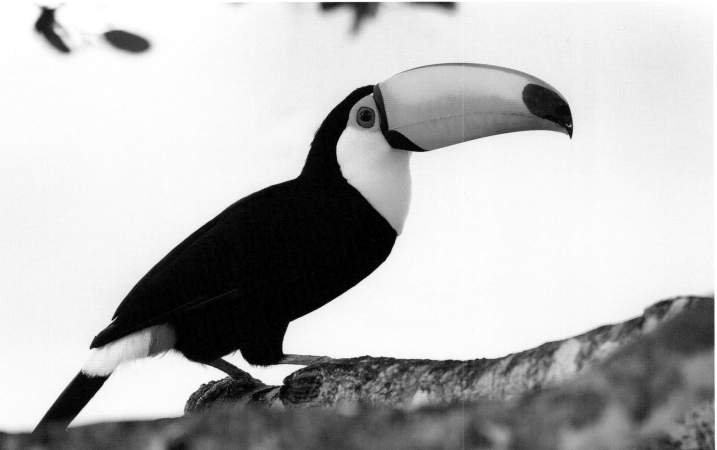

AUSTRALASIA AND THE ANTARCTIC ZONE

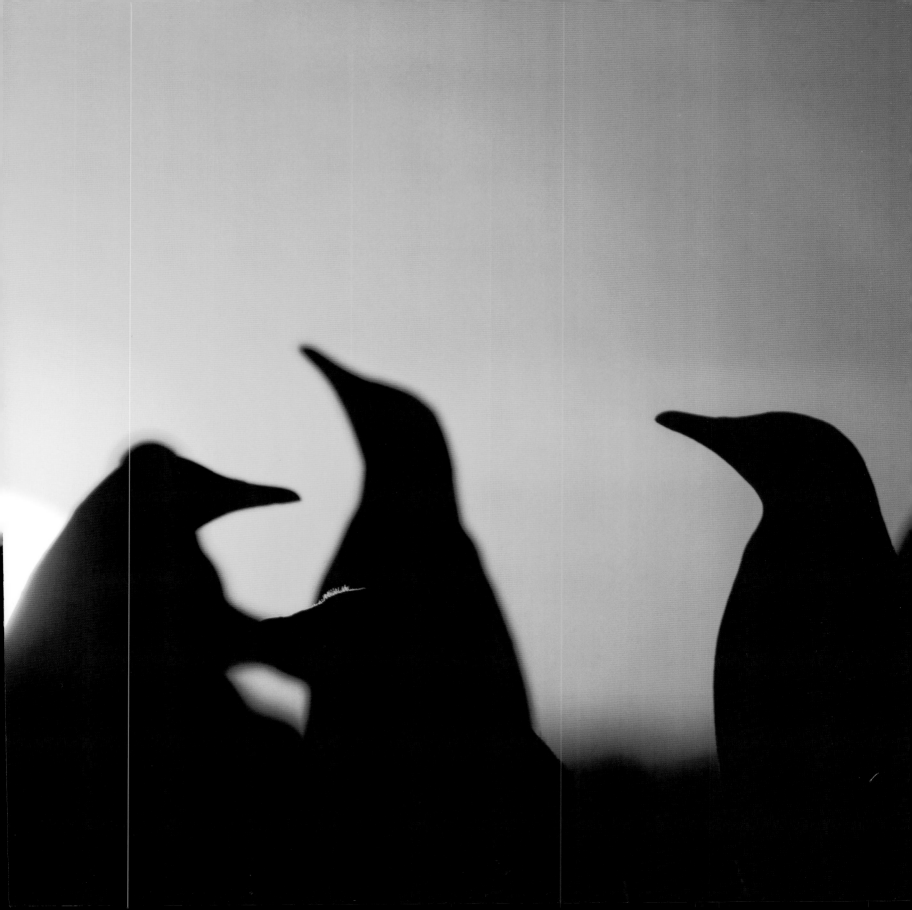

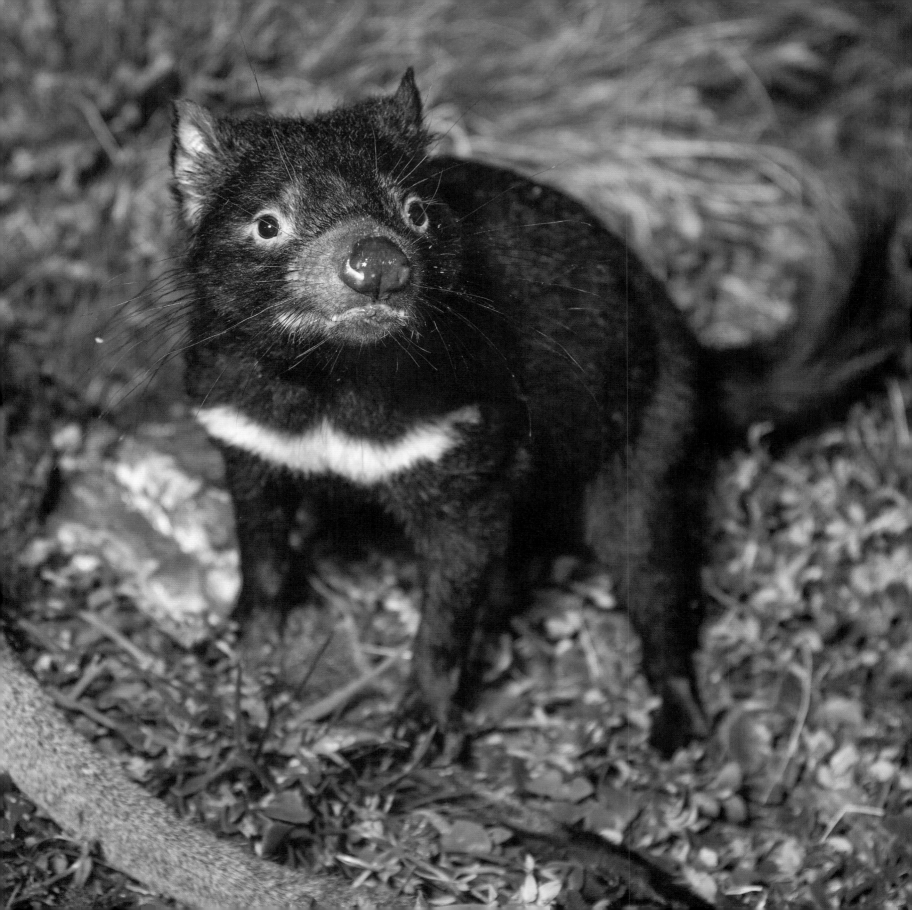

AUSTRALIA: TASMANIA

*"Over the howling wind, I could hear the faint sound of bones being crunched.
In the darkness, I crawled on my belly towards the noise and in the puddle of
light from my torch, I found a Tasmanian Devil feasting on roadkill."*

TASMANIA IS AN ISLAND STATE of Australia, located 140km (87 miles) south of the mainland. With a landmass of 68,000 sq km (26,250 sq miles), it is the 26th largest island in the world. It is a mountainous island, with a coastline of sandy beaches and an interior of jagged rocks, ancient temperate rainforests and heathlands. It is a wild place with stormy seas and howling winds, and is home to unique flora and fauna including the Tasmanian Devil.

Most of the native mammals on Tasmania are marsupials. Marsupials give birth to very tiny young that continue their development in a pouch. Fossil records show that up to around 60 million years ago both placental and marsupial mammals co-existed in Australia, but for unknown reasons the placental mammals disappeared leaving marsupials to dominate the Australian ecosystem without competitors. Tasmania's other native mammals include monotremes; the egg-laying Platypus and Short-beaked Echidna.

Many of the animals that were once widely distributed across southern Australia have failed to survive on the mainland. However, Tasmania's relative lack of predators and challenging terrain (making land clearance more difficult) have enabled several of them to survive and maintain healthy populations. Tasmanian Devil, Eastern Barred Bandicoot, Tasmanian Pademelon, Eastern Quoll, Long-tailed Mouse and Tasmanian Bettong are just some of the island's fascinating endemic species which can be found nowhere else on Earth.

Until recently, the island was also home to the Thylacine, which is also known as the Tasmanian Tiger. However, settlers mistakenly believed that they were a threat to their livestock and persecuted them to extinction. The last Thylacine died in captivity in 1936.

The Tasmanian Devil is a stocky creature, similar in size to a small dog, with a dark coat with white markings

OPPOSITE Tasmanian Devil feeding on roadkill.

NOTABLE SPECIES
Tasmanian Devil
Eastern Barred Bandicoot
Tasmanian Pademelon
Common Wombat
Wallabies
Platypus
Short-beaked Echidna

WHEN TO GO
Go during the Australian summer for better weather.

TIPS
The weather can be very changeable, so pack for all seasons.

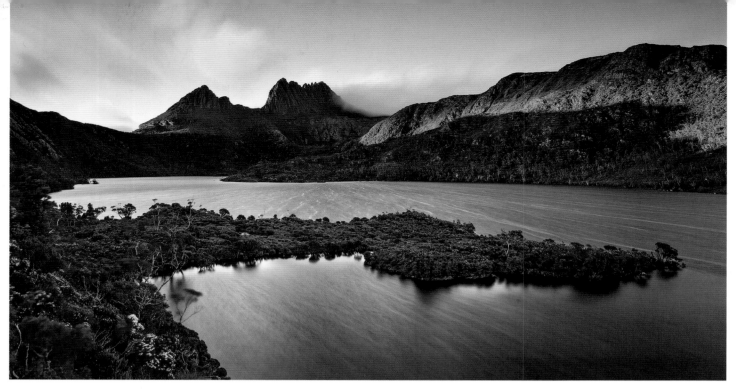

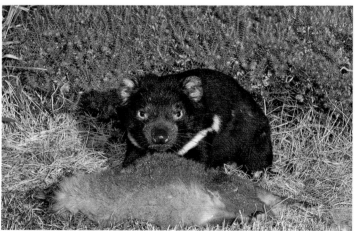

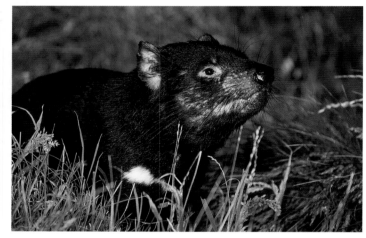

ABOVE CLOCKWISE FROM TOP Cradle Mountain; Tasmanian Devil; Tasmanian Devil feeding on roadkill.
OPPOSITE Red-necked Wallaby.

around the neck, shoulders and flanks. Although small, they have a fierce, tough appearance with sharp teeth and strong jaws. They are carnivorous marsupials which are known to growl and screech when threatened or competing for a mate. Devils normally live a solitary existence, but may congregate at night-time to feed. Communal mealtimes over a carcass can be an extremely noisy affair, with frequent squabbles. Although they can hunt, devils often opt to eat easy carrion such as roadkill. Roadside meals can spell disaster for the devils, which can easily be killed or injured by passing vehicles. Another threat facing the species is an illness discovered in the mid-1990s called Devil Facial Tumour Disease (DFTD). It is a contagious cancer that causes tumours to develop around the mouth and head, meaning that the animals struggle to feed and eventually starve to death.

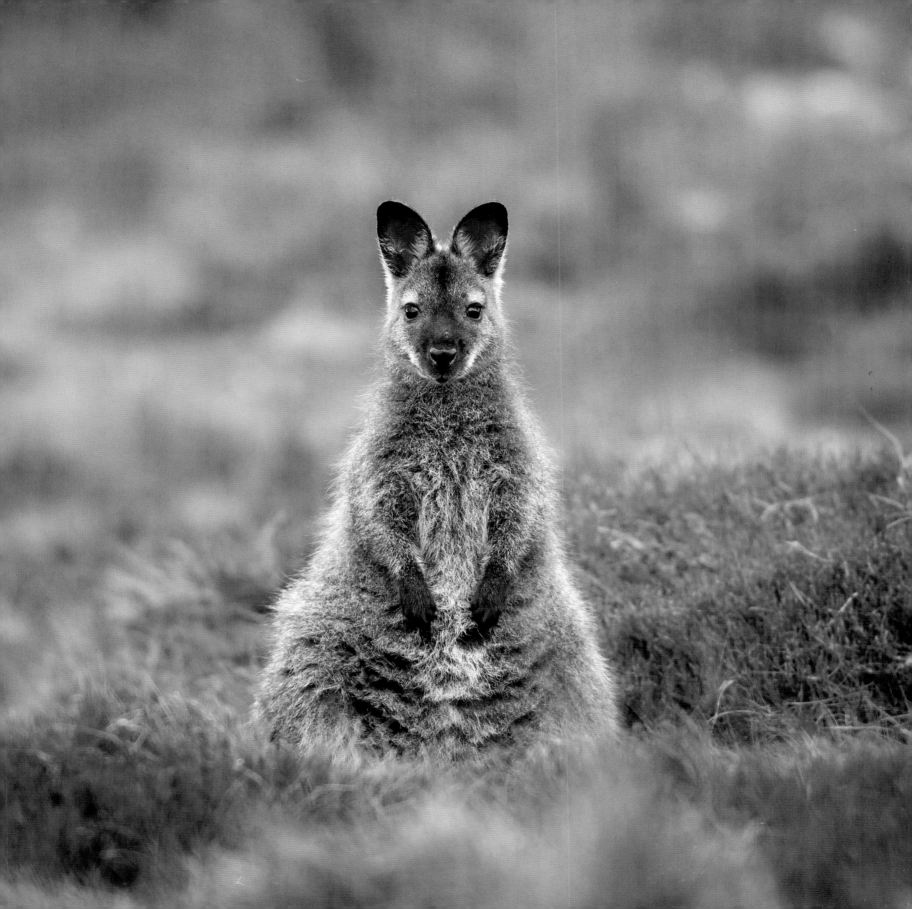

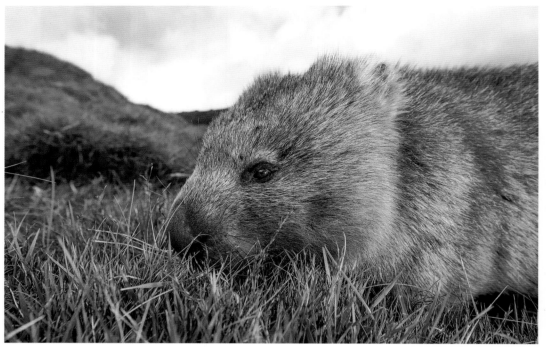

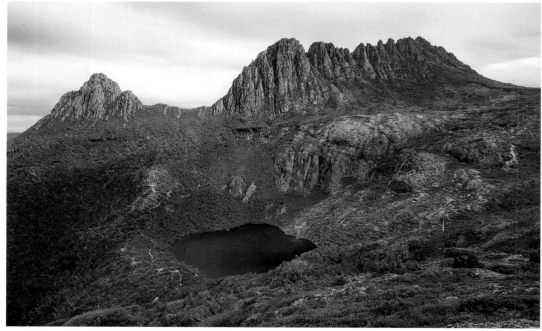

CLOCKWISE FROM TOP Common Wombat; Common Wombat; Cradle Mountain.

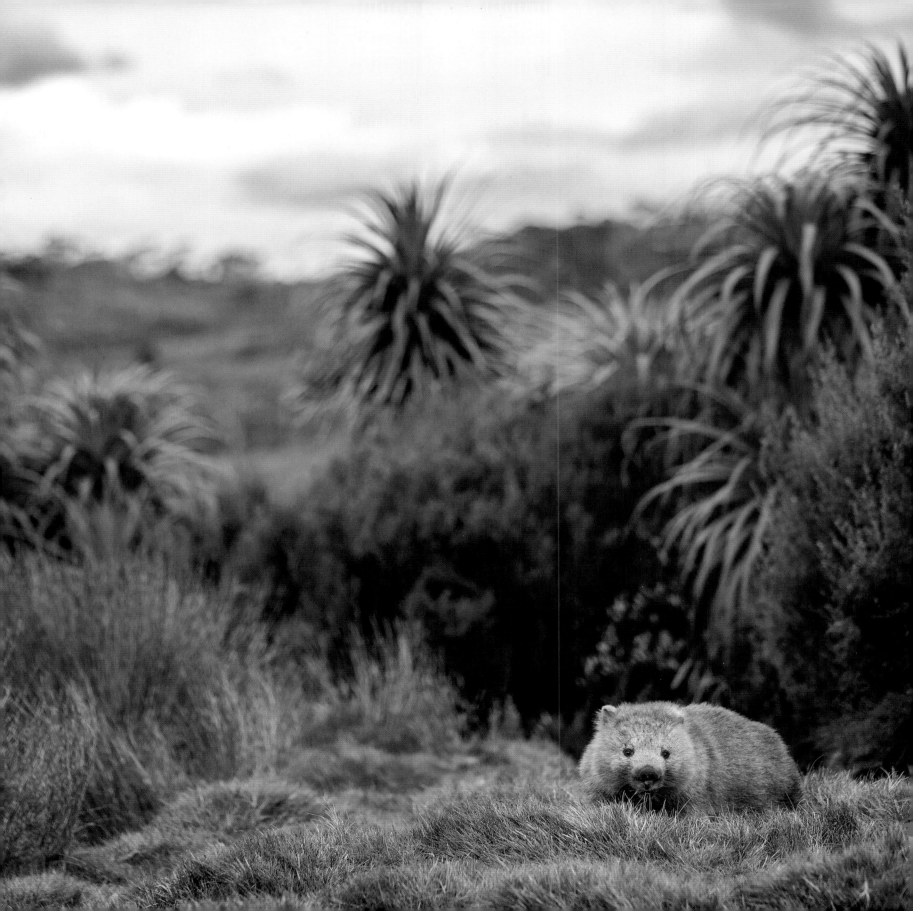

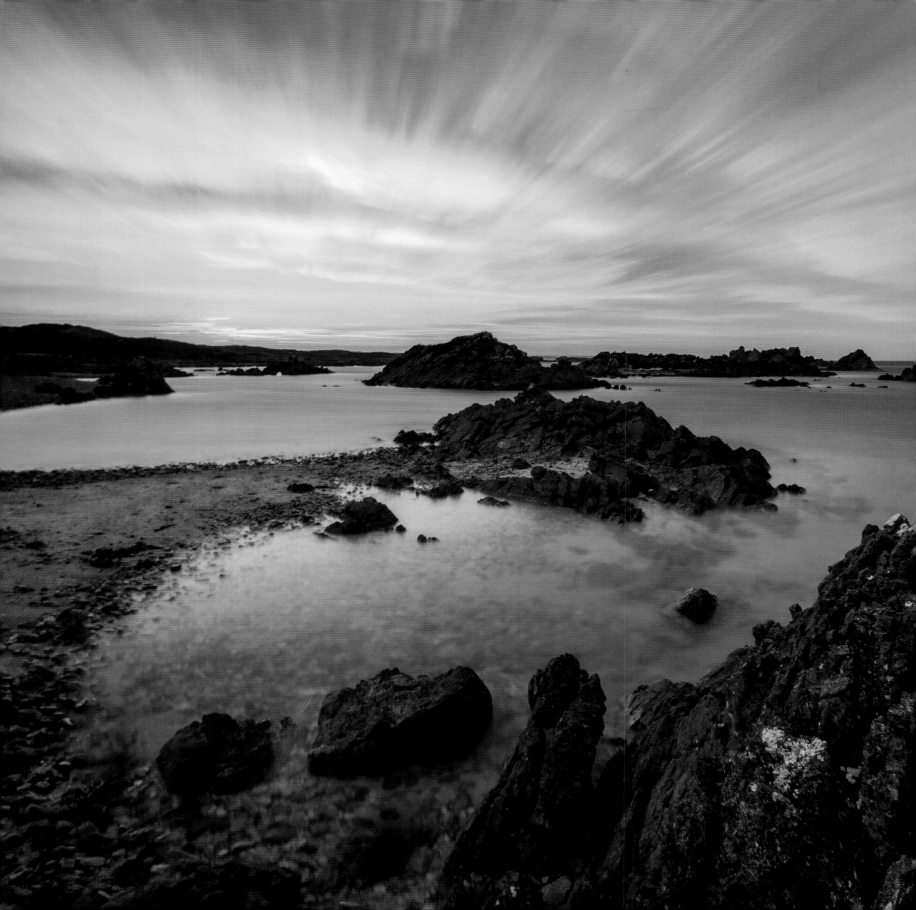

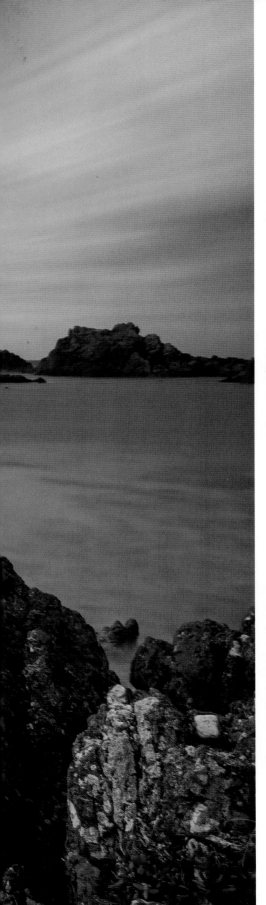

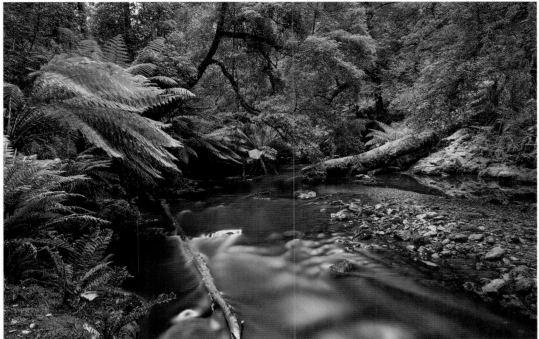

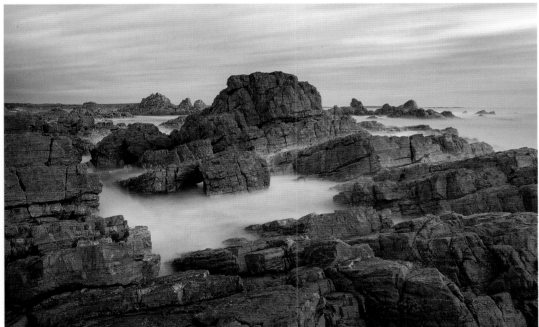

CLOCKWISE FROM LEFT Tasmanian coastline at dawn; Takine forest; Tasmanian coastline.

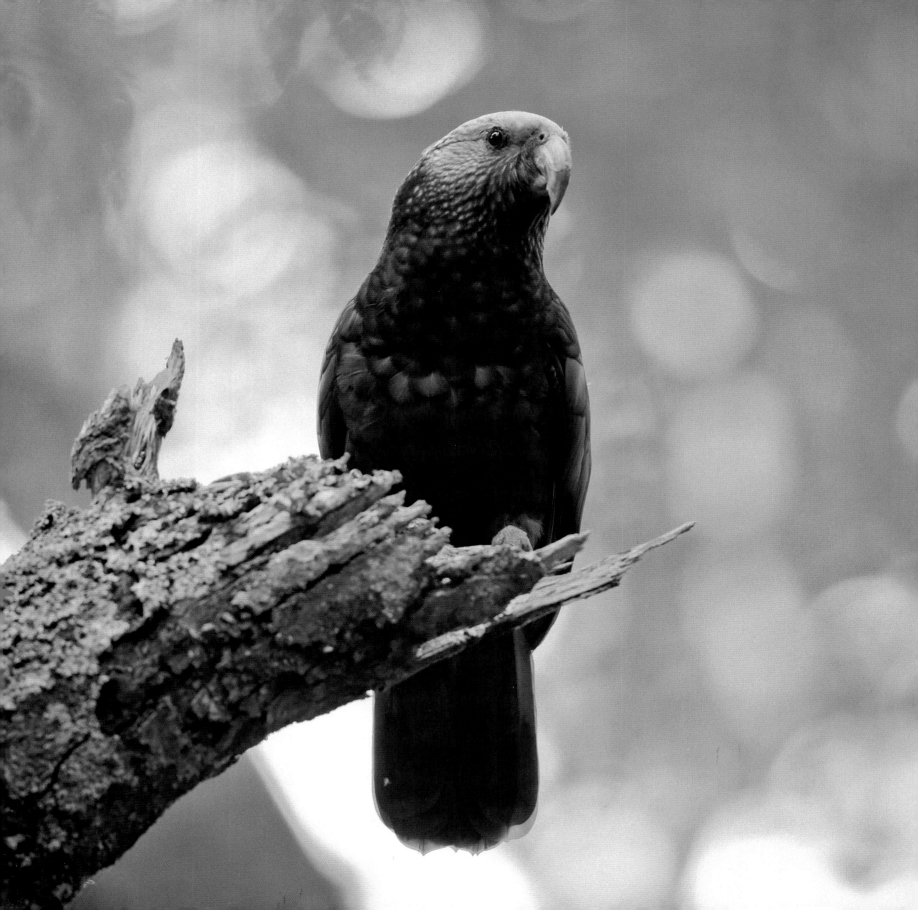

NEW ZEALAND: RAKIURA NATIONAL PARK, STEWART ISLAND

"We emerged onto the beach to the sound of lapping waves and a soft moonlight glow. The guide's flashlight scanned the beach and came to rest on a brown, furry ball. On closer inspection, it was a kiwi at the high-tide line, using his long beak to probe the sand for tasty morsels."

RAKIURA NATIONAL PARK opened in 2002, making it New Zealand's newest national park. It is made up of former nature reserves, scenic reserves and forest areas owned by the state and is teeming with native birds. The park is located on New Zealand's third largest island, Stewart Island, and covers almost 85 per cent of the island with an area of 1,570 sq km (605 sq miles). Stewart Island is less than 40km (25 miles) from the southern tip of New Zealand's South Island, and its South West Cape is the southernmost point of the country, with nothing but the Southern Ocean lying between it and Antarctica.

The wet and warm climate of Stewart Island helps to sustain the abundant flora and fauna, but it is the relative lack of introduced predators such as rats, cats, stoats, weasels and ferrets that has enabled the many native species of birds to thrive. Stewart Island is popular with birdwatchers from all around the world due to the spectacular landbirds and seabirds that live there. It is known to be one of the best places in New Zealand for viewing the shy kiwi in the wild. It is also home to large colonies of seabirds including the Sooty Shearwater. There are numerous breeding sites on the island for the endangered Yellow-eyed Penguin, as well as Blue and Fiordland Crested Penguins. The Weka, Kaka, albatrosses, Silvereye and Kereru are some of the other birds of interest on the island. Rakiura is the Maori name for the island, translating to glowing skies, which describes the warm sunsets as well as the aurora australis that can be seen from the island.

Kiwis are flightless birds, native to New Zealand and are the national symbol of the country. They are around the size of a chicken and are members of the ratite family which also includes ostriches, emus, rheas and cassowaries. It was originally thought that they were closely related to the extinct moas of New Zealand, but more recent evidence

OPPOSITE Kaka.

NOTABLE SPECIES
Stewart Island Kiwi
Sooty Shearwater
Weka
Kaka
White-capped Albatross
Wandering Albatross
Royal Albatross
Yellow-eyed Penguin

WHEN TO GO
Visit between November and April for the warmest weather and breeding season.

TIPS
The island is said to often have four seasons in a day and rain is plentiful here – bring waterproofs and sturdy shoes.

Sunset over Stewart Island.

suggests that their closest relative is the extinct elephant bird of Madagascar. Today, there are five species of kiwi, with numerous subspecies. The Stewart Island Kiwi is a subspecies of the Southern Brown Kiwi (or Tokoeka) and has slightly longer legs and a larger beak. Most kiwis are nocturnal, but the Stewart Island Kiwi can be found foraging for food during the day as well as at night. Kiwis lay the biggest egg in relation to their size of any bird, with an egg weighing around a quarter the body weight of the female bird. Producing such a large egg can be taxing for the female; she must eat three times her normal amount of food as the egg develops, but in the final days before she lays the egg the lack of room inside her body means she has little choice but to fast. Kiwis have suffered around New Zealand due to habitat loss and deforestation, which is thankfully reducing as more areas are turned into national parks and protected zones. However, the largest threat today comes from the invasive predators such as stoats and rats.

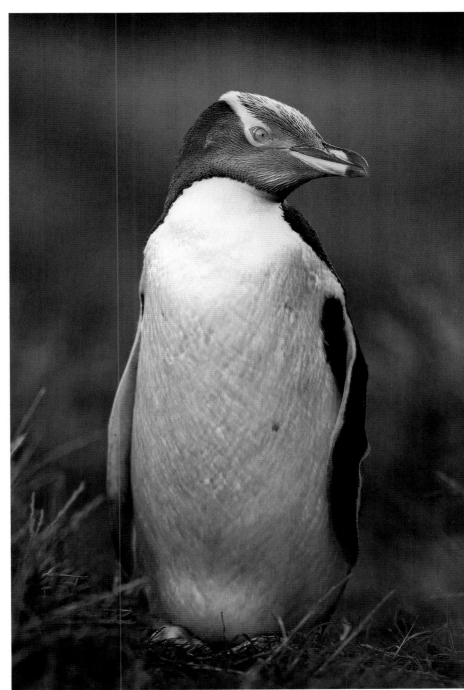

CLOCKWISE FROM TOP LEFT Weka; Yellow-eyed Penguin; Oystercatcher chick.

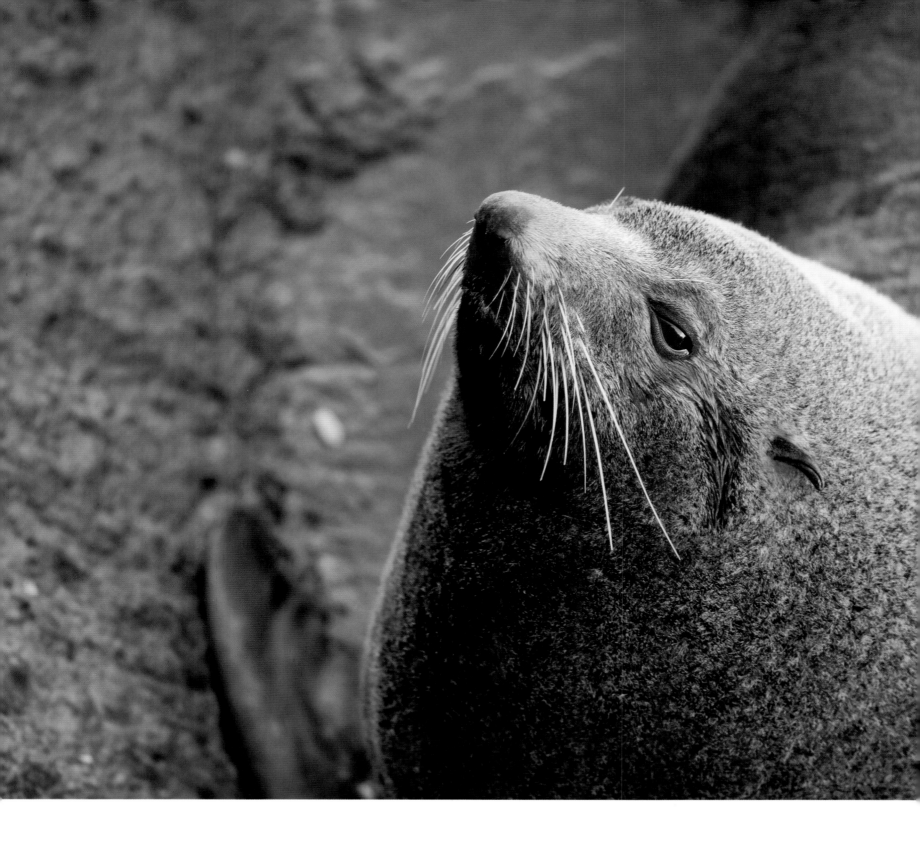

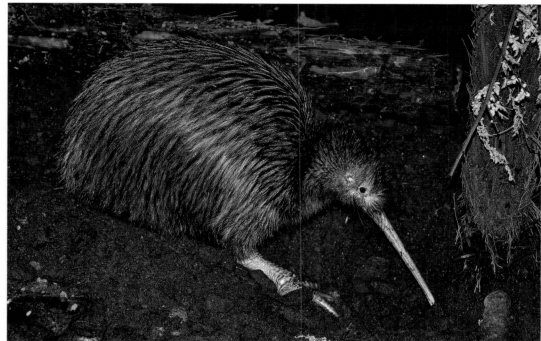
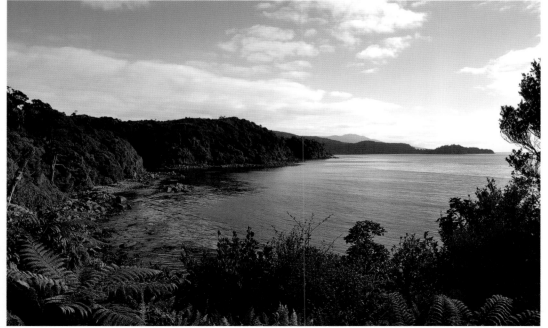

CLOCKWISE FROM LEFT Fur Seal; Brown Kiwi; cove, Stewart Island.

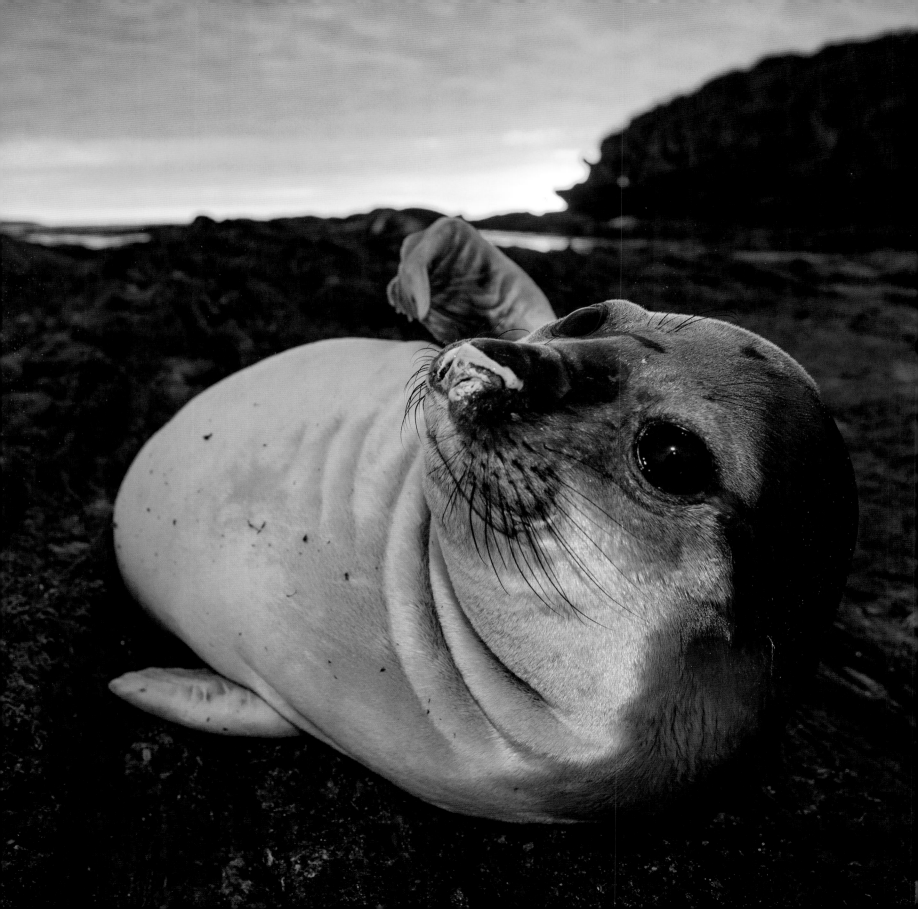

THE FALKLAND ISLANDS

"It felt like it was just me, the wildlife and the howling wind on the barren islands as I clambered around at the tops of cliffs photographing nesting albatrosses, crawled on my belly to get up close to cheeky Rockhopper Penguins and edged slowly closer to the enormous elephant seals with not another human in sight. It is a magical and wild place."

THE FALKLAND ISLANDS are an archipelago in the south-west Atlantic Ocean, 480km (300 miles) off the coast of South America. The islands have been a self-governing, overseas territory of the UK since 1833 and gained notoriety in 1982 during the 74-day Falklands War between Britain and Argentina. Nowadays, aside from the scattered war memorials and occasional wreckages of fighter jets and tanks that serve as a reminder of past events, the islands are quiet and peaceful. However, the sovereignty dispute between Britain and Argentina remains.

The 12,000 sq km (4,600 sq mile) archipelago has only 2,500 inhabitants, with the majority based in the capital Stanley. Therefore, it is likely that you will experience the wilderness and wildlife on the more remote islands completely by yourself. There are two main islands, East Falkland and West Falkland, with 766 smaller islands and 1,300km (800 miles) of coastline that supports healthy numbers of marine mammal and bird species. The islands are biogeographically part of the mild Antarctic Zone with a cold and windy climate. The howling wind is so forceful that the islands are virtually treeless, with anything higher than tussock grass struggling to remain rooted. However, the rich surrounding waters mean that wildlife is abundant, with five species of penguin breeding on the islands, gigantic Southern Elephant Seals lazing around on pristine beaches, graceful Black-browed Albatrosses in sprawling rookeries on the cliff-tops and Orcas cruising the shallow waters. The wildlife has little fear of humans, which makes a trip to the Falkland Islands a truly magical experience.

For me, one of the biggest draws of the Falkland Islands was the penguins. King, Rockhopper, Gentoo, Magellanic and Macaroni Penguins all breed on the islands, and King Penguins are the largest and most impressive species. They are the second-largest penguin after the Emperor Penguin

OPPOSITE Southern Elephant Seal pup.

NOTABLE SPECIES

Southern Elephant Seal
Orca
Sei Whale
King Penguin
Rockhopper Penguin
Gentoo Penguin
Magellanic Penguin
Macaroni Penguin

Black-browed Albatross
Imperial Shag
Rock Shag
Striated Caracara

WHEN TO GO

The best time to visit the islands is between October and April, which is when the Rockhopper and Magellanic Penguins and Black-browed Albatrosses are on land in breeding colonies. Elephant seals are ashore from September to December.

TIPS

Take a warm and waterproof windbreaker.

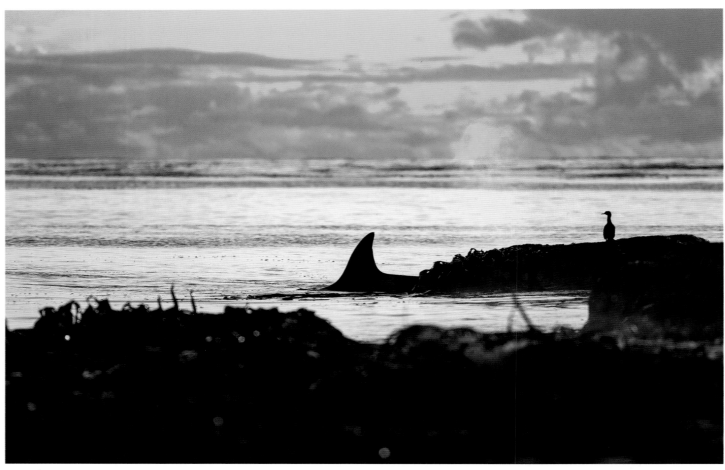

ABOVE Orca.
OPPOSITE TOP TO BOTTOM Imperial Shag; Imperial Shag colony.

of Antarctica and stand at almost 1m (3.3ft) tall. They can dive to depths of 300m (985ft), spending up to five minutes submerged in order to forage for small fish and squid. They are found in the northern reaches of Antarctica, South Georgia and other islands of the Subantarctic region, with the Falkland Islands being at the northern limit of their global range. Consequently, there are only around 400 breeding pairs on the islands, mostly concentrated at a single site called Volunteer Point.

Probably the most endearing penguin of the islands is the Rockhopper. They are the islands' smallest and most common penguin species and get their name from the fact that they hop and bound around on rocks with their feet together rather than waddling like other penguins. It is quite amazing to watch them tackle the challenging terrain, leaping between ledges on precipitous cliff faces. They have a characteristic crest of spiky black and yellow feathers that give them a rather comical appearance. Living in large colonies, often mixed in with albatrosses or Imperial Shags, means that there is always a lot of noise and commotion, with quarrels breaking out frequently. Their inquisitive nature and funny antics make them a delight to watch.

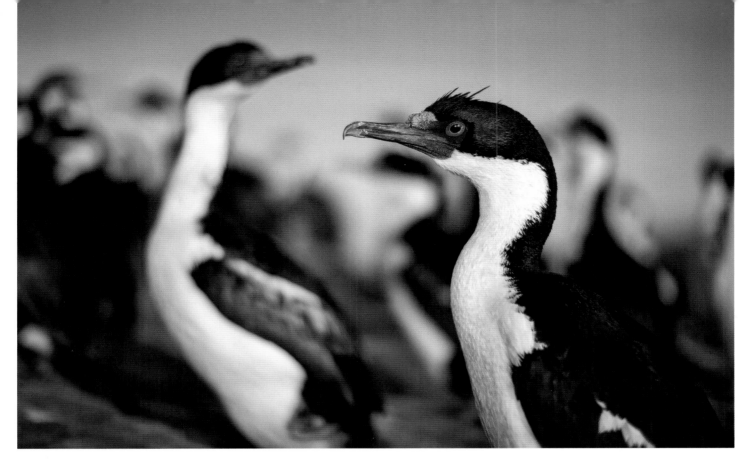

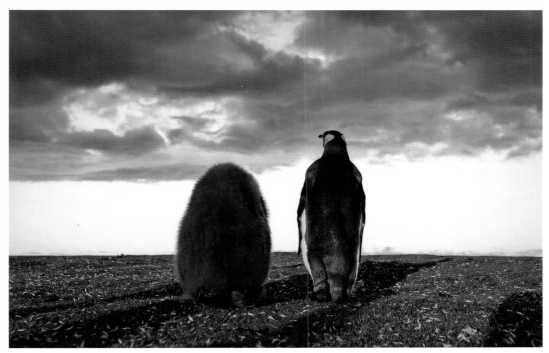
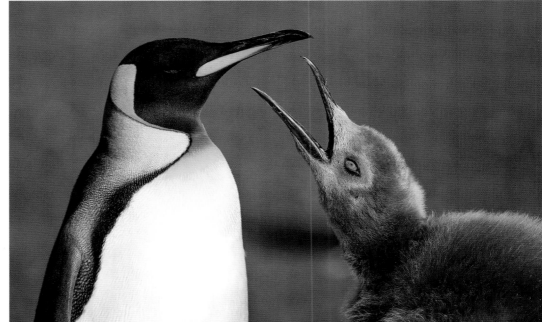

CLOCKWISE FROM LEFT King Penguins; King Penguin chick and adult; King Penguin chick begging for food.

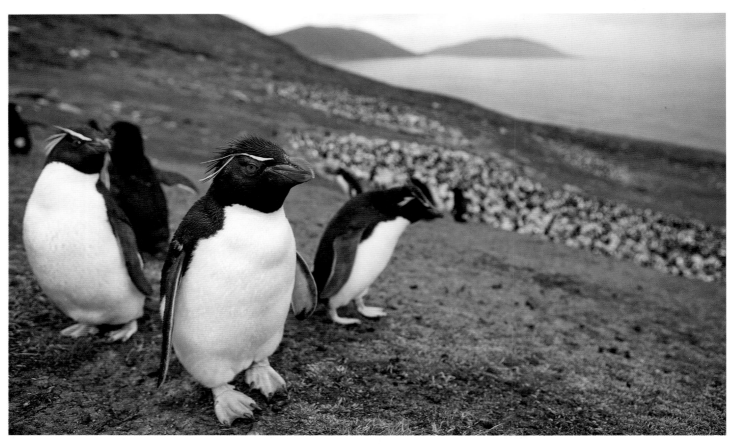

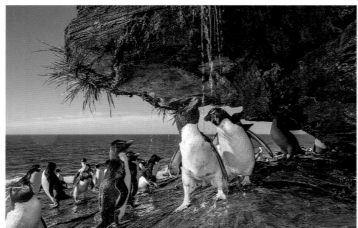

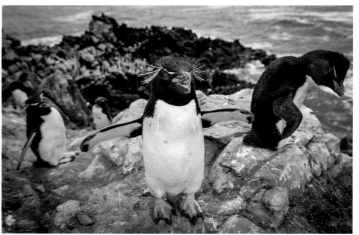

ABOVE CLOCKWISE FROM TOP Rockhopper Penguins; Rockhopper Penguins; Rockhopper Penguins showering in fresh water.
OPPOSITE TOP TO BOTTOM Black-browed Albatross; Striated Caracara.

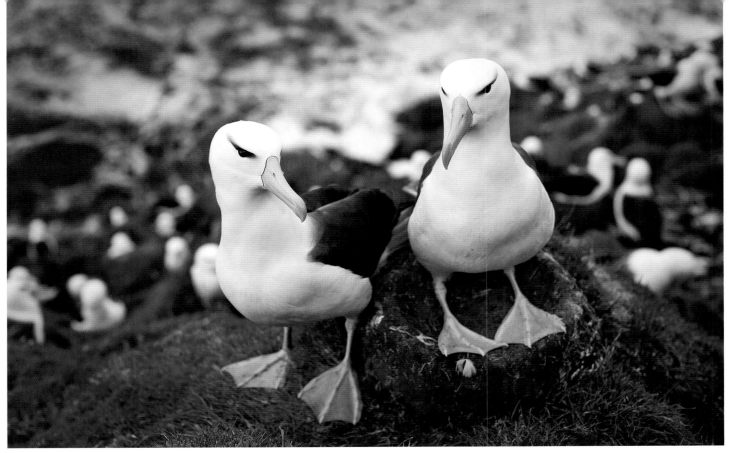

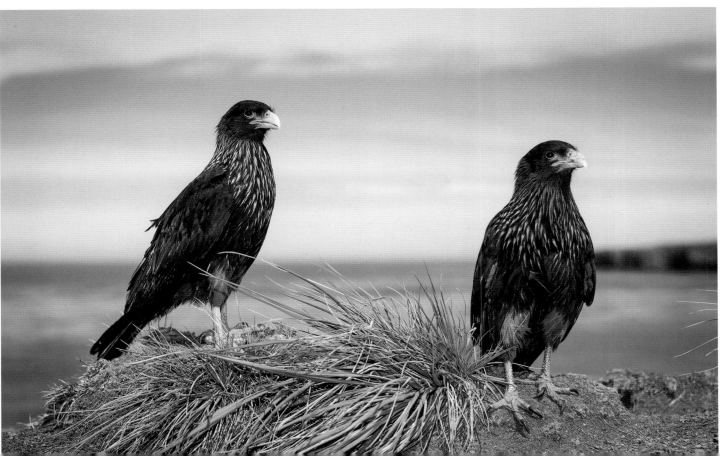

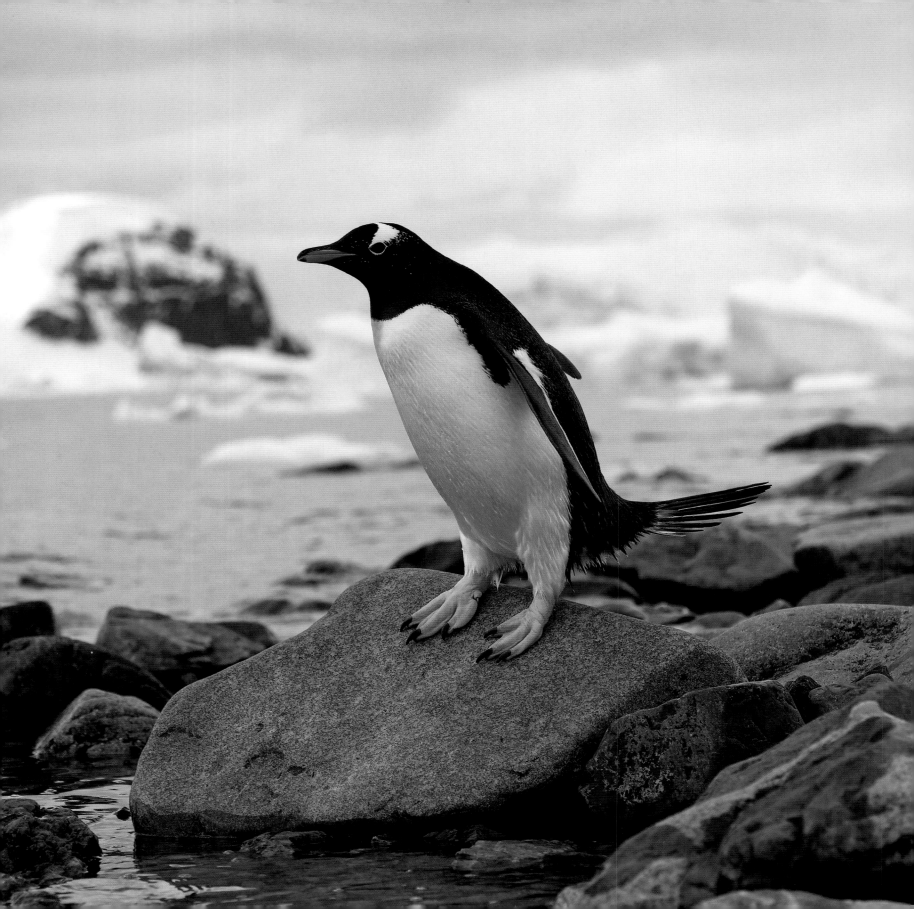

ANTARCTICA

"We are all adventurers here, I suppose, and wild doings in wild countries appeal to us as nothing else could do. It is good to know that there remain wild corners of this dreadfully civilised world."

—Captain Robert Falcon Scott

ANTARCTICA IS SITUATED over the South Pole in the Antarctic region of the Southern Hemisphere, surrounded by the Southern Ocean. The nearest land mass is South America, which is over 1,050km (650 miles) away. It is the coldest, windiest, wildest and most remote continent on Earth. Despite being nearly twice the size of Australia with a surface area of 14 million sq km (5.4 million sq miles), there are no permanent human inhabitants on the continent. This is due to the hostile conditions; over 98 per cent of Antarctica is covered by ice averaging almost 2km (1.25 miles) in thickness. It has the highest average elevation of all the continents and a complete lack of sunlight in winter.

Despite the lack of human inhabitants, Antarctica is not a barren, lifeless continent, in fact it is home to some captivating wildlife, including the famous Emperor Penguins. However, it is the sea – at a comparatively warm –2°C (28°F) – rather than the land that supports the most creatures. The plants and animals that do live permanently on land in Antarctica have to hug the ground to avoid the harsh, cold wind. Organisms such as algae, fungi, bacteria and plants all have cold-adaptations in order to survive.

The lure of the white wilderness, the fascinating wildlife and the opportunity to follow in the footsteps of great explorers such as Scott, pull in visitors despite the cold. It was the last frontier on Earth to be explored, with no man having reached the South Pole until the race for the poles between Roald Amundsen and Captain Robert F. Scott in 1911. Nowadays, from November to March, Antarctica can be visited aboard cruise ships making it possible to see the wonders of the continent without the struggles that the early 20th century explorers faced.

OPPOSITE Gentoo Penguin.

NOTABLE SPECIES

Antarctic Fur Seal
Crab-eater Seal
Leopard Seal
Southern Elephant Seal
Weddell Seal
Orca
Antarctic Minke Whale
Emperor Penguin
Adélie Penguin
Chinstrap Penguin
Gentoo Penguin

WHEN TO GO

Antarctica can only be visited during the summer months from November to March.

Visit early in the season if you want to see the pristine Antarctic ice.

December to January is the best time to view the penguin colonies once the chicks have hatched. February to March is the best time for whale-watching.

TIPS

Take travel sickness medication if you are prone to seasickness. The two-day crossing of the Drake Passage en route can be rough.

Glacial ice.

Paradise Bay.

Penguins often spring to mind when I think about Antarctica. There are four species of penguin that live and nest on the Antarctic mainland (Emperor, Adélie, Chinstrap and Gentoo). Of these four, it is only the Emperor and Adélie Penguins that take on the full brunt of the Antarctic conditions; Chinstrap and Gentoo Penguins breed on the very northern tip of the Antarctic peninsula where conditions are slightly milder. There are three other species that are considered to be Antarctic penguins (Macaroni, King and Rockhopper), but these in fact live on Antarctic or Subantarctic islands rather than on the continent itself.

The Emperor Penguins are the most well-known of the Antarctic penguins and regularly star in Hollywood movies and wildlife documentaries. They are the most southerly of all species of penguin, enduring the most harsh breeding conditions of any bird, as they live and breed on the sea-ice of continental Antarctica. The penguins live together in large colonies, huddling together to keep warm and taking turns to squeeze into the group's warm interior. They breed annually during the Antarctic winter between June and August. The female lays a single egg and then promptly heads out to sea to feed. At that time of year, when the extent of the sea-ice is at its greatest, she may need to travel up to 80km (50 miles) to reach open ocean.

She can be gone for up to two months, leaving the male (who remains without food) to incubate the egg during Antarctica's coldest months. He balances the egg on his feet and keeps it covered with his brood pouch (feathered skin). On the female's return, she regurgitates food for her chick, and the male is released from his duties to go and feed himself at last. The chick remains in their mother's brood pouch to stay protected from the harsh Antarctic winter. By December, the weather is warming up and the ice breaking, resulting in open water appearing nearer to the breeding site and the five-month-old chicks can start swimming and fishing.

Other famous inhabitants of the region include Orcas. These are the largest species of dolphin; they can measure over 9m (30ft) long. They have distinctive black and white colouring, along with a prominent dorsal fin. They are not unique to Antarctica, in fact they are the most widely distributed sea mammal, found in every ocean on the planet from polar regions to the equator. They are also the fastest sea mammal and are highly effective predators, hunting in pods of up to 40 individuals. In Antarctica, Orcas grab seals directly off the ice and use other clever, coordinated techniques such as wave washing to get the seals into the water.

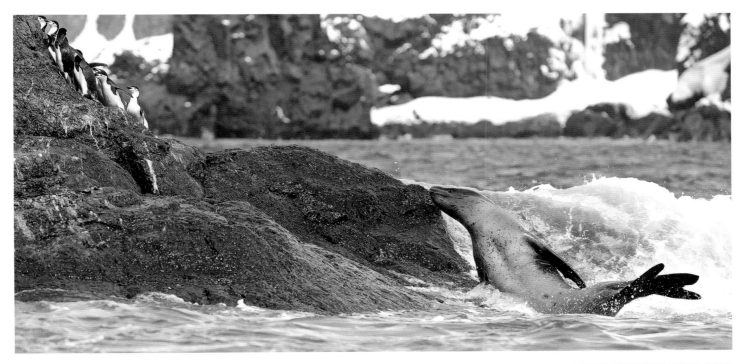

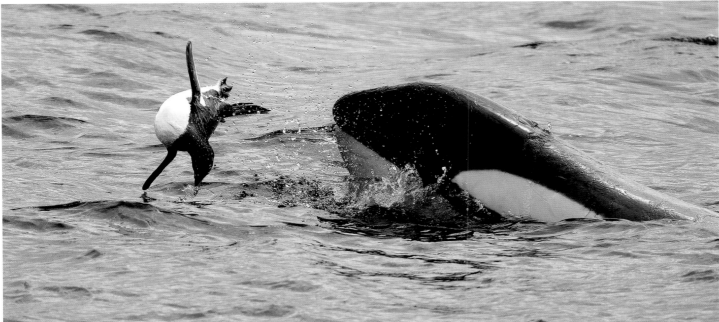

ABOVE TOP TO BOTTOM Leopard Seal hunting; Orca playing with Gentoo Penguin.

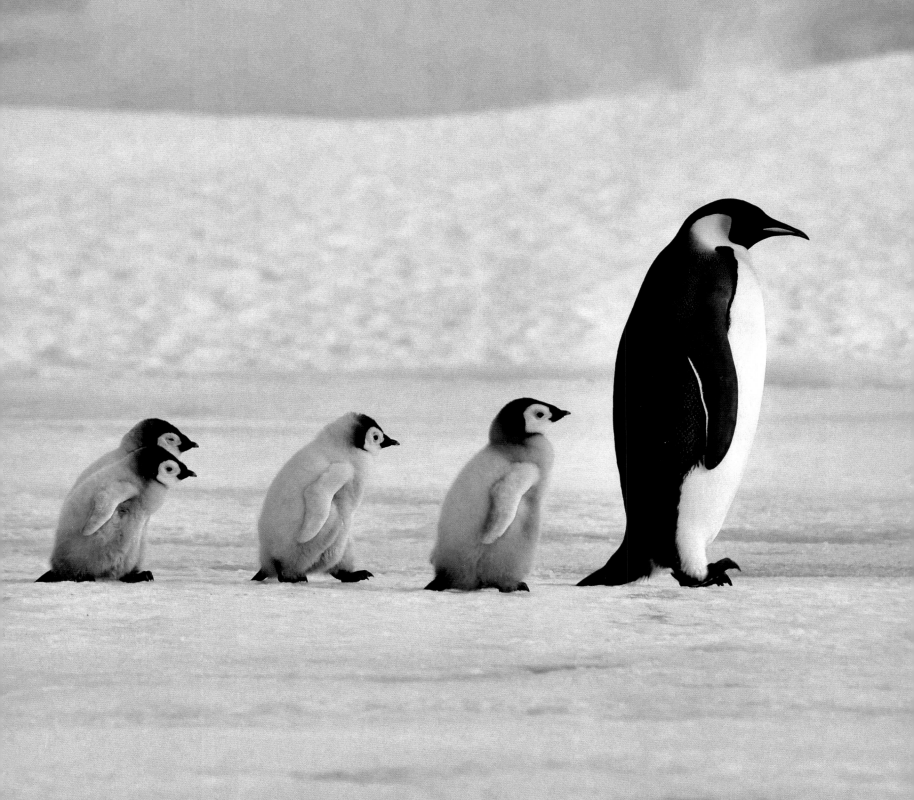

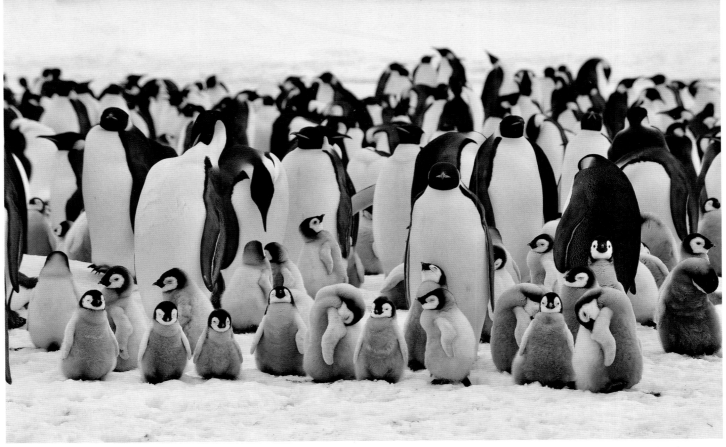

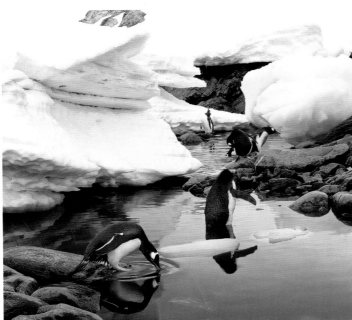

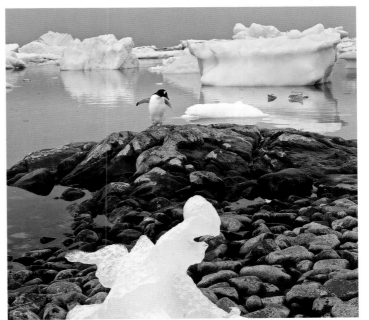

OPPOSITE AND ABOVE Emperor Penguins.
BOTTOM LEFT AND RIGHT Gentoo Penguins.

ABOUT THE IMAGES IN THIS BOOK

MOST OF MY IMAGES have been taken using Canon equipment. My go-to wildlife lens is the Canon 400mm f2.8 II. I also like to get close to my subjects and use a wide-angle lens to gain a more immersive perspective.

Getting close-up images of potentially dangerous animals such as lions and elephants presents some serious challenges! To help me achieve this, I created BeetleCam in 2009. BeetleCam is a remote-controlled buggy with a mount for a DSLR camera. It has helped me to capture unique shots such as those seen on pages 82, 84, 86, 94 and 95.

Elusive creatures and nocturnal animals can be very hard to see and to photograph. I therefore designed a camera trap system for this purpose. This comprises of a high quality DSLR camera that can be left out for prolonged periods of time. A motion sensor detects the animal and triggers the shutter, enabling me to photograph animals such as the porcupine on page 106 and the Brown Hyena on page 143. Due to popular demand, I have now made these devices available to other photographers through my company called Camtraptions.

You can see behind the scenes footage of me at work in several of the wildlife destinations featured in this book at www.wildlife-experiences.com.

LEFT Remote-control copters help to gain an aerial perspective.
OPPOSITE TOP LEFT Camera trap set-up on an animal trail in Zimbabwe. The Camtraptions motion sensor is in the foreground with the camera and flash behind.
OPPOSITE TOP RIGHT Photographing Meerkats in Botswana, using a Canon 1DX and 400mm f/2.8 lens.
OPPOSITE BOTTOM LEFT Photographing a large Komodo Dragon with a remote camera.
OPPOSITE BOTTOM RIGHT In the Serengeti with the fifth-generation BeetleCam.

IMAGE CREDITS

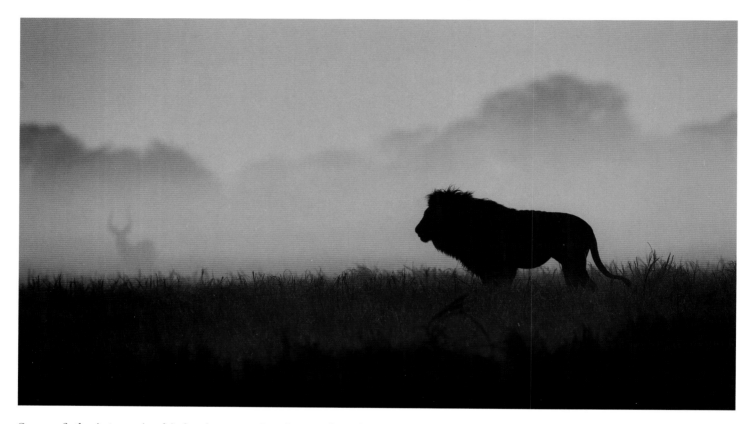

Some of the images in this book were taken by my friends and colleagues. I would like to say a special thank you to Rebecca Jackrel (www.rebeccajackrel.com), Richard Peters (www.richardpeters.co.uk), Elliott Neep (www.elliottneep.com) and my brother Matt Burrard-Lucas, for their photographs and support. The full list of photo credits is as follows:

Matt Burrard-Lucas (pages 16, 17 below left and below right, 18 below left and below right, 19 left and above right, 22, 24 above left, 85, 98, 100 centre left and right, 181 below right, 183 above, 205 below and 214).

Rebecca Jackrel (pages 14, 17 above, 18 above, 19 centre right and below right, 156, 158–161 all images, 178, 230, 232 both images, 233 above, 235 below left and right).

Richard Peters (pages 26 and 28–29 all images).

Elliott Neep (pages 44, 46, 47 both images and 48).

Dreamstime.com (pages 23, 25, 30, 31 all images, 41, 42, 43, 49 both images, 61, 167 above right, 196 below, 197, 201 centre left, 221 above right, 221 above right and below right, 233 below, 234, 235 above).

INDEX

A

Aardvark 127, 131
Aardwolf 127
Adder, Horned 145
Alaska 156–161
Albatross 217
 Black-browed 223, 229
 Waved 185, 186, 189
Amber Mountain National Park 146–153
Anole, Blue-throated 170
 Little Cayman 175
ant, army 177
 bullet 177
 leafcutter 183
Antarctica 230–235
Anteater, Giant 199, 202–203
 Silky 177
Antelope, Roan 111, 119
 Sable 111, 133, 136–137
Australia 208–215

B

Bale Mountains National Park 70–75
Bandicoot, Eastern Barred 209
Bat 196
 fruit 63, 66
 Straw-coloured Fruit 110–116
Bear, Alaskan Brown 156–160
 American Black 161, 163
 Brown 16, 20–24, 156–160, 163, 166, 167
 Kodiak 16
 Polar 14–19
 Sloth 39, 45, 51
 Sri Lankan Sloth 51
 Sun 57
Beaver, American 157, 163, 165
Bee-eater, Southern Carmine 109
Bettong, Tasmanian 209
Bison, American 154–155, 162–164
Boar, Wild 39, 45, 46, 57, 63–64
Bongo 77
Booby, Blue-footed 185, 188
 Brown 171, 174
 Nazca 185
 Red-footed 171, 185
Botswana 126–139
Brazil 10, 198–205
Buffalo, Cape 86, 89, 103, 105, 123, 133, 134

Forest 77, 79
 Water 46, 51, 63–64
Buzzard, Augur 72

C

Caiman 177, 180, 193, 199, 201
 Black 193
Capuchin, White-faced 177
Capybara 199, 200
Caracara, Striated 223, 229
Cat, African Wild 143
Cayman Islands 170–175
Chameleon, Amber Mountain Leaf 147
 Brookesia 151
 Elephant-eared 151
 Petter's 151
Cheetah 83, 89, 90, 92, 119, 133, 134
Chimpanzee 77
China 32–37
Chitwan National Park 38–43
Civet, Asian Palm 63–64
Coati 10, 178, 202
 White-nosed 177
Cock-of-the-rock, Andean 197
Corcovado National Park 9, 176–183
Cormorant, Flightless 185, 186
 Great 27
Costa Rica 9, 176–183
Crab, Sally Lightfoot 186
Crocodile 46, 57, 177
 Mugger 38, 45, 51
 Nile 89, 103, 133, 134
ctenosaur 181

D

Deer, Barking 45
 Marsh 199
 Spotted 45, 51
 Timor 63–64
Devil, Tasmanian 208–210
Dog, African Wild 103, 105, 119–122, 133, 134, 139
dolphin 64
Dragon, Komodo 62–65
dugong 64

E

Eagle, Bald 157, 158, 163
 Golden 33, 163
 Harpy 193
 Martial 109, 112

Echidna, Short-beaked 209
Ecuador 184–191
Eider, Common 27
Eland 83
Elephant 6–7
 African 77–79, 83, 85, 89, 97, 103, 107, 118–121, 133, 134
 Asian 12–13, 39, 43, 50–53
 Forest 77–79, 97
 Sri Lankan 50–53
Elk 163–164, 168
Ethiopia 70–75

F

falcon 112
Falkland Islands 9, 222–229
Farne Islands 26–31
Fer-de-lance 177
Finch, Darwin 187, 190
Finland 20–25
fish-eagle 112
Flycatcher, Galápagos 187
flying-fox 63, 66
Fossa 147, 149
Fox, Arctic 15, 17
 Bat-eared 91, 127
 Red 167
Francolin, Chestnut-naped 73
Frigatebird 185
 Magnificent 171
Frog 78
 Glass 9, 182
 poison-dart 176–177
 Red-eyed Tree 182
 Strawberry Poison-dart 176
 tree 153, 177, 182

G

Galápagos Islands 184–191
Gazelle, Thomson's 83, 89
Gecko, Day 153
 Leaf-tailed 147, 148, 152
Gemsbok 119, 141, 144
gibbon 57, 61
Giraffe 89, 123
 Maasai 83
 Thornicroft's 103, 106
Gorilla, Mountain 11, 96–101
 Western Lowland 76–81
goshawk 130

Grand Teton National Park 162–169
Guillemot, Common 27, 31
Gull, Swallow-tailed 185

H

Hawk, Galápagos 185
Heron, Yellow-crowned Night 174
Hippopotamus 8, 89, 103, 107, 133–135
Hog, Giant Forest 77, 97
horse 63
Hwange National Park 118–125
Hyena 90
 Brown 119, 127, 130, 141, 143
 Striped 45

I

Ibis, Crested 33
Iguana, Grand Cayman Blue 5, 171–173
 Green 181
 Marine 185, 186, 190
 Sister Isles Rock 171, 175
Impala 103
India 44–49
Indonesia 56–67
Indri 148

J

Jackal 46
 Black-backed 143
Jaguar 177, 193, 196, 198, 199–201

K

Kainuu region 20–25
Kaka 216, 217
Kalimantan 56–61
Kasanka National Park 110–117
Katmai National Park 156–161
Kenya 82–87
Kereru 217
kite 112
Kittiwake, Black-legged 18, 27, 31
Kiwi, Southern Brown 217, 221
 Stewart Island 217, 221
Komodo National Park 62–67
Kuhmo region 20–25

L

Langur, Grey 49, 51, 54–55
 Hanuman 39
Lechwe, Red 133–135
Lemur 146–149
 Crowned 147–149

Lesser Bamboo 147
 Mouse 148
 Sanford's Brown 146, 147
Leopard 39, 45, 46, 51, 77, 83, 89,
 102–104, 133, 134, 138
 Clouded 33, 57
 Sri Lankan 51
Lion 4, 82–84, 89, 90, 94, 95, 103, 104,
 119, 127, 133, 141, 144
 Desert 141, 144
lizard, basilisk 181
lobelia, giant 72, 73
Lynx, Canada 163
 Eurasian 21

M

Maasai Mara National Reserve 82–87
Macaque, Crab-eating 63–64
 Rhesus 39
 Toque 51
Macaw 193
 Hyacinth 199, 204
 Red-and-green 193–195
 Scarlet 177
Madagascar 146–153
Makgadikgadi Pans National Park
 126–131
mantis, flower 78
Manú National Park 192–197
Marmot, Yellow-bellied 163, 165
Marten, American 157
Meerkat 126–129
Minneriya National Park 50–55
Mockingbird, Galápagos 185, 187
Mole-rat, Giant 71, 73
Mongoose, Ring-tailed 147
Monkey 148
 Bale 71
 Black Howler 204
 Blue 111
 Central American Squirrel 177
 Geoffrey's Spider 177
 Golden 97
 Mantled Howler 177
 Proboscis 57–60
 Qinling Golden Snub-nosed 33, 36
Moose 21, 157, 163, 166
Mouse, Long-tailed 209

N

Namibia 140–145
Narwhal 15
Nepal 38–43
New Zealand 216–221
Norway 14–19
nudibranch 64
Nyala, Mountain 71, 72

O

Ocelot 177, 199
Odzala-Kokoua National Park 76–81
Okavango Delta 132–139
Orangutan 56–59
Orca 9, 223, 224, 231–233
Osprey 168
Otter, Cape Clawless 111
 Giant 192–194, 199
 River 163
Owl, Galápagos Short-eared 185
 Great Grey 21, 169
 Pel's Fishing 111
Owlet, Pearl-spotted 125
oystercatcher 219

P

Pademelon, Tasmanian 209
Palmwag Concession 140–145
Panda, Giant 32–34
 Red 33
Pantanal 10, 198–205
Parrot, Cayman Brac 171
 Cuban 171
 Grand Cayman 171, 174
 Grey 77
Penguin 206–207
 Adélie 231, 232
 Blue 217
 Chinstrap 231, 232, 235
 Emperor 223, 231, 232, 234, 235
 Fiordland Crested 217
 Galápagos 185–187
 Gentoo 223, 230–233, 235
 King 223, 224, 226, 227
 Macaroni 223
 Magellanic 223
 Rockhopper 223, 224, 228
 Yellow-eyed 217, 219
Peru 192–197
Pheasant, Golden 37
Platypus 209
porcupine 57, 106
Pronghorn 163
Ptarmigan, Rock 15
Puffin, Atlantic 26–29
Puku 103, 108

Q

Qinling Mountains 32–37
Quoll, Eastern 209

R

Rakiura National Park 216–221
Ranthambore National Park 44–49
Rat, Rinca 64
ray 64
Razorbill 27

Reedbuck, Bohor's 71
Reindeer, Svalbard 15, 18
Republic of Congo 76–81
Rhinoceros, Black 83, 140–142
 Greater One-horned 39–41
 White 142
Roller, Lilac-breasted 109
Rwanda 11, 96–101

S

Salmon, Sock-eye 157–159
Sambar 39, 45, 46, 49, 51, 57
Sea-lion, Galápagos 185, 186, 190, 191
seahorse, pygmy 64
Seal 232
 Antarctic Fur 231
 Bearded 15, 19
 Crab-eater 231
 Fur 220–221
 Galápagos Fur 185, 186
 Grey 27
 Harbour 15
 Leopard 231, 233
 Ringed 15
 Southern Elephant 222, 223, 231
 Weddell 231
Serengeti National Park 88–95
Serval 89
Shag, European 27, 30
 Imperial 223, 225
 Rock 223
Shark, Bull 177
 Hammerhead 185, 186
 Whale 64, 185, 186
Shearwater, Sooty 217
Shoebill 117
Silvereye 217
Sitatunga 111, 133–135
Skimmer, African 137
Skua, Arctic 18
Sloth, Three-toed 177
 Two-toed 177, 178
snake 57
South Luangwa National Park 6–7, 8,
 102–109
spider, golden orb 177
Squirrel, Red-and-white Giant Flying 37
Sri Lanka 50–55
starling, glossy 124
Stewart Island 216–221
Stingray, Southern 175
Stork, Jabiru 205
Svalbard 14–19

T

Takin, Golden 33, 35
Tamandua, Northern 177

Tanjung Puting National Park 56–61
Tanzania 88–95
Tapir, Baird's 177, 178
 Brazilian 193
Tasmania 208–215
Tern, Arctic 27
Thrush, Amber Mountain Rock 150
Thylacine 209
Tiger, Bengal 39, 42, 44–48
Tokoeka 217, 221
Topi 83, 93
Tortoise, Galápagos Giant 184–186
Toucan, Toco 205
Tsessebe 133, 134
Turtle, Hawksbill 171

U

United Kingdom 26–31
USA 146–169

V

Viper, Eyelash Pit 177, 183
Volcanoes National Park 11, 96–101
Vole, Sibling 15
vulture 90

W

Wallaby 209, 211
 Red-necked 5, 209
Walrus 4, 15, 16, 19
Weaver, Golden 137
Weka 217, 219
Whale, Antarctic Minke 231
 Beluga 15
 Bowhead 15
 Sei 223
 Sperm 64
Wildebeest 68–69
 Blue 83, 88–95
 Cookson's 103
Wolf, Ethiopian 70–75
 Grey 21–22, 25, 71, 157, 163–164, 167
 Maned 199
Wolverine 21–23
Wombat, Common 209, 212–213
Woodpecker, West Indian 174

Y

Yellowstone National Park 162–169

Z

Zambia 6–7, 8, 102–117
Zebra 89, 90, 92, 93
 Burchell's 127, 132–135
 Crawshay's 103, 106
 Mountain 141
Zimbabwe 118–125